The Traveling Nature Photographer

Steven Morello

Schiffer
Publishing Ltd
4880 Lower Valley Road, Atglen, Pennsylvania 19310

This book is dedicated to
Wayne Costa,
a man who made sense of life.

Covers and book designed by: Bruce Waters

Type set in Jenson Pro and Humanist 521

ISBN: 978-0-7643-3055-1
Printed in China

Schiffer Books are available at special discounts for bulk purchases for sales promotions or premiums. Special editions, including personalized covers, corporate imprints, and excerpts can be created in large quantities for special needs. For more information contact the publisher:

Published by Schiffer Publishing Ltd.
4880 Lower Valley Road
Atglen, PA 19310
Phone: (610) 593-1777; Fax: (610) 593-2002
E-mail: Info@schifferbooks.com

For the largest selection of fine reference books on this and related subjects, please visit our web site at **www.schifferbooks.com**
We are always looking for people to write books on new and related subjects. If you have an idea for a book please contact us at the above address.

This book may be purchased from the publisher.
Include $5.00 for shipping.
Please try your bookstore first.
You may write for a free catalog.

In Europe, Schiffer books are distributed by
Bushwood Books
6 Marksbury Ave.
Kew Gardens
Surrey TW9 4JF England
Phone: 44 (0) 20 8392-8585; Fax: 44 (0) 20 8392-9876
E-mail: info@bushwoodbooks.co.uk
Website: www.bushwoodbooks.co.uk
Free postage in the U.K., Europe; air mail at cost.

Contents

My photographic career has been a life-long learning experience that is continuing everyday. I have been blessed with colleagues and friends who have mentored me along the way, and I am sorry if I leave anyone out. It's not that I don't remember what you have done for me; it's just that it is so difficult to remember everyone while under the stress of writing this down.

I want to thank the professional photographers who have helped me. Stephen J. Krasemann got me my first break in publishing and taught me the benefit of being altruistic. Fred Brummer treated this novice "know it all" like an equal. There are few things that can compare with having colleagues who make photography such a terrific experience, and for that I need to thank Jeff Foott, Steve Drogin, Norbert Rosing, and Mario Corvetto.

As much as I owe to my colleagues who are photographers, I also owe as much to my colleagues who are guides. If you want to be a good photographer, be a good naturalist. I have had the pleasure to work with and learn from some of the best there are, and I am always amazed at the knowledge and devotion they bring to our craft. They include Mike Bruscia, Colin McNulty, Eric Rock, Andrew Reynolds, Paul Ratson, Pilot Manga, Conrad Henning, Steve Seldon, Ward Dixon, Brendan O'Neil, Paulo Valerio, Ken Wilkinson, Darcy Callahan, Bonnie Chartier, Astrid Frisch, Roberto Plaza, Denny Gignoux, Melissa Scott, Leonardo Chaves and all the guides at Unique Safaris, Wilderness Safaris, and Classic African Adventures.

The people I have mentioned so far are the professionals in their field, but there are just as many people who, simply by means of earning a living doing something else, are not professional photographers or guides. Everyday naturalists and photo enthusiasts who I have spent time with, enjoying life and learning about my craft, include Mike O'Connor, Wendy Willard, and Mike Orbe who were with me on Cape Cod and are still in my thoughts all the time. Brad & Mary Ayler, Sue Wheeler, David & Eleanor McCain, Rick Guthke and Ian Keller all traveled with me and shared the incredible moments that have defined my life. I need to include Wayne Johnston and Mark Lacharite, who are my local photo buddies and always ready to join in an adventure to find something new; my life would be boring without you. I thank Dick and Kathy Ralston for sharing their wonderful backyard.

I also thank the organizations and people that have helped me along the way, specifically Ben Bressler at Natural Habitat for allowing me to help him start something very worthwhile decades ago. Besides Ben, all of the people at Natural Habitat, including Jennifer O'gara, Suzanne Kiser, Aly Woodward, Greg Courter, Trista Gage, Wendy Klausner, Matt Hicky, Valerie Wimberly, Susanne Matt Kareus, Nicole Hicky, Emily Supernavage, Maggie Cummings, Caroline Fernandez, Matt Unger, & Sarah Knight. Every one of you has helped make this book possible.

Matt Goddard deserves special recognition for his help at Natural Habitat and for his unselfish help with Green Planet Expeditions, my company. I could not have grown it without him. The wonderful people at Asia Transpacific Journeys, Meg Katzman at Unique Safaris, Phil Ward at Classic African Safaris, Helena Lovo at Brazil Eco Travel all made my life easier. I also thank my friends and fellow photo enthusiasts at World Wildlife Fund, particularly Shelia Donoghue, Jill Hatzai, Roberto Brooks, and Debra Gainer for their support over the years. For help with images of products for this book, I thank Ms. Suzanne D Caballero at Lowepro, Michael Burnem from Hoya Filters, Pam Barnett from Epson, and Jeff Bell from Kirk Enterprises.

I also thank the people who believed in my abilities when I started Green Planet Expeditions: Rob Fure and Susie Thompson at Washington & Lee University, and Bert DeVries at the Philadelphia Zoo. My Aunt Beth, who shared travel escapades and provided so many funny stories for all my clients; I would not have it any other way. My mom, who obviously had reason to make me her favorite, and my brother Anthony and sister Grace I love for becoming the family you are.

I also thank the thousands of travelers I have met throughout the last twenty-five years. You have all been a part of this project, even if you were an example of what *not* to do, I appreciate that you were there with me along the road.

Last, but never least, my wife Marie has always supported me any way I needed. You have been my porter, gofer, constant companion, best editor, and biggest fan, but most of all you give me a reason to be happy every day.

Steven Morello

4

Preface

I never thought I would end up a professional photographer. Actually, I remember being annoyed at my hiking companions who carried cameras with them on camping trips in the Catskill Mountains when I was a teenager. They would always need to stop and get their cameras from their packs, fiddle with lenses, then take forever to compose the picture and make the image. Of course, then we had the process of putting everything back into the packs before we could resume our hike to the inevitable next Kodak moment, where the whole process began anew. My interest was in the natural world; I was there to be away from city life in Patterson, New Jersey, and enjoy a day or more in the wilderness. Well, it wasn't exactly wilderness, but at the time any place with more than two trees and a flock of pigeons was wilderness. However you looked at it, I had little patience for my photographically inclined friends.

Time went on, and in my mid-twenties I found myself working as a naturalist on a whale-watch boat in Cape Cod, Massachusetts. I was also part of a group of great people who consisted of naturalists (one was me), filmmakers, photographers, and writers who produced environmental, educational programs for school kids. The photographers would join me on whale-watch boats and photograph whales for our productions. I still had not developed any love for the camera, but soon that would change.

In winter months, when the whale-watch boats were finished for the season, I would go to sea as the Marine Mammal Observer on government research vessels stationed at Woods Whole. My group thought this would add volumes to our educational material,

but there was a problem; photographers where not allowed on research boats. All agreed it was time for me to invest in a camera and bring it with me to document what happened on research cruises. I reluctantly gave-in. With instructions on the basics of making photos, I headed to sea to make my mark in photography. At the time, my mark was rather insignificant, but I discovered something about myself; I loved pushing the shutter release.

I was fortunate to have very talented photographers around me who never minded my pestering questions to improve my photography. I was also fortunate to use my camera every day while I was whale watching. It seems like everything to make me a better photographer was happening right at the right time. I was a naturalist first, and this gave me insight into the things I liked to photograph. I knew more about whales than I knew about any-

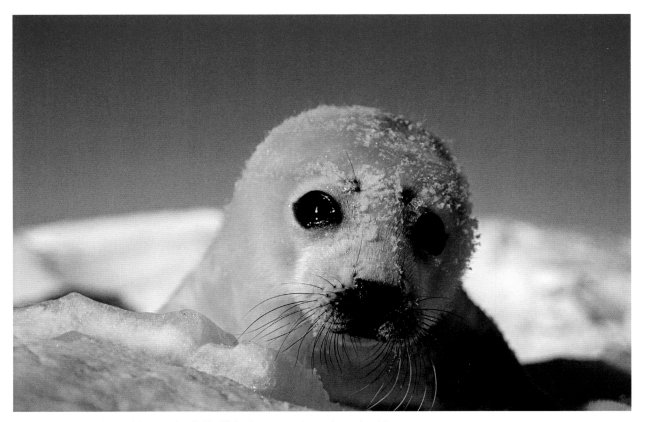

Harp seal pup on the pack ice on the Gulf of Saint Lawrence. It was here that I first had the chance to share my love of photography with others.

thing else. People around me really knew the craft of photography and were happy to share it with me. I found this so important and I owe much to my first photography teacher, Chuck, who gave me a foundation. Being able to photograph almost everyday taught me how to use the camera and developed my eye and personal style. Most importantly, I put what I was learning into practice and learned for myself the many nuances of photography. I later discovered three recommendations to making good images: learn your craft, photograph whenever you can, and photograph what you love.

One more piece of luck helped me to my present career-- the whales. When I was photographing whales, very few other people were doing so. Only a couple of whale-watching boats operated at the time and many of events I was photographing had never been documented before. My skill progressed just in time to sell my first images for *Americas Seashore Wonderlands*, published by The National Geographic Society. I was soon practicing more photography and less science; I was becoming a photographer.

In 1989 I was photographing harp seals on pack ice in the Gulf of St. Lawrence. I wasn't alone. I was guiding a small group of tourists and had the chance to use my own experience to help others with their photography. Since then, I have continued to guide natural history and photographic tours around the world. Often I work with fellow travelers to help overcome complexities they face to make images while traveling. Whether it is with the simplest or most complex cameras, we all have problems while traveling with cameras.

This book is the result of my experiences and the experiences of many others who travel to make images. It is an effort to answer many questions photographically inclined travelers have asked me and other tour operators over the years. I wrote the text of this book, but much of the information comes from people with whom I have shared journeys, both professional photographers and lay people. Much of what I know has come from their experiences, and hopefully by sharing this collective fount of knowledge more still will benefit. Photographing nature is all about being prepared.

This book can be a teaching tool, but it is also a celebration of the beauty of this Earth. It is a tribute to people I have been blessed to work with who committed themselves to saving or preserving other beings that share the Earth with us. From my desire to preserve the natural wonders around me, photography became my passion and I have been fortunate to share it with the people who traveled with me. It is sobering to know that much of the wildlife I photographed may not exist in the future. Photographs are a record of what existed at a particular time and place. I spend a lot of time now making images for the World Wildlife Fund photo library and I hope they are used to promote welfare for the animals that share our planet. Photographic images connect us to the natural world and make us amazed at what exists. You, too, can make photographs of the world that will inspire others.

Chapter 1
Preparation

In photography, preparation can be the difference between showing a picture of the big moment and having stories that begin with, "If only I had been ready with my camera." Nature is unpredictable. If you want to capture special moments, you need to be ready. That means knowing what to expect and how to access your equipment as quickly as possible.

This and more is easily accomplished with preparation and practice. Doing your homework before you go, having an idea of what images you hope to bring home, and being able to use your equipment to its fullest potential can be as important as taking the picture. To some, preparing for a vacation may seem like more work than they are willing to do to, however prep work is a way to extend your enjoyment of the adventure. Preparation can be part of the excitement; start from the beginning before you leave on your trip.

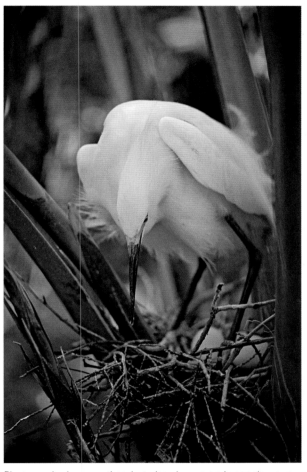

Photography is more than just showing up and snapping away. Being prepared for weather, having the right equipment, and knowing what to expect should all be done prior to your journey. Snowy Egret, Everglades.

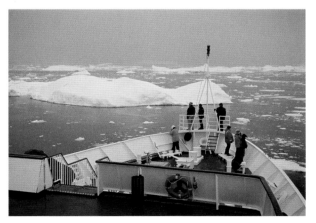

No matter where you are heading, chances are that someone else has been there before you and there is information about your destination available to you. Cruising through icebergs in Antarctica.

The Place and What You Need

Chances are that unless NASA is preparing your itinerary, someone else has been there before you. This means that somewhere there is information about the destination, wildlife, and conditions you will be working in. Information will be your best tool in forming ideas about what equipment to bring, how to carry it, and how it will be used. If you are traveling on a pre-organized tour, the travel company will probably send you pre-departure material with lots of information about where you will be going and useful tips to help you along in your travels, however, you can still improve on your knowledge base with the other information available to you. The big question is how do you access this information? Often the best place to learn about the places you will be visiting is the computer. The Internet is a wonderful way to virtually visit many of the places on your itinerary before you actually go there. If you have a predetermined itinerary you may find web sites for each individual lodge or motel. The websites frequently have very useful and detailed information about the surrounding area, attractions, events, and photos for you to see what the place and terrain look like. This will give you ideas about what the light is like, what the habitat is like, and this can be an aid in deciding which equipment to bring. If you have specific subjects you are interested in you may be able to email the hotel or lodge directly with questions.

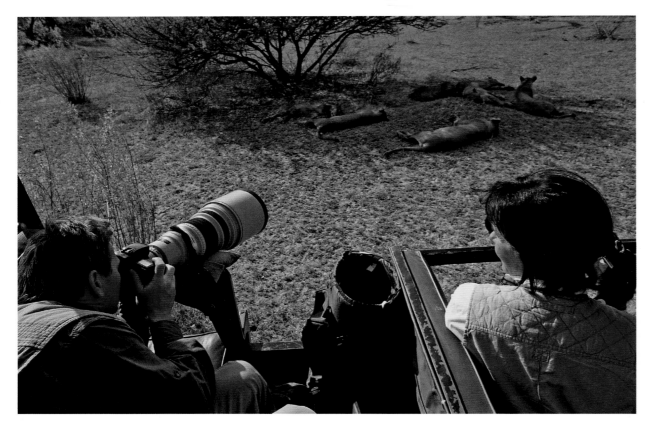

place like Africa to photograph, I want to have the right photographic equipment with me. Of course, sometimes the added cost of paying for extra space for my gear is just too high for my budget, and then I look for other places to cut down on weight. Pay attention to what you really need for your trip. This often comes down to a question of fashion verses function. If you are on an organized tour, the pre-departure booklet normally has a section on what to pack. This is often designed for non-photographers and for travelers who are more concerned about the way they look than how much photography equipment they can bring.

My gear for two weeks in Africa.

Knowing what the photographic conditions are will help you plan for your expeditions. In Africa different areas use different types of safari vehicles. They may be vans with cut out roofs, or open like this Land Rover in Botswana.

In Africa for instance, some lodges provide beanbags in their vehicles to stabilize your camera, saving you the trouble of bringing your own, or they may recommend specialized equipment others have found useful in pursuit of good photo images. You may have plans to visit a popular site for photography and you may learn through lodge owners of a special place, less popular, but more productive than the better-known places. You may find that a lodge owner will go out of their way to accommodate your particular needs if they know them in advance. In any event, the more information you have about the place you are going, the better you will be to prepare yourself for that destination.

Read your itinerary and (if you're on a pre-arranged tour) the pre-departure material your tour operator sends you. The first thing I look at in a pre-departure booklet is weight restrictions on luggage. Because of weight concerns, small planes are a curse to nature photographers. My standard camera pack weighs in at about 50 lbs, and that alone sometimes exceeds my weight limit on some small planes. If I know this in advance I can try to make arrangements to allow me to carry the extra weight. Of course this normally means paying an extra fee, but if I am traveling all the way to a

Sometimes you just need to decide where your priorities lie; are you willing to live in the same clothes while you are on your trip? Fortunately, people expect nature photographers to look like they just came from the bush, so here is your chance to play it up. Today's expedition clothing is often quick-dry, lightweight, and easy to care for, even in the field. Put the emphasis on the "care for" part of the last sentence. I have no problem wearing the same clothing day-in and day-out, as long as I don't smell

that way. The trick here is hand-washing. When I do travel to a destination where I am limited in the amount of weight I can carry, I frequently bring the clothes on my back and only one change of clothing in my bag. This way, I can hand-wash what I wore during the day and have something clean to wear to dinner in the evening. I always bring a small amount of biodegradable laundry soap, a portable clothesline, and a sink stopper and I always have something clean to wear. The soap and clothesline are available in most camping stores for just this purpose. Learn about where you are going and then make decisions about what you absolutely need to bring.

Compromise is sometimes a must in the field; by knowing what you are getting into you can make the right decisions before you leave home.

The Wildlife

Learn as much about the wildlife you may encounter before you leave on the trip. The more you know of the habits of the animals you wish to photograph the better your chances will be of achieving good results.

It really is about "the more you know." Check bird and mammal lists to find what will be at your destination when you are there. Where can that subject be found? What kind of habitat does it live in? You will also want to know if there are any special restrictions to photographing in the area you wish to visit. Some types of animals are very approachable in some places and extremely wary of people in other places. Getting close photos of a great blue heron in Maine is not so easy, however in Florida the birds act like you are not even there.

Local knowledge of an area is also very handy and if you can speak to people who live there or who have visited there before, you may end up with valuable information. Cape Cod, Massachusetts, is an incredible place to photograph whales in the spring, summer, and fall; however, going there in spring or fall will not only free you from the crowds of summer but also get you days with less atmospheric haze from the summer heat. Information is a very important tool for photographers. Ask questions.

Ngorongoro Crater in Tanzania is beautiful all year long. However, the flowers of spring added a unique background to this image of a Black Rhino.

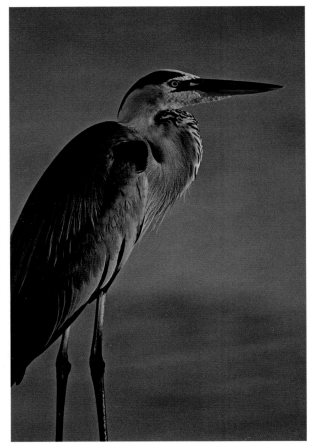

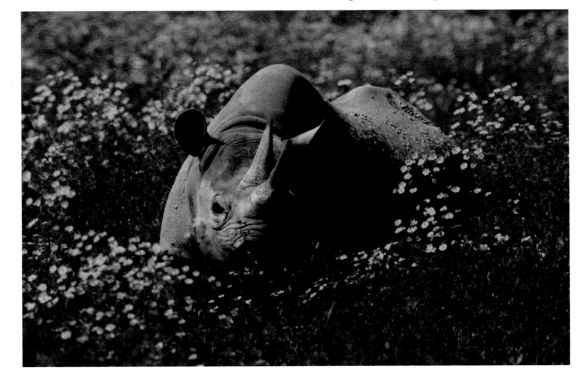

Wildlife behaves differently in different locations. This Great Blue Heron in Florida was very tolerant and easy to approach. In Maine I would never be able to approach this bird so easily.

Your Equipment

Knowing how to use your equipment is another part of preparation for creating great images. You should be able to use your camera without thinking about the controls. Spend quality time with your camera and practice using the controls. Go out and use your camera; you don't need to be taking pictures, just learn how to use the settings and controls on your camera. A couple of days of practice using your camera will make taking photos as comfortable as an old pair of jeans. It will probably fit better, too. Using your camera should become second nature.

Knowing how to use your camera is essential. Once you have that down, you can then develop a way of organizing your gear. What good is knowing how to use your camera if you can't get to it when you need it.

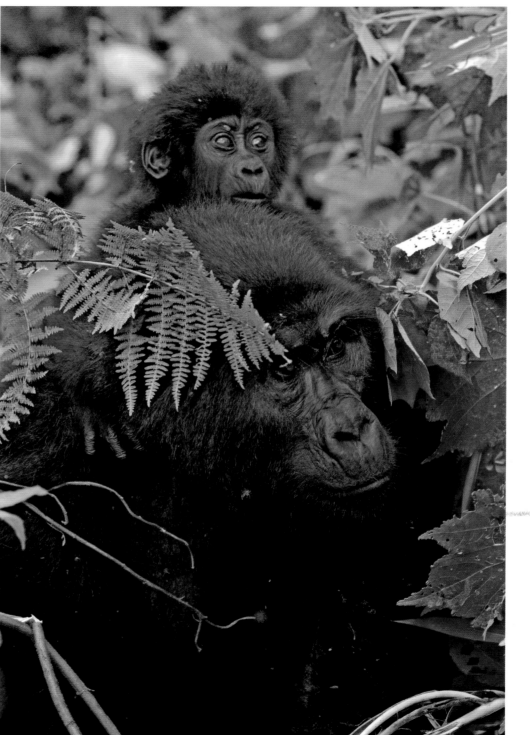

This female Mountain Gorilla came out of the bush for just a few seconds. Not having to worry about how to adjust the controls on my camera allowed me to capture this very special moment.

I was fortunate to have my brother, Tony, accompany me on a safari in Botswana. Now I love my brother dearly, and Tony, if you ever read this, don't take it personally, but I have never seen anyone more chaotic in my life! Every time he needed something it was always on another seat or in the pocket of his jacket that he put in his pack; he never was able to simply access his gear. This not only takes up time looking for your equipment, but it can be quite distracting to others in the group. It's OK Tony, you're my brother, and it was no big deal, but you do make a great example of how *not* to be organized. Keep your gear with you and know how to access it fast. Get used to putting things in the same place all the time, so you can just grab and go, instead of having to look in every compartment for the right lens or accessory. This is especially true when it comes to the little things, like filters, film, flash cards, or batteries. Time spent looking for camera equipment is time not taking pictures. How may times have you seen someone fumbling with their equipment just at the peak of action? When things are happening, you often need to be instantaneous in your reaction. Photography is so much easier when you can reach down and grab the equipment you need, without ever having to remove your eyes from action happening in front of you.

Being distracted by not being able to find what you need, or not being able to operate your camera, can frustrate you enough to ruin the entire experience, and not only lose the image you were hoping to record. When I hear people say they need to put the camera down to experience the moment, I know the person does not know how to use their camera. If they did, they could pay attention to what they were experiencing without worrying about what button to push or what dial to turn. I never feel that I miss the experience because I am looking at it through my camera lens.

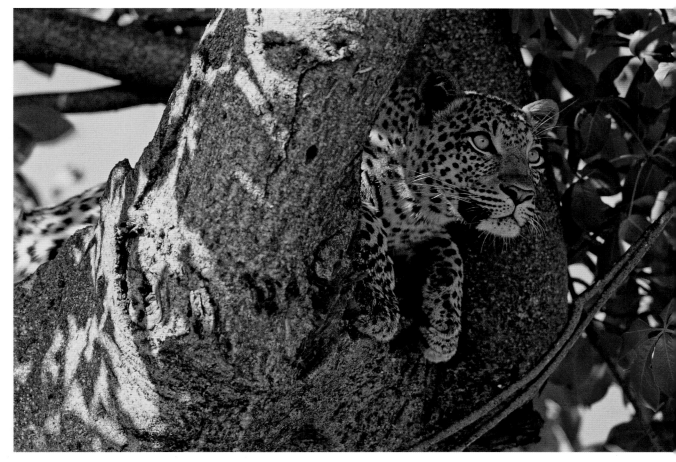

Photography is so much better when you can just reach down and grab the equipment you need. This Leopard in Botswana was just getting ready to move, having my gear ready allowed me to get this image.

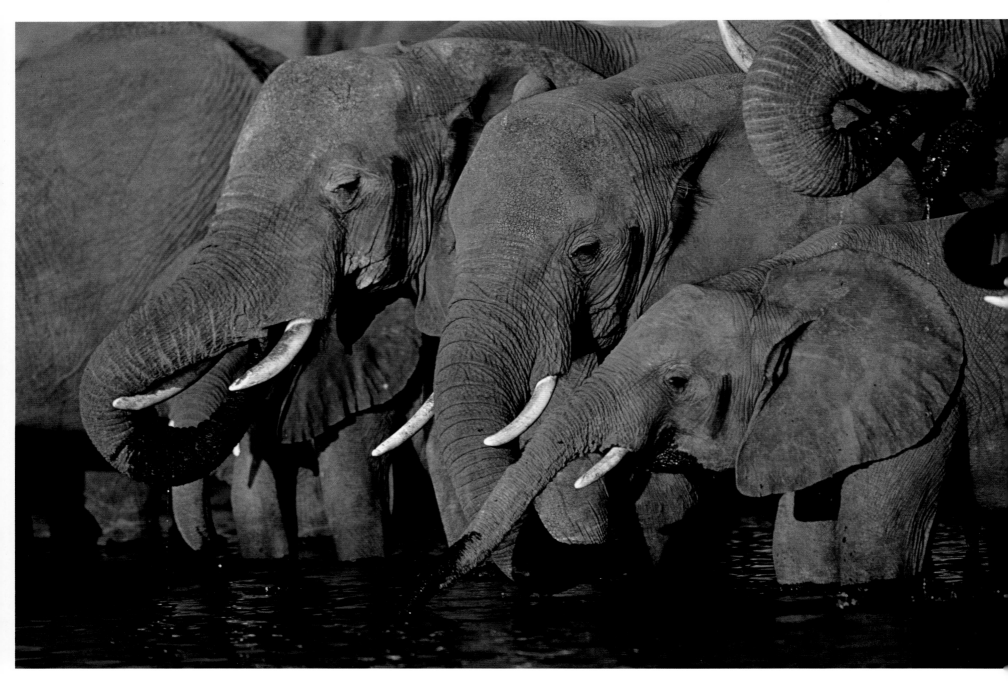

The wall of elephants. I shot roll after roll of this incredible event. When it was all over, I didn't remember changing film or checking my camera settings, I only remember the elephants.

Which Lenses?

On another occasion in Botswana, my group was in a boat on the Chobe River. Our guide saw some elephants walking towards the water, so he had the boat pull up against the shore where he thought the elephants would be coming to drink. Well, he hit it right on the money. Not only where we in the right place, but the evening light was perfect. It was one of those magical moments in nature and everyone in the boat was overcome by the experience. Just yards away was a wall of elephants. Young elephants were nestled between older animals, and there was an overwhelming vocalization by the elephants as they drank from the river. I don't think my camera ever worked so hard or so fast as on that day. Roll of film after roll of film shot through my camera as I photographed the incredible event. It lasted for about fifteen minutes, then the elephants left as quickly as they came. When it was all over, I didn't remember changing film or checking my camera settings, I only remember the elephants.

I think the most commonly asked question from people who are traveling with me has to be what lenses should I bring? In a perfect world it would be nice to be able to bring them all but the reality is that weight, room, and convenience of use all have to be considered. I start off by thinking about the photographic possibilities and then let that dictate what lenses I might need. If you have an itinerary, memorize it so you know how to pack your gear for any special day. Sometimes compromises need to be made so this is an area that deserves some attention. Zoom lenses let you cut down on the number of lenses you need to carry and yet still allow you the variety of different focal lengths. Fixed focal lengths are typically faster which is important with high magnification and low light conditions. Macro (or micro if you are a Nikon photographer) lenses are important for close-up work but there are accessories to allow you to photograph close-up without the expense of a new specialized lens. For wildlife, long telephoto lenses are normally necessary but a tele-extender will increase the focal length of a shorter lens at much less the cost, while cutting down on weight and size. Shorter telephoto lenses are good for many uses such as candid portraits and wildlife that is acclimated to people. Wide-angle and normal lenses are important lenses for use in landscape photography but we often overlook their many other uses. There are places where it is possible to approach wildlife very closely, allowing you to capture both wildlife and landscapes in the same frame. This all needs to be considered when choosing the equipment you will bring when traveling with your camera, again, the best way to choose is to know what to expect. I will go deeper into which lenses do what for you later on in the chapter on equipment, but for now the answer to the question is, pack the lenses you will need.

500mm to isolate the single penguin.

This image and the two on the following page illustrate the use of three different lengths of lenses on the same subject. I used three different focal lengths to photograph King Penguins on South Georgia Island.

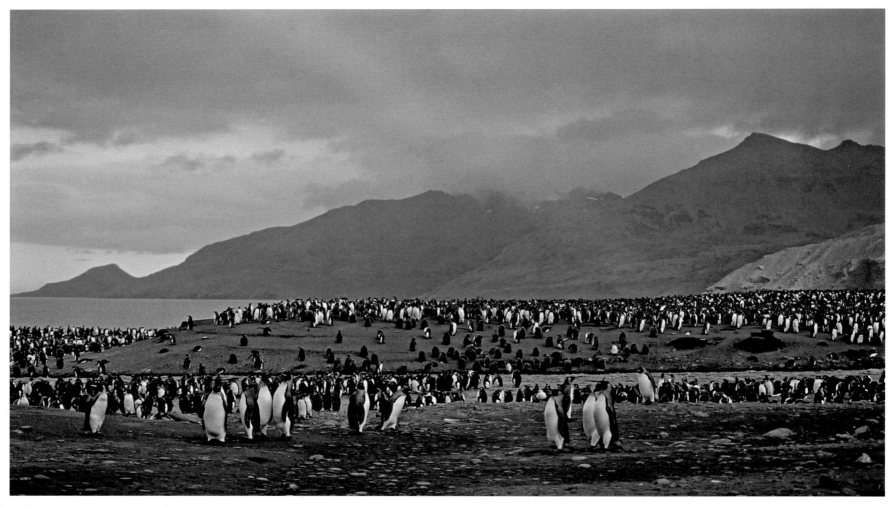

24mm to capture the colony and rainbow.

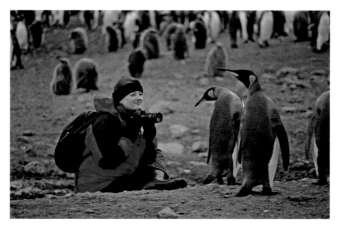

80-200 zoom to get the young woman sitting with the penguins.

Chapter 2
What to Photograph

Whenever I go to a new destination I try to photographically document as much of the experience as possible. This can be very challenging because many places have so much to offer and deciding what to photograph can be daunting. I like to break it down to a few categories and try to capture a story about the place on my film. A good way to do this is to write a storyboard. A storyboard is simply an outline of what I want to make images of, and it normally covers everything from the accommodations, habitats, the wildlife, and the people. The outline can be as general or as specific as you want to be but remember, the more diverse your choice of images, the more stories you can tell about the destination. Remember that the storyboard is simply an outline to help you decide what to photograph. You probably won't get every image that's on your list and you want to be open to new ideas when come across images you did not think of. The storyboard will help you organize your priorities and keep you on track about what you want to photograph. Here again information plays a big role in organizing your list. What kinds of shots are easy to get and which ones will need time to acquire.

I often need images of rooms for brochures so I try to photograph my room as soon as I arrive when it looks its best and before I have a chance to create a mess. Want pictures of the lodge? If you are with a group and have a set itinerary, check it to see what time of the day you will actually be at the lodge and how the light falls on the buildings at that time of the day. Lots of lodges have bird feeders or water sources that attract wildlife and this is a wonderful place to get images since the wildlife will be accustom to people watching them.

If you are traveling in a group you may need to be extra creative because you will be tied to the groups schedule and have less flexibility to move on your own. This is not the end of the world and many experienced guides will put you in the best places at the best time of the day to see and photograph them. When you are on your own your schedule is normally up to you. Take advantage of this by planning your photographic endeavors to the time of the day that is best to make the images.

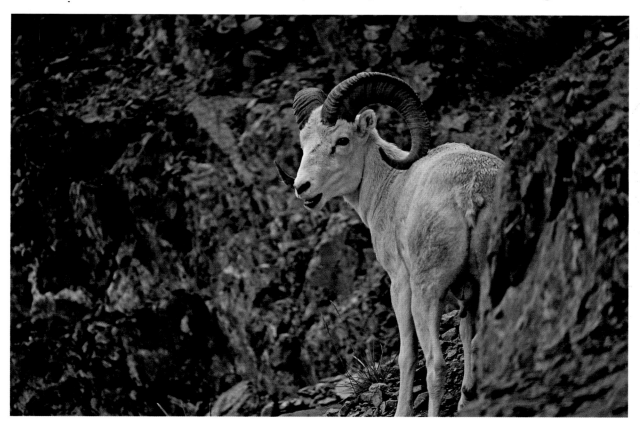

Having a list of which images are more difficult to obtain than others helps you decide what your priorities will be. This Dall Sheep in Alaska is one of the difficult animals to access so I was really pleased to get this image.

Early in the morning the villagers are working getting their stands in order. This stall in a Chilean market had just been stocked.

If I am going to photograph a local market I try to get there as all the local vendors are just setting up, this helps me in many ways. First, it allows me to see the layout of the place and see which direction the light will be coming from. Of course the sunlight is less harsh in the early morning so people will tend to have their wares and themselves out in the open where they are visible. Once the sun starts warming things up you will often find the umbrellas coming out to create some shade. This obscures your view and may prevent you from making the kind of image you really want. Getting to the market early also allows the locals to get use to me so I am less of a concern to them. (See the section on photographing people.) Last but not in anyway least, when you are there early you beat the crowds.

Another nice aspect of being on your own is that you are not on anyone's schedule for other stops. Noting can be more frustrating than having to stop photographing something really wonderful because the group is scheduled to be at lunch at a certain time. The freedom to have meals when you want them and not when they are scheduled can really add to your photographic opportunities. Does this mean that if you are on an organized tour you won't get good images? No, of course not, but on a tour you need to realize you are not alone and desires of the group outweigh the desires of the individual. Even on a tour there are some steps you can take to increase your chances of good images. If it is a non-photographic tour you can simply talk to your tour guide and let them know what your photographic interests are. A good guide will always go out of their way to help you get the photos you desire. They may make special time just for you and get up early to take you to a good spot for sunrise; all it takes is a little communication.

You may even find that in some circumstances the organized tour may have access to special events someone on their own would not know about. This is often the case in Churchill, Manitoba, the polar bear capital of the world. Just outside of town there is a holding facility called bear jail where they house problem bears. As the bear jail fills up the local conservation officers airlift the bears outside of town by hauling them underneath a helicopter. This is quite the photographic opportunity and if you were on your own you would never have any advance warning of the pending bear-lift. Somehow however all of the local bus drivers and guides always seem to have an hour or two advance knowledge of this event. Even though the bear-lift is not announced, the tour groups always seem to be at the jail at the right time. I will talk more about the different ways to travel later on.

Books by other photographers about the places you plan to visit or the animals you plan to see are also a good place to look for information. Photos give you an idea of how other photographers have treated the subject and even what subjects are available. If you like what another photographer has done you can learn from them and use them as an example for technique or style. If you do not care for another photographer's work it can show you what to avoid. Often photo books give specific information about the difficulties the photographer faced and how they overcame them. You may get guidance on what lenses or film or other equipment to use in that particular situation. One other point I want to mention about using other photographers as teachers or examples. There is a big difference between emulating and copying. If you like the style of a specific photographer and wish to use it as a way to stir your own creative juices that is complimentary and flattering. If all you want to do is to copy the exact photo another photographer took you might as well just buy one of the other photographer's photos. Your photography should be an expression of your personal experience not how well you can copy someone else's work. Now, with that said that does not mean you should not try to capture some classic shot that everyone is familiar with? You are bound to have some images that are just like many other photos that have been made. Just remember to put your own perspective in your images and look for new and exciting ways to make the image stand out from all the rest. Make it your image.

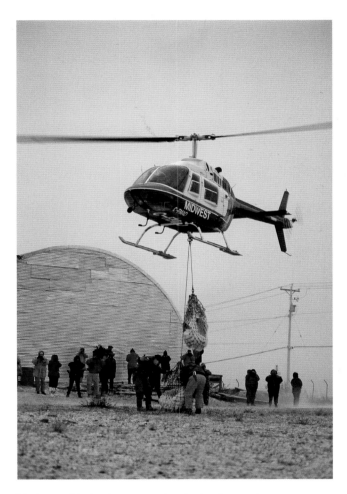

Having a guide that is connected to the local grapevine can get you to the right place at the right time, like being on hand when the local wildlife authorities are airlifting a polar bear out of the polar bear jail.

Document the Entire Adventure

I know some photographers don't care about having images of people; modes of travel, or images of lodging but these images can really bring your presentations together. I am not talking about the gratuitous group photo of everyone standing around the table at the final dinner; I am talking about images of people experiencing the adventure hanging around the campfire or hiking up the mountain. When the viewer of your images sees people in the photos they get to understand what it was like to be there, in their mind, it could have been them.

I don't know about you but when I come home from a trip and someone asks me what it was like I am often at a loss. Sure I can say how incredible it was but I can never express the internal feelings I had during the experience. Photos can do that job for you. When they see the excitement on the face of someone watching a whale surface next to their boat the viewer understands how amazing the experience really was. Make your images of people worth looking at and they will be as important to your overall presentation as any image you come home with.

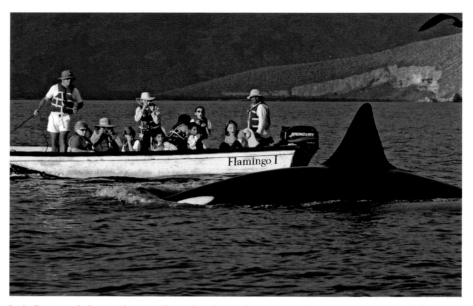

Including people in your images allows the viewer the opportunity to experience what is in the photograph themselves. The faces on the people in the panga let the viewer see just how exciting it was to have the orca whale so close.

Images of lodges and people on the tour can be the glue that holds your presentations together. Show people what the entire tour was like allows them to understand what it was like first hand.

I was on an adventure with a family tour in the Galapagos Islands. The group was divided into two separate groups as we motored around looking for wildlife. We were traveling in two separate pangas, the small boats used to shuttle us to and from shore and the larger boat we lived on, When we spotted two orcas whales feeding and away we went in hopes of getting closer views. We had no idea how close we would end up being. All of a sudden, on either side of us the two orcas surfaced right next to the boat. Talk about exciting! You could see the whole length of the whales alongside of us and it really reminded us of how small a boat the panga really was. So much was happening so fast it was difficult to know what to photograph. Whales, birds diving in for scraps left by the whales, it was constant excitement. I managed to compose myself to try to capture what was going on with my camera and I decided the way to do it was to photograph the whales surfacing next to the other panga. Their faces tell the whole story. When people see the image for the first time I always hear an "oh my God!" It's wonderful when your image gets an "oh my God", or a gasp, or anything that lets you know your image made someone have an emotional reaction like that. Let your images do the talking.

Even if you don't have the benefit of orca whales to add that bit of excitement you can still use your imagination to bring your photos to life. Instead of simply making an image of someone walking down a trail, imagine how you can add excitement to the image. How will that image look if you make it while you are laying on the trail next to him or her as they walk by? Using a wider-angle lens and being at foot level and looking up at the subject as they walk by will give your image impact. Use your creativity and think about angles, perspectives, and movement. Use slow shutter speeds to show movement, use wide-angle lenses to emphasize objects close to the camera, be creative.

Baby Animals

If you want to pull on someone's heartstrings when they are viewing your images, show them photos of baby animals. Cute does the trick, and there is nothing more cute than young animals, especially if they are mammals. Besides being adorable young animals are often animated and comical, and images of them will give your presentation special warmth. I like to call it the "Ahhhh" factor. There are very few people who do not like baby animals.

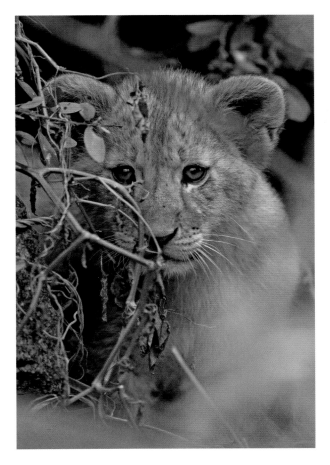

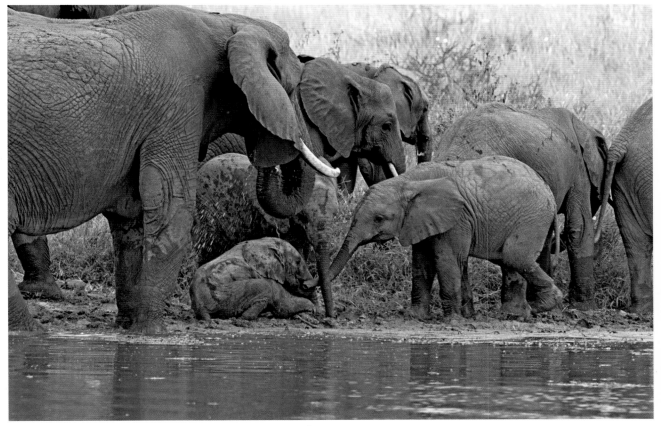

Sometimes adults will try to put themselves between you and there young so be ready to get your image when you can. Young animals are often animated and may not give you much time. Elephants, Tanzania.

Images of young animals like this lion cub certainly have lots of cute appeal, but remember that cute young animals are normally accompanied by a protective adult. If getting the image will interfere with your subject or your own wellbeing then back off.

Photographing them can be tricky since baby animals often come with their escort of a full grown adult animal and they tend not to be so cute and cuddly when they are concerned about the welfare of their young. Sometimes the adult animal will put themselves between you and their young so be ready and make your images when you can. Sometimes even the cute little baby animal can become dangerous to be near if they are disturb. This is one of the places that knowing your subject will come in handy.

Interaction

Interaction between wildlife is a way of bringing life into your images and your presentations. Interaction can come in many forms and show excitement, caring, drama, and so much more. Think of the excitement of images of two polar bears mock fighting, what shows more caring than the interaction between a mother bear and her offspring, and how about the drama between two male elephants facing off for the right to mate with females?

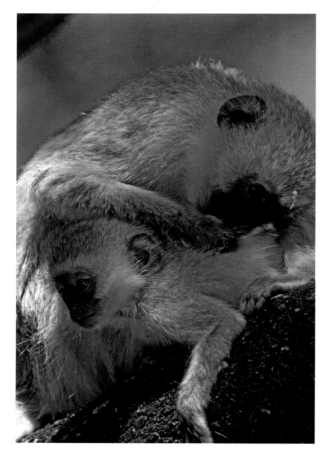

Interaction will show you a window into the life of the animal you are photographing. Primates spend many hours each day grooming as a way of cleaning themselves of parasites and bolstering bonds between individuals like this mother and young Vervet Monkey.

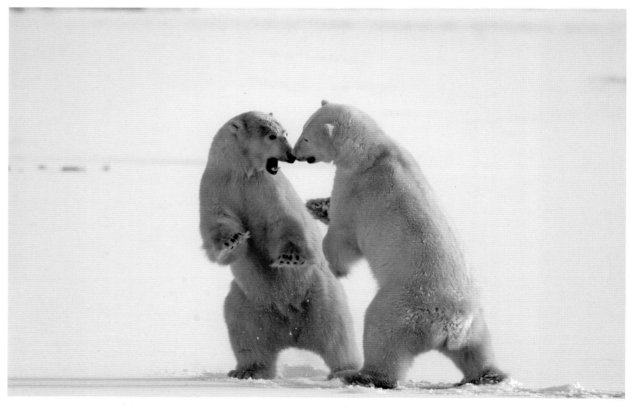

Images with exciting interaction like this one show two polar bears play fighting bring life into your photos.

Portraits of wildlife are wonderful and can be very moving images, however wildlife in the process of living gives you a window of what being wild is all about. Look for Interaction and remember that it does not occur only between animals, think of how much more interesting an image of a flower is if there happens to be an insect on the petal, or how wonderful it is to see a humming bird feeding on nectar from a flower.

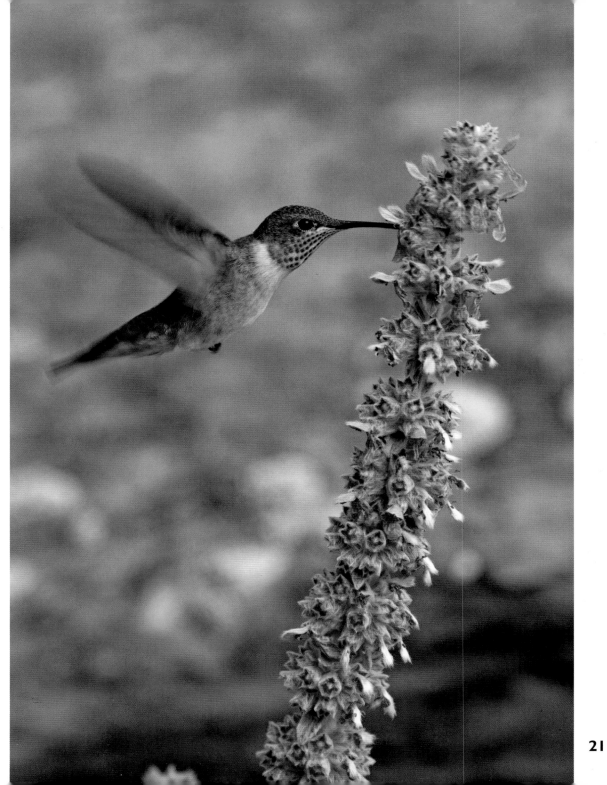

This humming bird feeding on the nectar of the flower is much more interesting then simply the bird by itself.

Don't be Afraid of Habitat

When I am with others photographing I often notice that some will wait until an animal comes out into the open before they make any images. I also notice that too often their wait never rewards them with the image they were hoping to get. Animals live in trees, bushes, grass, and all kinds of interesting habitat. Why not include some of this habitat in your images?

This is especially true if you are trying to photograph wildlife that is secretive or elusive, or if you are trying to portray the subject in their natural surroundings. Including habitat give the viewer of your image more information and a better idea of what it was like to have been there. The trick is to make sure you can see the eyes. If you can photograph the animal's eyes then what you don't see in the image does not matter.

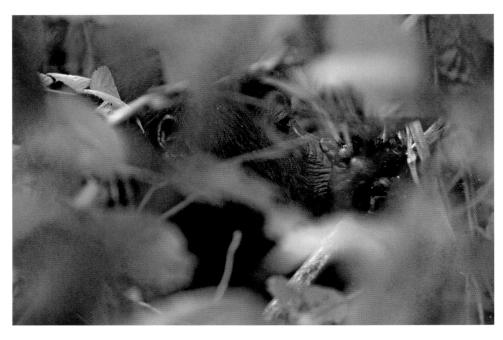

Of all the images I have made of Mountain Gorillas, this one hidden in the Impenetrable Forrest represents what it is really like to visit them in their natural habitat.

Don't be afraid of habitat, like this female lion hidden in the bush wildlife is not always out in the open. Let the habitat help tell your story.

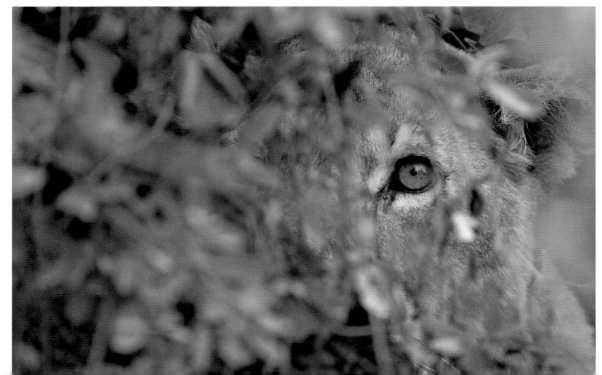

I have been to Uganda to photograph mountain gorillas several times, and photographing there can be challenging at best. There is always the chance of a torrential downpour, muddy trails, heat and humidity, and working at altitude in some of the densest forests I have ever been in. There is always the question of what the terrain will be like when you find the gorillas and you always wonder if the apes will show themselves enough to be photographed. Well I must say that I have never been disappointed and I have been well rewarded for all my efforts. I have seen dominant silverbacks standing defiantly in the open, mother and young walking down an open trail, and sub adults hanging from branches playing. All of these circumstances have resulted in lots of great images but of all the images I have my favorite gorilla photo is one where only parts of his head are visible through the dense vegetation. To me this is what I think of when I think of mountain gorillas living in the impenetrable forest. It is a small glimpse into the life of an incredible animal and is the closest I have come to putting my minds idea of the gorilla into a photograph.

The Peaceful Times

I have been telling you about the wow moments where the excitement carries the image, but there are times in nature when you feel the calm come over you and realize that even among all the drama in the wild world, there is a time for peace and tranquility. The predator resting in the grass, or the silhouette of the elephant against the African sunset, to some these times are sometimes the hardest to portray in your images. Here you need to relay on your instinct and sense of beauty.

Think about what it is about this scene that moves you and then what you need to do to make an image of this feeling. Is it the light, or the animal in a unique setting, maybe it is the way the wind is blowing the fur on the animals back or simply the pair of eyes showing through the tall grass. Knowing what moves you about the image will allow you set your camera controls to capture that feeling.

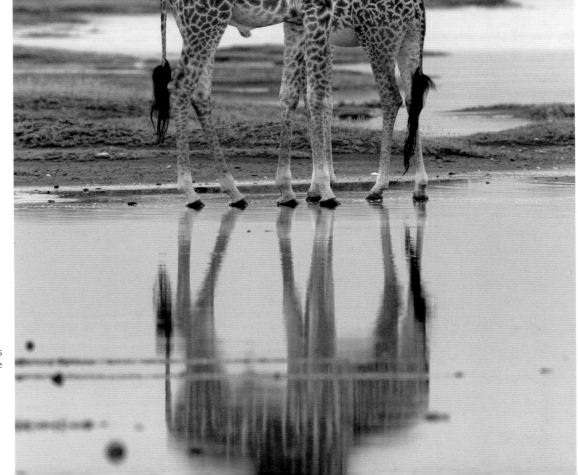

The serenity of these two giraffes reflected in the water is what stood out in my mind when I made this image. Nature can be exciting, but it can also be peaceful.

The Landscape

Images of the landscape will give your presentations a sense of place. The person viewing your images will understand what it was like to be there at the location you were photographing. This is besides the fact that landscape photography is a beautiful genre all to itself; whole books are available on this type of photography alone.

Landscape is often the place many people start practicing nature photography because you really don't need specialized lenses, you can start right away. Landscapes are not, however, a matter of simply holding up the camera and clicking, and it is important to really apply the rules of good composition (see Chapter 19). Simple things like making sure your horizons are straight, having sufficient dept of field, and having good light are crucial to landscape photography.

This image of the Alaska Range and Reflection Pond show the vastness and majesty of Denali National Park.

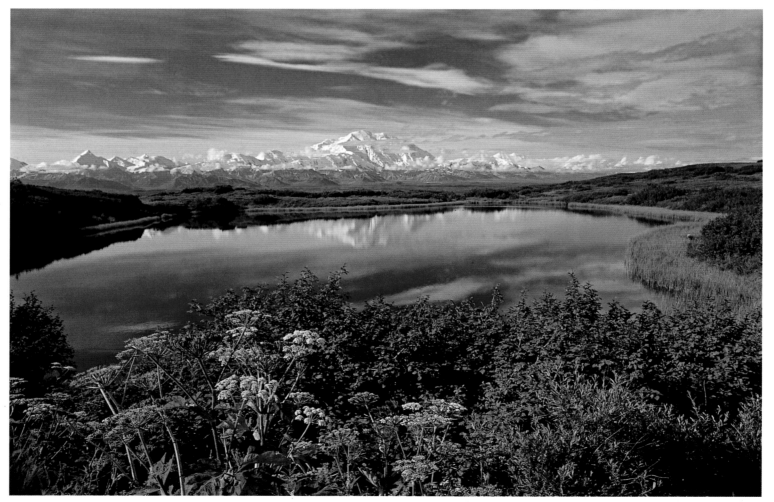

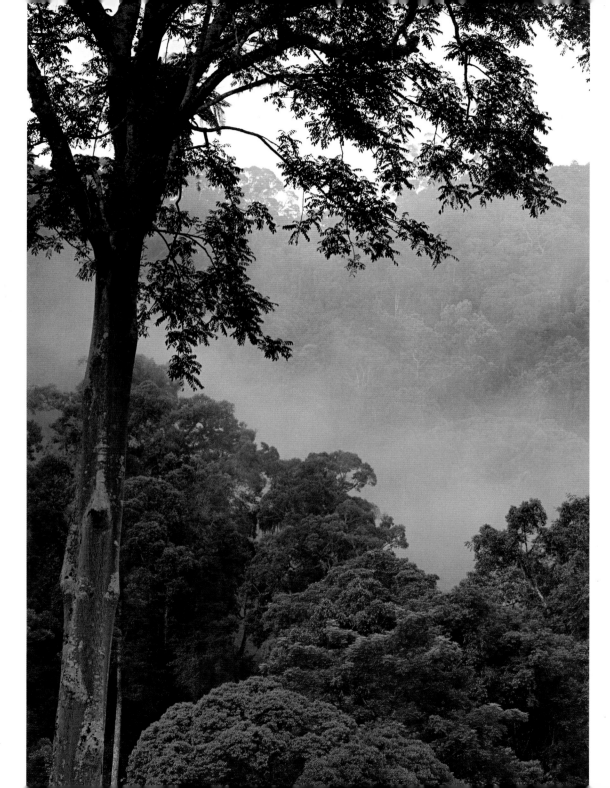

The key to landscape photography is the foreground. Having something interesting in the foreground allows the viewer to move into the image. Foreground can be simple, a branch of a tree framing the photo or a rock at the pond's edge. Anything that stands out in the front of the image can add depth and drama to the photo.

Foreground is the key to landscape photography. The tree in this image of the Borneo jungle brings the viewers eyes into the photo.

Landscapes can be used to portray wildlife as well as scenery. Using a wide-angle lens and placing the animal in the foreground is a wonderful way to illustrate the animal's habitat. Making wildlife landscapes are also a way of portraying wildlife without the use of long telephoto lenses. The key is to get close to the animal so it takes up as much space in the frame as possible. In wildlife landscapes, the wildlife is more a component of the entire image and less the main point of interest. Obviously, this is not possible with some species of animals, but the technique works well when you can approach an animal closely.

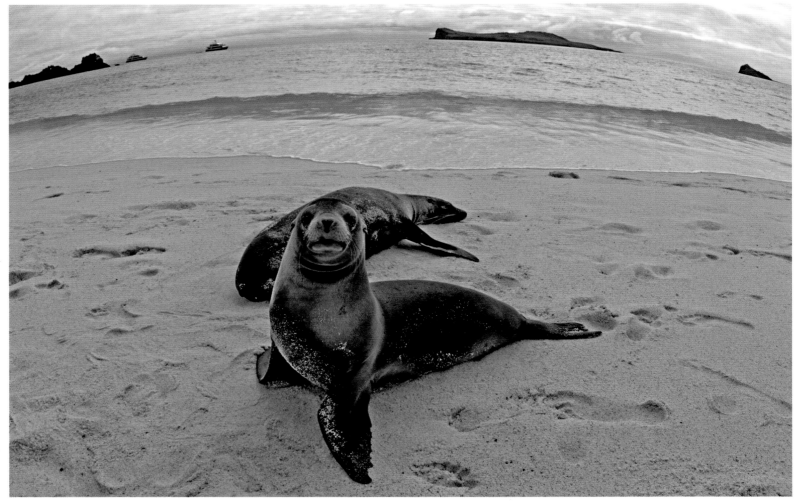

In this 16mm fish-eye view of Galapagos Sea Lions, the sea lions are a component of the entire landscape.

Chapter 3
Painting With Light

The word photography literally means "to paint with light," and it is the creative use of light that can make the difference between snap shots and beautiful photos. If you want your photos to have that extra quality of warm sunlight to bring out detail, you need to be photographing when the sun is low in the sky.

Early morning and late afternoon the sun is low on the horizon creating a warm light like this image of sunrise on the Nile River in Uganda.

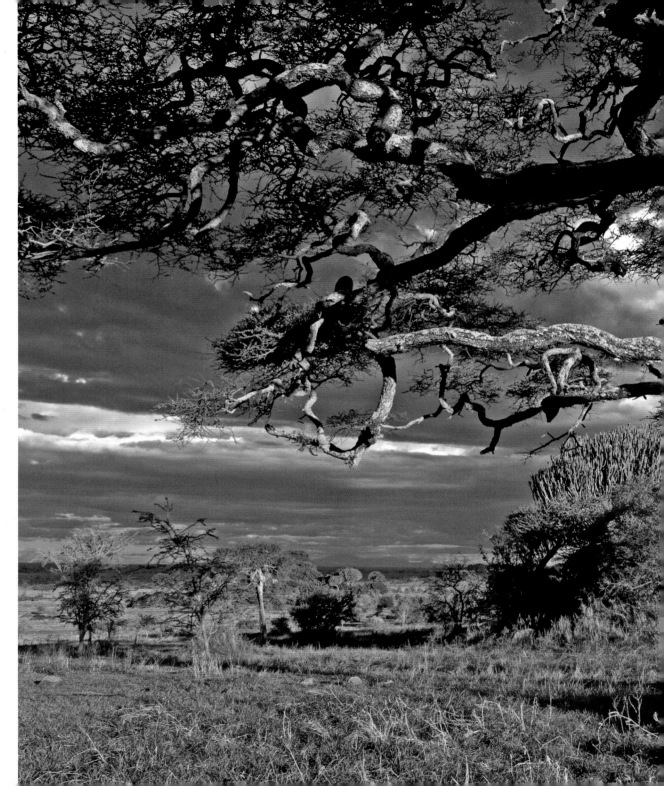

As the sun comes up and is low on the horizon, the light it creates covers the earth with a warm glow that brings out detail and casts wonderful long shadows. Conversely, it also happens when the sun is setting at the end of the day. The down side of this that for photographers it means no sleeping-in on workdays. Get up early and you will not only have the chance to be outside during one of the best times of the day, but you will also improve your photography. This works well for those who like a good road trip, since it enables you to photograph first thing in the morning. Once the light has gone, you can get some driving done to be at your next photo site in time for nice afternoon light. Don't get me wrong, if you happen to be someplace really fantastic at noon, and the photo of a lifetime presents itself to you, take it; but if you have the chance and the time to be at the right place for the best light, that is when you should be photographing. This can be challenging when you are traveling, since you may not have control of being at a location at the right time of day. A festival's parade may not start until mid-day, or you may only have a few hours at the location before you need to move on, or it may be raining the day you are there. In these cases you simply make the best of what you have.

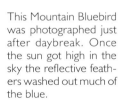

This Mountain Bluebird was photographed just after daybreak. Once the sun got high in the sky the reflective feathers washed out much of the blue.

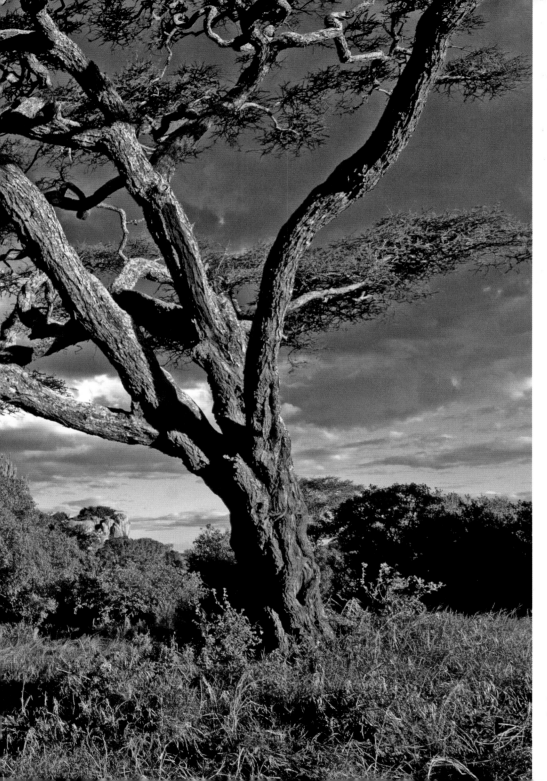

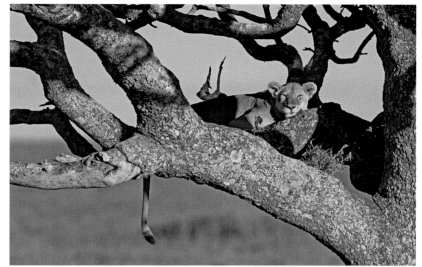

The setting sun gave this lion in a tree warmth and detail.

The low angle of the setting sun lit this acacia tree from underneath creating a sense of drama as the ominous clouds approached from the east.

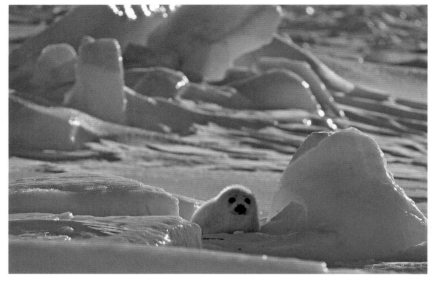

The backlighting on this baby harp seal created a wonderful rim light on both the seal and the ice.

I discuss photographing in bad weather in Chapter 17, but here I would add that inclement weather can be used to make beautiful photographs. Use the atmosphere to make images more interesting. Fog, rain, and snow it have been used to enhance photography. When you are out in nature, if you are not prepared and comfortable you will not want to take the time to photograph correctly. The lure of hot chocolate (or a hot rum toddy) inside may make you miss some wonderful opportunities.

Inclement weather can add drama to your photos like this approaching storm in the Galapagos.

Don't be afraid to use light to enhance your photography in creative ways. Many will tell you that it is best to have the sun at your back, ie. you between the sun and your subject, but remember that side lighting and backlighting can be very useful in photography. Sidelight can create wonderful shadows while backlighting can give your subjects a nice rim light to make your subject stand out. Unfortunately, wildlife is not always in the best place to be photographed. A subject might be backlit or standing in shadows, or you may simply have to make the best use of what light there is. Try not to judge this as a setback, but rather a challenge and chance to be creative. With that said, you should realize that sometimes bad light is just bad light, and it may be better to try to maneuver to a more pleasing angle, or just enjoy the moment without getting it on film.

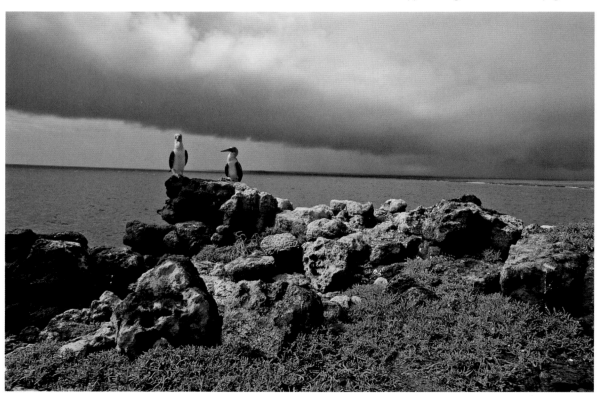

Where to Start

When first learning photography, people should photograph what they love and know. Nature photography is 80% knowing your subject, 10% knowing your camera, and 10% luck. By photographing what you love, you already have 80% of the battle won because you already have the intuitive understanding of what makes the subject special.

In some photo classes, instructors give an assignment to photograph "moods of the day." What is a mood of the day? If I wanted to get in touch with my inner self, I would take a class in meditation, not photography. But if you are trying to capture your feelings on film, just start photographing subjects familiar to you. If you love flowers, photograph flowers; if you love your dog, photograph your dog. If you love your mom, then do her a favor and call her once in a while. Photographing what you love frees your mind of worrying about the subject and enables you to concentrate on learning how to use your camera. If your photos are not perfectly exposed or focused at first, there at least will be something unique about your results. Find an essence of what makes the subject special to you, and that will help you overcome technical obstacles. Photograph what you love and your inner feelings will be in the image.

Many years ago, before I was a photographer, I had two friends who both took photos of a hiking trip we did in the Catskill Mountains. One friend had very expensive equipment and was a very good photographer. He was even offered a job photographing for a very popular magazine, but he did not have any great love for the outdoors. The other friend had a point-and-shoot 110 cam-

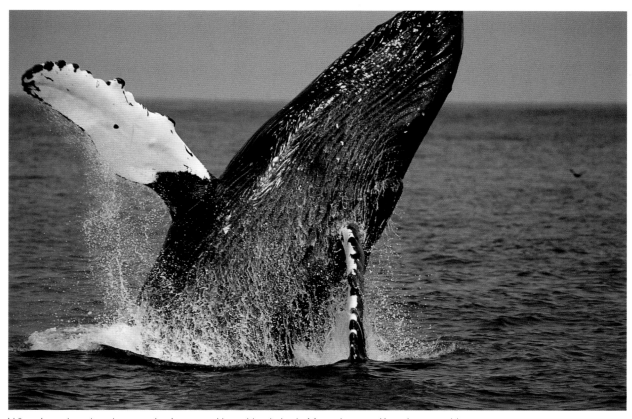

When I was learning photography, I was working with whales in Massachusetts. Knowing my subject so well gave me one less thing to be concerned about while trying to learn how to use the camera.

era and very little interest in photography, but he loved the mountains and went hiking as often as possible. After they had developed their film from that day, the professional photographer had very good photos. They were technically correct with proper exposure and depth of field, and yet, they were just like any other good mountain pictures. My friend with the point and shoot had poorer quality in the pictures he took; however, he had captured something special about the mountains. His photos made you feel like you were on that mountain with him.

When I first started taking pictures I was doing research on whales. I spent almost everyday on whale-watch or research boats and knew more about the animals I was watching than anything else in my life. After a while, anticipating their behavior became second nature. Since I was already familiar with the whales, it was easy for me to concentrate on learning the nuances of my camera, without the worry of wondering what the whale would do next.

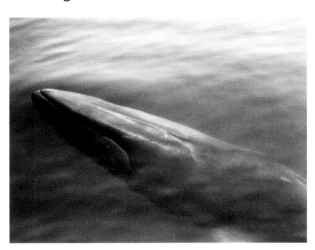

One of my earliest photos, a black and white image of a finback whale just below the surface of the water.

Wildlife photography requires intimate knowledge of your subject. As a matter of fact, knowing your subject is more important than any other aspect of wildlife photography. If you want to photograph animals looking their best, you'll need to know when they are in their peak breeding plumage or when their fur looks its fullest. When are the moose antlers biggest, do the elk prefer one meadow to another? How disappointed would you be if you headed to Alaska to photograph bears catching salmon but arrive there a week before the salmon normally run?

The more you know about your subject, the better your chances are of capturing the photo you have dreamed about in your mind's eye. Whenever you go to a new place, you must find out as much as possible about the area and the things you might see while you are there. Become as prepared as you possibly can be before you actually start taking pictures. (Nature is unpredictable, but knowing in advance about the places you will be will make you as ready as possible for the unexpected.) Knowing what to expect will also help you decide what equipment you'll need to get the photos you want.

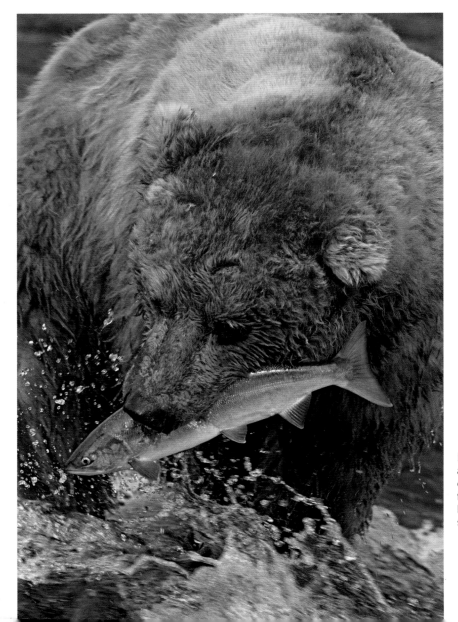

Learn as much about your subject as possible. In Alaska, Brown Bears eat salmon and Brooks Falls is world famous for this spectacle. The bears however, are only at the Falls a few short weeks for feeding.

Photographing what you love will help your photos, but it also gives you insight to purchasing the right equipment. If you want to photograph big game or birds, a long telephoto lens is in order. If your interests are more towards flowers or insects, a macro or close-up lens should be the choice. Thinking about your needs and interests will prevent you from buying equipment you will not use and help you get equipment to get photos you will treasure.

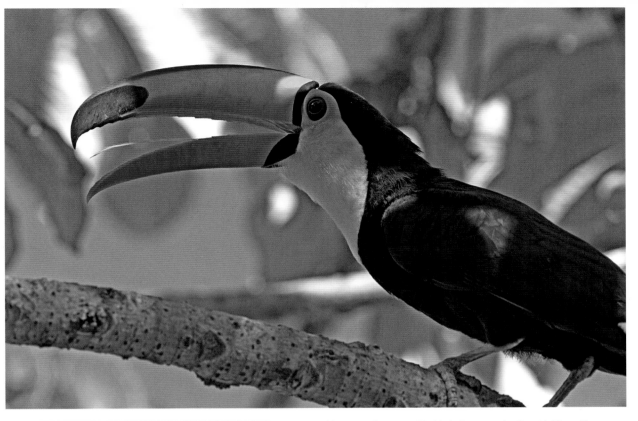

If you are interested in small subjects like these two Monarch Butterflies in Mexico, why not make your first lens a close-up or macro lens.

If you are interested in bird photography like this Toco Toucan in Brazil, then you will want to consider long telephoto lenses right from the start. I made this image with my 500 F4 lens.

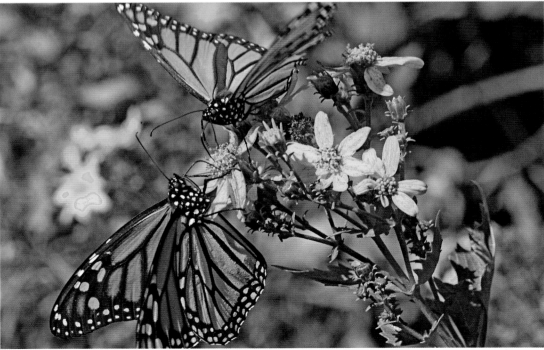

If you are a beginner and not sure what subjects you might want to photograph, think about the possibilities. I do not believe in starter cameras, or cameras people buy "until I learn a little more about photography." I believe in buying equipment you will not replace in a year or two, and buying equipment you can grow with and add onto. Skimp on the body with bells and whistles, but spend as much as you can afford on lenses. When I say skimp, I don't mean to settle for a body that does not suit your needs; think about your choices and choose the features that will make you a better photographer. You are not choosing features to make your camera look good; you are choosing features to make your photos look good.

Don't be intimidated by the equipment you don't have. Whenever I am on a tour and I pull out multiple camera bodies or long lenses, I often hear people say that they will not be able to get a photo as good as I get because they "don't have the equipment I have." Nothing could be further from the truth. They may not be able to get the same pictures I get, but that does not mean they can't get photos that are just as good. When you think of your photography in terms of what your equipment cannot do, you automatically limit yourself. Think of your photography in terms of what your equipment *can* do, and your potential will be limitless. Your 50mm lens may not be powerful enough to get full-frame head shots of the elephant you see on your safari, but your 50mm lens may be the ideal focal length to show the elephant in the splendor of its native habitat. Realize the potential of your equipment and you will not be disappointed.

Given the fact that some lenses are designed for specific applications, and some applications need specific types of lenses, understand the kind of photography your equipment will accomplish. If you want an image of small bird some distance away, you need a very long telephoto lens. If you want a full-frame image of a ladybug on a flower, you need a macro lens. Expand your vision of photography by understanding what your equipment can do, and don't try to make it do what it was not designed to do.

I cannot over-emphasize the importance of knowing how to operate your camera. Read your owner's manual and memorize it. Practice using your camera so it becomes an extension of your hands, not something you need to examine each time you use it. Get to know the controls without having to look at them every time you need to change a setting.

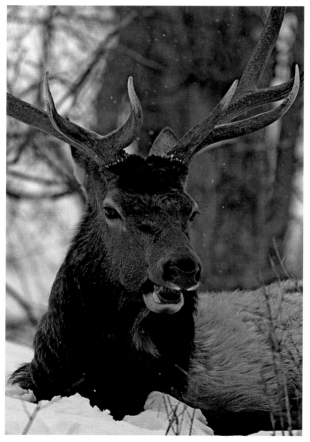

Wildlife sometimes appears quickly and you may only have a second to grab your camera and take a few frames before your subject disappears. Having your fingers instinctively know where the right buttons are, instead of having to look at the camera to see where it is, may mean the difference between getting and missing the photo.

I can't tell you how many times someone on a tour has handed me a new camera or lens hoping I could show them how to use it. If you are on one of my tours, I will graciously smile and say, "Sure, let's see what I can do," but in my head I am thinking, "Bonehead!" Every camera and lens is different, depending on the manufacturer and model. To think that a guide or instructor will know how to use your particular camera model is unreasonable (although somewhat flattering). Having to master the use of the new equipment at the time you actually need to use it will probably give you disappointing results. You invested money in your equipment; invest a little time learning to use it. You can always ask a guide or instructor for hints on fine-tuning your gear, but you should understand the basics of your equipment before you are on tour. Not only will you be able to use it right away, you will have discovered any problems while you had time to exchange it or have it repaired.

When buying a camera you should look for features that help your photography. I want my cameras to be well sealed against the elements. While photographing this male elk in Rocky Mountain National Park, I did not want to be worried that falling snow would damage my equipment.

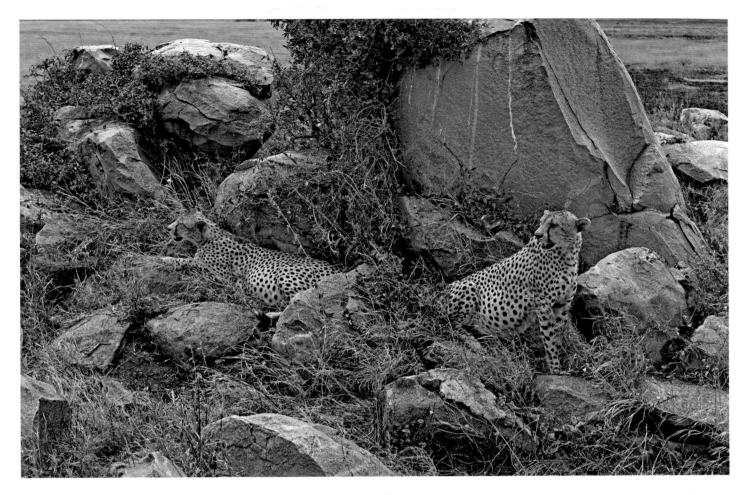

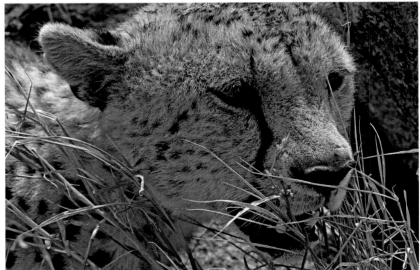

Here are two images of cheetahs taken at the same place, just moments apart. The close-up of the cheetahs face was made with my 500mm lens, however my 18 to 35 zoom gave me the opportunity to include more than just a close-up of a face, I was able to show two cheetahs in their natural habitat.

Chapter 5
Tour Group vs. Photo Tour Group

In an ideal world, you would be able to hop on a plane, be met at your destination by a private guide, and be whisked off in a private safari vehicle for your own personal tour. If you can afford that, great; quit reading this book and hire me as your personal instructor. If not, you are probably like the rest of us who sometimes take a trip on their own and sometimes travel with a group of like-minded strangers. There are pros and cons to both types of travel for someone interested in taking serious photos.

I want to dispell the myth that you cannot take good photos while traveling with a group. Much of my traveling is with groups, and not only am I guiding, but my photo opportunities are limited by my first responsibility to the clients. The advantage of traveling by yourself is making all the decisions of where, when, and how you photograph; but it is possible to achieve good results on a tour. If you are new to photographing wildlife, there are big advantages of going with a tour company familiar with the area and wildlife. A seasoned and respected tour operator gives you confidence that you will probably not be stranded in a foreign country. It should also mean that the tour operator has knowledge to bring you to a destination at the optimal time and has taken care of logistical worries. This enables you to concentrate on photography. They will tell you what to pack, feed you, and make sure you have necessary permits and licenses. In some cases, the only way to get to a certain destination is with a tour operator.

Tours are often the most economical way to travel but being with a group of people does not mean having to sacrifice your photo opportunities.

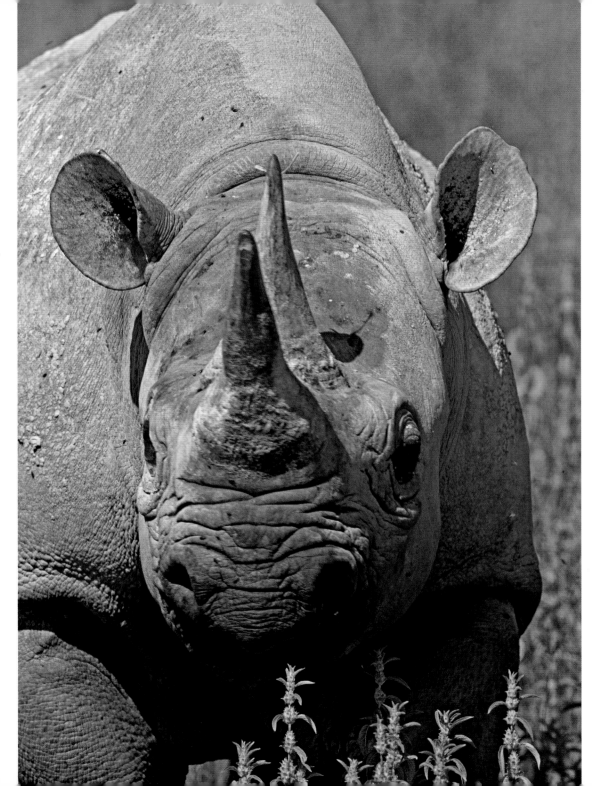

A good guide can make your trip. Astrid Frisch of Ecotours De Mexico, my guide for photographing Monarch Butterflies in Mexico.

A major reason for traveling with an organized group is that an experienced guide will always accompany you. It is the guide who can make or break a trip. Many lodges in premier locations are booked years in advance, so without a pre-arranged tour you will not gain access when you want to go.

Once you decide to sign on with a tour, you can choose a regular natural history tour or a photo tour, and there are advantages to each.

I made this image of a Black Rhino while I was guiding a tour in Tanzania. I would never have been able to travel to many of the places I have been if not for the fact that I was guiding tours.

37

A Photo Tour

On a photo tour, the primary advantage is that you have a professional photographer as a guide. This is especially helpful if he or she is also a biologist or is accompanied by a local guide with knowledge of the local natural history to augment the photographer's knowledge. The more information you have about the subject, the better your chances are of getting good photos. The photographer/guide will give suggestions and information as well as help with special problems, such as properly adjusting for tricky exposures. Evenings are often spent discussing photo issues with other photographers, and their camaraderie is not to be underestimated. Photo tours let you see and talk about other equipment and gadgets, and an itinerary may be changed to take advantage of photographic opportunities.

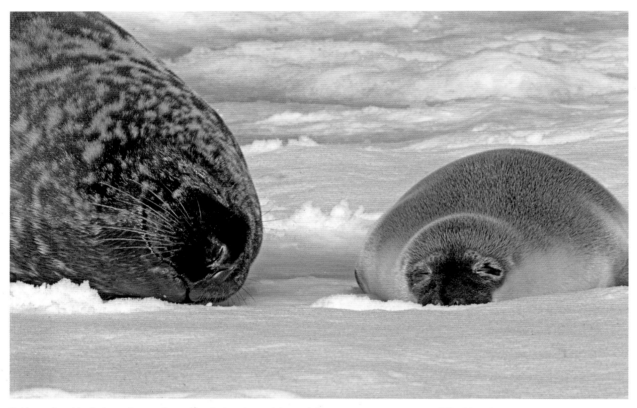

Subjects like this dark mother and pup hooded seal on white pack ice can present exposure difficulties. A photography guide will be able to give you the information needed to expose the image properly.

If there is a down side to photo tours it is that everyone is typically a big shooter. Sometimes space will be cramped so plan on being a good sport.

GREAT WHITE BEAR PRO PHOTO TOURS
675-2781

The down side is that most people on a photo tour are photographers. There are lots of big lenses and everyone has their own agenda in terms of what they want to photograph. Although most of your fellow travelers will be good sports, there are times when you may find fierce competition from other participants who feel they and their photos are all that matter.

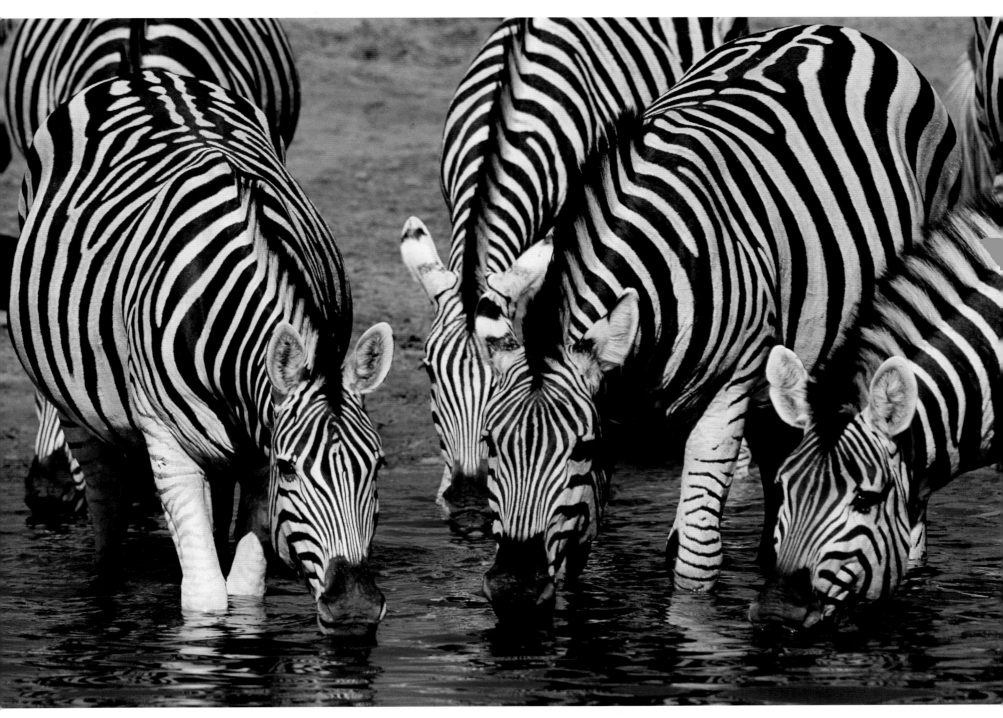

If you are on a photo tour be prepared to be a photographer, that means sometimes sitting at a watering hole and letting the wildlife come to you. That is precisely how I got this image of Zebra in Botswana.

On a photo tour, plan to be a photographer, not someone whose only interest is seeing one animal after another, ticking off the species as you go. The guide may decide to wait at a watering hole for an extended period of time in order to maximize the chances for good shots. This is a tried and true method of getting the best results. Participants, however, may become impatient from sitting and waiting. Patience should be on the packing list. If you become anxious about what you are not seeing, you will not be able to enjoy what you have at hand. You cannot get everything on a single tour. There will be aspects of the wildlife that you simply will not see. Some professional photographers spend their career photographing a single subject and still do not have it all documented. Be open to what presents itself and take advantage of it.

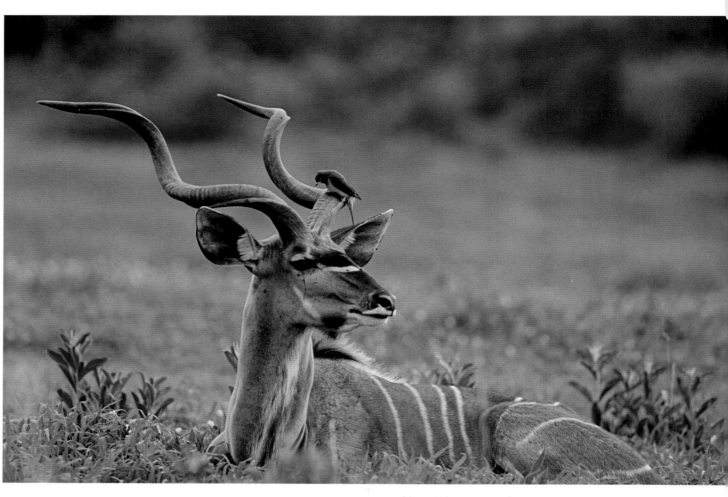

Natural history tours often cover more ground than a photo tour since the purpose is to see as much diversity as possible. Kudu with Oxpecker, Botswana.

A Natural History Tour

A natural history tour that is not specifically geared to photographers may present some advantages to someone who wants good photos. The only difference between natural history and photo tours is the emphasis placed on photography. Don't think that that photo tours will bring you to places any different than a natural history tour, everyone wants to see the same things. As a matter of fact, a natural history tour may cover more ground, since less time might be spent at a single site. If getting the most diversity is what you are after, a natural history tour might better suit your needs.

Another plus on a natural history tour is that you may be the only one who is serious about photography. If you are polite, you may find that other members of the group get excited about you being the photographer. I have often seen non-photographers tell photographers in the group to get in front of them, since they have the equipment to get better results. If you explain to everyone that you are interested in photography and add in a little "but I don't want to get in anyone else's way," you may find others helpful to your needs. This works especially well if you volunteer to be the group's photographer and make copies or a CD of some of your work for the group. Speak to the guide and explain what you are hoping to accomplish, they will often let you know when you can lag behind to take extra shots. They may even seek out extra opportunities for you or bring you to a special place they know. The key is to be nice; making friends with the guide and other participants can open doors for you along the way.

The down side of a natural history tour is that your photography will come second to the needs of the tour. If it is getting close to lunchtime, the group may decide to head back to the lodge to eat rather than wait for the sleeping lions to awaken. Also, there may be a limit to the group's patience when it comes to hanging around while you take pictures.

Either tour can give you wonderful results; base your decision on your desires. Ask your tour operator about your options and if they can refer you to others who have already traveled on the tour. Be as well informed about the tour as you can be before you make your decision. One last thing to remember about traveling with a tour, whether it is a photo or natural history tour, is that you are on a tour. The guide will always make decisions based on the group, not the individual. If the majority of the tour wants to photograph mammals and you want to photograph birds, don't expect to stop at every little bird you see. If you let your interests be

known to the guide, they will sometimes try to give you get the opportunities you want.

Special Note

On a photo tour, everyone is there to photograph as well as learn, however sometimes there are times for photography and other times for learning. If you need help with specific areas of photography, a better time for asking your photographer/guide may be while you are at the lodge, not during a photo session. This is especially true if you are photographing wildlife, which may be sensitive to noise or motion. Your photographer/guide may not be able to talk to you when you are close to the animals, for fear of disturbing them. Many photographer/guides lead trips so they to have an opportunity to get images themselves. As a paying client, your needs should come first, but sometimes it is simply not possible at that time. Ask questions about your equipment or technique at camp before you head into the bush. Your photographer/guide should be happy then to give you all the time and attention you need.

On a tour with non photographers, volunteering to be the groups photographer and supplying everyone some photos or a CD of your images is one way to get others on your tour excited about your photography. Antarctica Landing.

Chapter 6
Going It Alone

Going to exotic places is often better accomplished on organized tours, however, for me, it is hard to beat getting out there on your own or with a choice group of friends or other photographers. In North America, we are blessed with many incredible places to photograph. National and State Parks are designed for individual travelers seeking to discover the natural heritage. Proper planning will make the difference between success and disaster. Let's break it down to a few small steps.

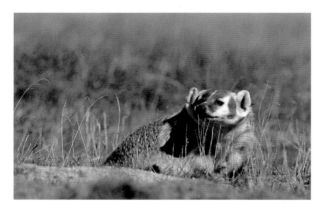

Living close to Rocky Mountain National Park my wife and I frequently head there early in the morning before any crowds come. Being able to get out before the crowds makes encounters like this one with a badger all the more special.

Step One. Timing

The first thing you need to decide is when you want to travel. This sometimes seems pretty simple, but if you have never been to a place it will pay to check on when the subject you want to photograph is at its best. For example, wildflowers in the Rocky Mountains are at the height of their season in mid-July. The altitude makes them bloom later than in places nearer sea level. If you are unsure when to go, check with your computer for photo tours of that particular area. Organized tour operators know when conditions are optimal and they schedule their tours accordingly.

Step Two. What are you going to photgraph?

Knowing what you might encounter is probably the most important bit of information you will need. It will indicate what equipment to bring and give you your game plan. How do you find out what you might see? Almost every State and all National Parks have web sites, and most of them will provide you with a list of area plants and animals. They may also have information about photo restrictions at certain times of year when wildlife may be sensitive to disturbance. Some areas of a park might be closed during nesting or rutting seasons.

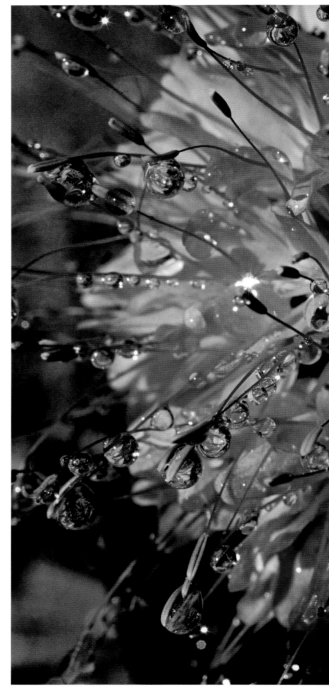

Many people interested in wildflower photography would think of spring as the best time to come to Colorado, but this image of dew covered Rocky Mountain Bee Plant was taken in August. Our altitude effects when plants bloom.

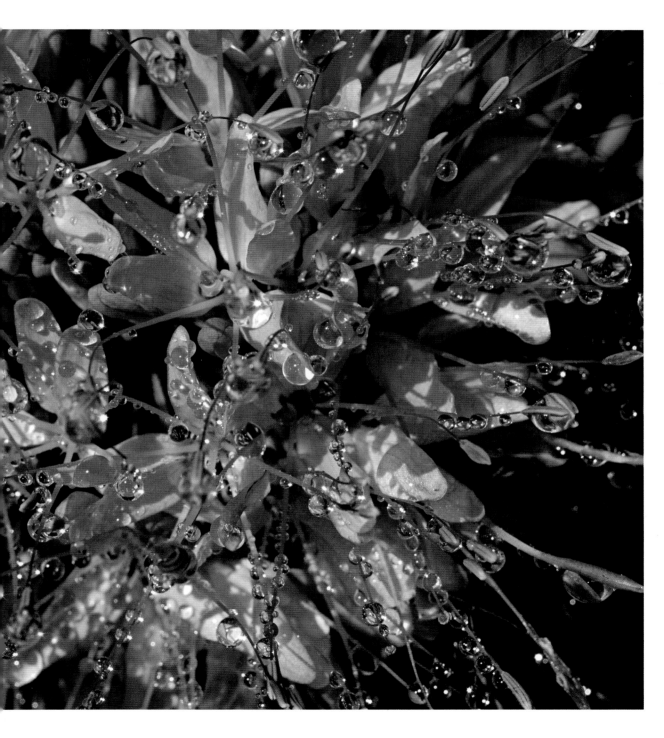

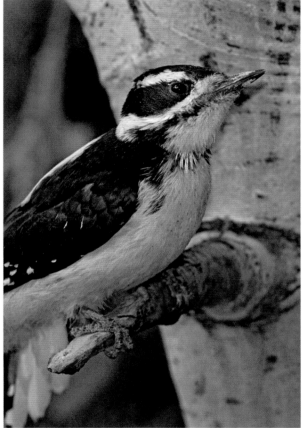

This Hairy Woodpecker was photographed in Rocky Mountain National Park, in Colorado. Most parks have web sites where you can download bird and mammal checklists.

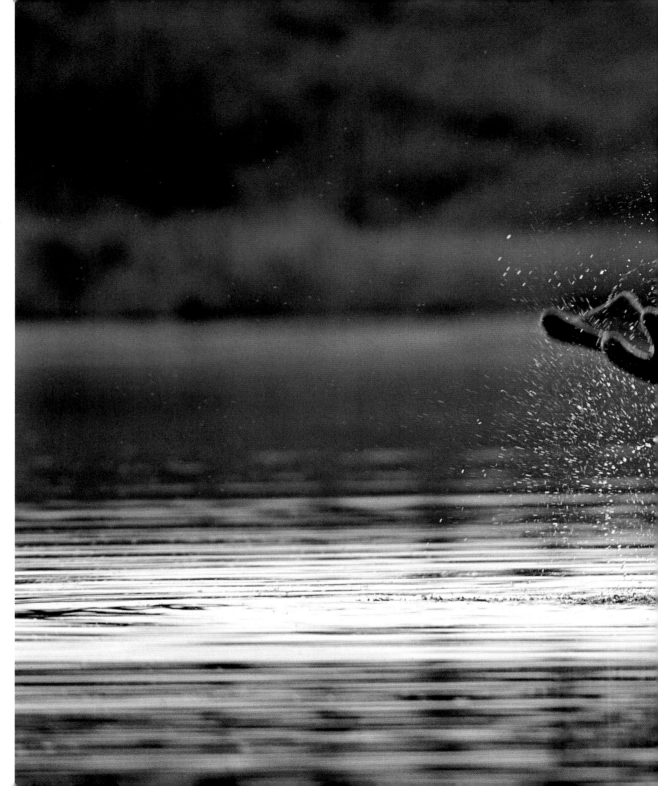

Once you know what you are likely to see, you may need to research a particular animal or plant. Suppose you are hoping to find moose. What habitat should you be looking in; forest, willows, or wetlands? The answer may be different at different times of the year. Since knowledge is cumulative, the more you learn the less you will need to learn the next time, and practice in the field is incredibly satisfying.

Step Three. Where will you see it?

It is sometimes hard to know where to look for what you want to see. Contact the park or rangers who work there, but often the reply is that you never know where wildlife will show up. There are better places than others to start your search. Go to a bookstore for photography of the place you plan to visit. Photographers often share the name of the valley, river, or section of the park where a picture was taken.

This moose was photographed in Denali National Park in Alaska where they tend to favor the pond vegetation in spring and early summer.

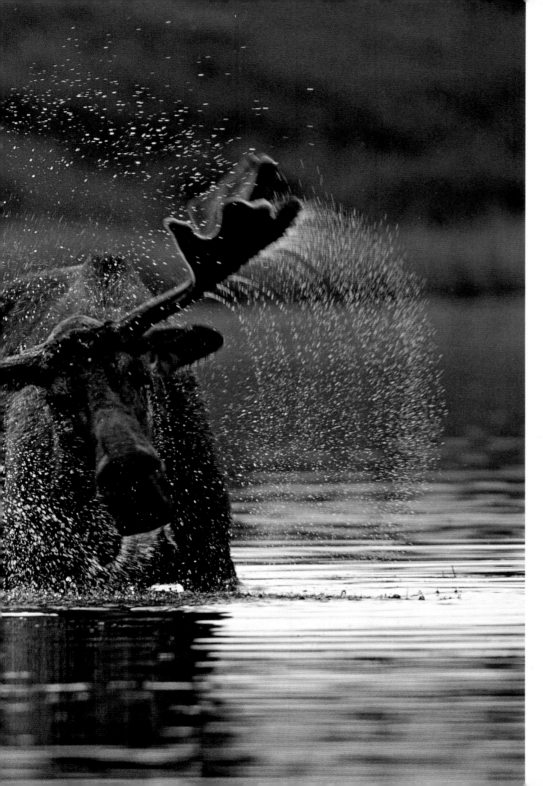

Once at the park, ask Rangers or other photographers about photo opportunities.

Use your time wisely. In the middle of the day, when light is not good for shooting, scout out photo sites you plan to visit. Consider where the sun will rise and set. It may be a good morning place or better to visit at night.

Some people like camping and others prefer a lodge, but there are more things to consider than comfort. The wildlife you want to see will be found in specific places. Staying at a lodge may mean you have to wake up a half hour earlier to insure you get to the wildlife on time. Staying at a campground may be closer to the wildlife. It's a little thing, but sometimes worth a few extra minutes of sleep.

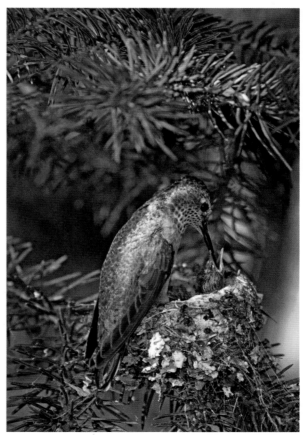

A friend and researcher showed me this broad-tailed humming bird feeding her young. Having local knowledge on your side can really open you up to incredible opportunities.

45

Great Expectations

A key element in feeling good about results from a photographic trip is not having expectations that are impossible to obtain. Photo books, magazines, brochures, and other presentations are typically the result of many hours spent, sometimes over many years, photographing a specific subject. This is necessary to be able to portray the entire life history of an animal or the life style of a group of people. It is normally impossible to get it all in one trip. The more you visit a place, the more things there are to photograph. Going back to a place over and over again will give you access to the big picture and what is happening over time during different seasons. It also allows you to get closer to your subject through an intimate knowledge that only time can give you.

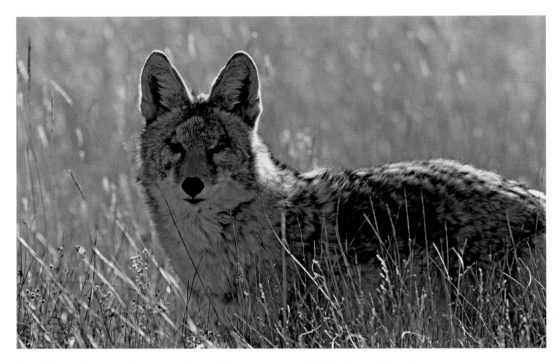

Returning to the same place over and over gives you access to the big picture. These two images of coyotes were taken in the same place just different times of the year.

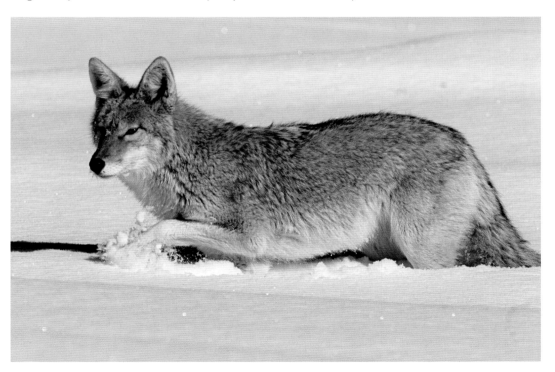

Don't think that by going to a place only once won't give you wonderful images. Be prepared for the expected opportunities, take advantage of unexpected ones, and be content with what is happening before your eyes.

If you take advantage of what is in front of you in a creative way, you will have worthwhile photographs at the end of your trip. Attitude counts when you are taking pictures. A negative attitude is reflected in your results. Live in the present and photograph what is there. I have seen people complain about photographs they are not taking, while wonderful opportunities pass right in front of their lenses. If the sun is not shining, the sunset shot you were hoping for will have to wait for another day. Think about what other photographic opportunities the overcast day has to offer. Being flexible and having the ability to go with the flow will be more successful.

It pays to be prepared for unexpected events. I took this image of a Galapagos sea lion when the sea lion decided to have a closer look at the mask and snorkel lying on the beach. She picked it up and tossed it right onto her head. I could never have planned for this but serendipity was on my side. I had this image on my website and many people were very unhappy that I would do this to the sea lion, but actually I only took the picture, the sea lion did the rest.

I was on my way to photograph whales off the coast of the Dominican Republic. In route I received word that the boat had broken down and could not be repaired for two weeks. There were three of us stranded in Miami. It did not take long before we had rented a car and were on our way to photograph birds on Sanibel Island. There is always something wonderful to photograph.

I always have a good time photographing. A good friend and fellow photographer, Steve Drogin, is one of my favorite people to travel with because he always asks if we are having fun. Traveling with Steve makes me feel good about life and that opens me up to opportunites. If you are not having a good time taking photos, why bother?

While safari in the Serengeti we broke for lunch. I was waiting for food to be ready when I took this image of the Serengeti beer bottle with everyone looking like that was what the meal was all about. There is always something to photograph.

A tri-colored heron preens itself at Ding Darling National Wildlife Refuge on Sanibel Island, Florida. After finding out our intended plan of whale watching in the Dominican Republic was cancelled we quickly rented a car and made Sanibel Island our plan B.

47

Chapter 7
Lenses

We ask the question, "what lenses do I need?" This is hard to answer because there are many ways to treat a subject. Many choices depend on your personal taste and ability to carry the equipment. Lens selection is important, especially when you are traveling. There are some general rules for photographing different subjects, but as your photography improves and your style develops you may choose different lenses.

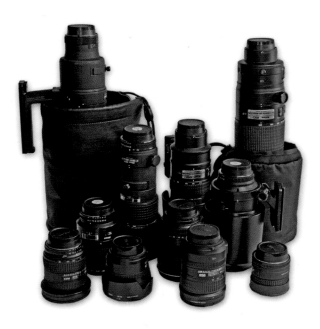

Most of the time you just won't be able to bring all of your lenses. Lens selection is a very import decision to make.

Understanding what each lens does will help you decide whether to use a shorter focal length and move closer to the subject, or a longer focal length and stand further away.

For this image of some rafters preparing for a good dousing under Iguaçu Falls in Brazil, I used a 16mm fisheye lens on my digital camera. Using it on the digital no longer gave it the fisheye effect, but the ultra-wide angle enabled me to include the rafters and the upcoming falls in the picture.

The three types of lens focal lengths are wide angle, normal, and telephoto. Add to this specialty lenses, such as macro and vibration reduction or image stabilizing lenses. Each can help make your photography exciting and a reflection of your way of seeing the world.

Buying Lenses

A few years ago, if you wanted to save a few dollars, I would have told you to buy a less expensive camera body but spend as much as you could on your lenses. Now, because of digital technology, you need to spend on the camera body as well. Still, I think that you should spend as much on the lens as you can afford. Don't be afraid to look for a good deal, but don't try to save money buy purchasing a lesser-quality lens. The two primary reasons for this are glass quality and speed.

Lesser Goldfinches are very small, only about the size of my ring finger. Using my 500mm telephoto lens was the solution to not having the bird lost in the frame.

Getting this image of a Hooded Weaver Finch building its nest required using a fast shutter speed. High quality glass and a large aperture enabled me to use a shutter speed that would freeze the working bird.

Glass quality

Quality glass is an important consideration because it is what the light passes through to register the image. The better the quality of the glass in a lens, the easier it will be for light to pass through it. This is especially important along the edges of the frame and when you are shooting with the lens fully open. The better the glass is the more expensive it is going to be.

Speed

The amount of light able to pass through a lens at its largest aperture is called the speed of the lens. (The aperture is commonly referred to by its f-number). This is the reason that a 300mm lens with an aperture of f/4 wide open will cost you hundreds of dollars. Another 300mm lens with an aperture of f/2.8 wide open will cost you thousands. An f/2.8 lens is twice as fast an f/4 lens. Faster lenses are brighter to look through because they allow more light into the lens and can be used in lower light conditions. They allow you to use higher shutter speeds to freeze the action in low light conditions. If you shoot from the hip in a market place, without time or freedom to set up a tripod, a faster lens allows you to get good sharp images. Generally, faster lenses are also heavier because they have more lens elements. My 500 mm, f/4 lens weighs eleven pounds.

I am not telling you that without the fast and expensive lenses you won't be able to get good results. The more expensive lenses will typically expand your potential. Before you refinance your home to buy new lenses, lets think about what your needs and choices are. If you can afford it, buy the best. If you are like most of us, you will end up with some fast and some slow lenses. Understanding that you may make some compromises, here are guidelines to keep in mind when purchasing new lenses (or other photographic equipment:

What can you really afford? Having a realistic idea of what you can afford will save you anxiety and decision making right away.

What are your needs? Do you really need the faster lens or will one a little slower be everything you will really ever need?

How often will you use it? Are you buying this lens for a special once-in-a-lifetime trip or will it be something that you use on a regular basis.

Can you carry the weight? Three or four heavy lenses can make your photo endeavors more of a chore and less of a pleasant experience. This is not only a question of whether you can carry the weight, but can your mode of transportation carry the weight? Remember, when you are traveling you may need to use small planes with strict weight limits.

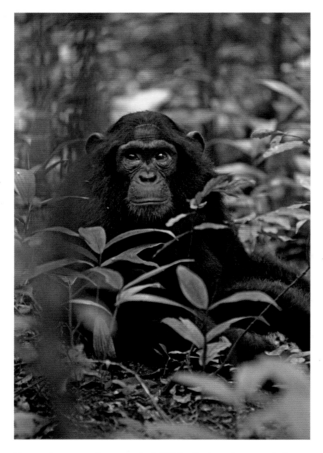

Even using an asa/iso speed of 400 I relied on the speed of my 80 to 210 2.8 lens to be able to get a image of this chimpanzee in Uganda.

Wide-angle Lenses

Now we look at the three general lengths of lenses and learn what they are used for. Wide-angle lenses give the widest picture angle and extra depth of field. Although there are extreme wide-angle lenses, such as 13 and 18mm focal lengths, most wide-angle lenses cover the 20 to 35mm focal length.

Wide angle lenses weather they are fix focal length or zoom are for more than just landscapes.

My fondness for wide-angle lenses did not develop until late in my photographic career. I was stuck with a belief that wide-angle lenses were only for landscapes. I always had a wide-angle lens in my bag, but I fell into the hole that many wildlife photographers fall into and tended to think only with my biggest lens in mind. Once I realized the potential of wide-angle lenses, a new way of making photographs presented itself to me.

Wide angle lenses allow you to include more of what your are actually looking at. This is especially helpful when you are trying to tell a story with your images like this group of tourists and sea lion in the Galapagos.

Wide angle lenses add depth to your images and include more of the elements of what you are seeing. The grandeur of Denali National Park is in this image of two women at Wonder Lake at the bottom of Mt McKinley.

Wide-angle lenses add depth to the subjects you are photographing and include more of the elements you see in the photograph. They stretch out your depth of field and allow the viewer to understand the immense grandeur of inspirational landscape. It allows you to see the forest and the tree, and to experience the solitude of a single person walking along a deserted beach.

Wide-angle lets you focus on objects close to you that will lead the viewer into the photograph. One of my favorite uses is to get down low, with my subject in the foreground, and include the habitat my subject is living in. When photographing close to an object, it is important to know that wide-angle lenses can distort the foreground and make the subject appear closer than they really are. A hand reaching toward the camera will seem enormous or the nose on a person's face will seem bigger than the rest of their head. Although you should be careful of this, it is also a technique you may use to accentuate a subject in the foreground. Use a wide-angle lens and find a new way of seeing things around you.

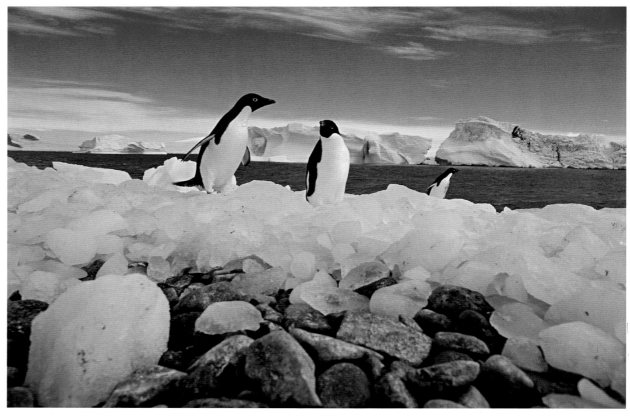

Like this image of Adele Penguins in Antarctica, one of my favorite uses of a wide angle lens is to get down low, with my subject in the foreground and include the habitat my subject is living in.

During one of my trips to the Galapagos, the only lens I brought with me was a 24mm lens. This was an ideal place to test my theory because the wildlife there is so approachable. Taking care not to disturb any of the animals, I was able to place the lens close to wildlife and still include the dramatic landscapes around them. These wildlife landscapes have become favorites of all the photos I have ever taken there.

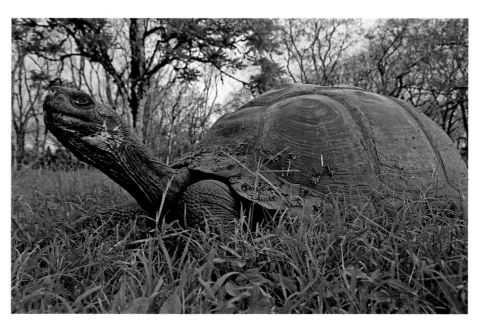

When wildlife allows you to approach closely without disturbing it wide angle lenses let you create wildlife landscapes like this Galapagos Tortoise.

Wide-angle lenses are ideal for tight spaces with limited space, such as a crowded market or the inside of a Masai home. They let you include big picture elements of your experience, such as a portion of the boat the whale is next to. The person looking at your photos can imagine what you saw as if he had been with you. You will find a wide-angle lens to be an invaluable part of your field gear.

Which ones do I have? I own a 16mm fisheye, 20mm, 24mm, 35mm, 18-35mm zoom, and a 28-70mm zoom.

Normal Lenses

What does "normal" lens mean? The photo produced by the normal lens gives you about the same viewpoint as the human eye. The normal, or 50mm, lens has been much maligned because it is the lens most cameras come with. People can develop a dislike for the common; it's just not unique enough for them. But what is the potential for any one piece of equipment?

Normal lenses, those in the 35mm to 55mm are sometimes overlooked simply because they are not specialized enough.

Wide angle lenses are perfect for working in close quarters like the hut of this Masai warrior.

Normal lenses cover a wide range of uses because it is the focal length that we see the world through. This is an image of a stone tent ring in the Namibian desert put there by some ancient people a long time ago.

50mm lenses see the world at the same focal length that we see through our 50mm eyes. This can be a big asset for grab-and-shoot street photography. When you see something that catches your eye, you can capture the moment just as you see it. Normal lenses are typically fast and have close focus range. It is a versatile lens. 50mm lenses have largely been replaced with short zoom lenses that cover the 50mm range and more, but it gives you a realistic view of the world that should not be overlooked. I cover the range of the normal lens with my 28 to 70mm zoom lens.

I love that lenses in the normal range let me work close to my subject like this young Penan girl in Borneo.

This image of a women in the Octavalo Market was made with my 28-70 zoom set at about the 50mm range. This focal length allows me to work fairly close and see the world as I see it making ideal for street photography.

Telephoto Lenses

As much as I say you should not underestimate the possibilities of the shorter focal length lenses, I must also admit that telephoto lenses are the workhorse of the wildlife photographer. My Nikon 500mm lens.

If there is any lens that I use more than any other for up-close wildlife images, it is my 500mm F4 lens. This young orangutan was photographed in Borneo.

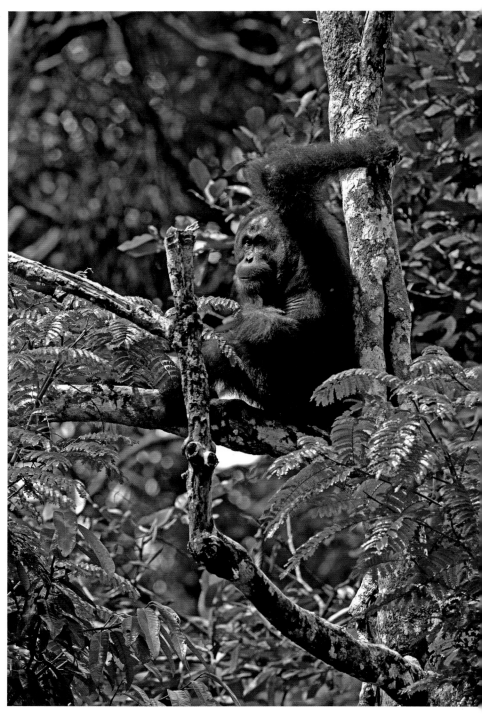

Telephoto lenses are the workhorses of the wildlife photographer. They are separated into three categories: short, medium, and super telephoto range. All telephoto lenses share the same qualities, and these are the points you should consider when choosing which to use.

In the Galapagos, the wildlife is very tolerant of people. Since I was within four feet of this Great Frigate bird sitting on the nest I was able to use a shorter telephoto lens. I had my 80 to 400mm lens set just under the 200mm setting.

This image of a masked weaver finch was taken with my 300mm lens, a medium telephoto lens. The bird was quite accustomed to people at a popular picnic area in the Serengeti in Tanzania.

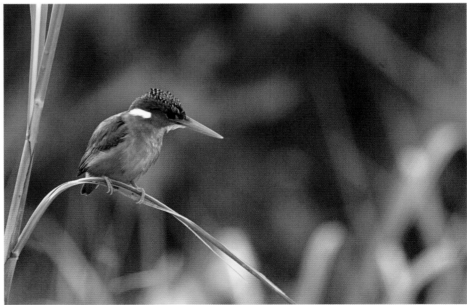

At little more then 5 inches in length, I needed the magnification that my 500mm, a super telephoto lens, with a 1.4 tele-converter provided me in order to make this image of a Malachite Kingfisher in Uganda.

Telephoto lenses do not bring you closer to the subject, rather they isolate the subject from its surroundings. The only way to get closer to your subject is for you or the subject to get up and move. If you think of telephoto lenses this way, you will compose better images.

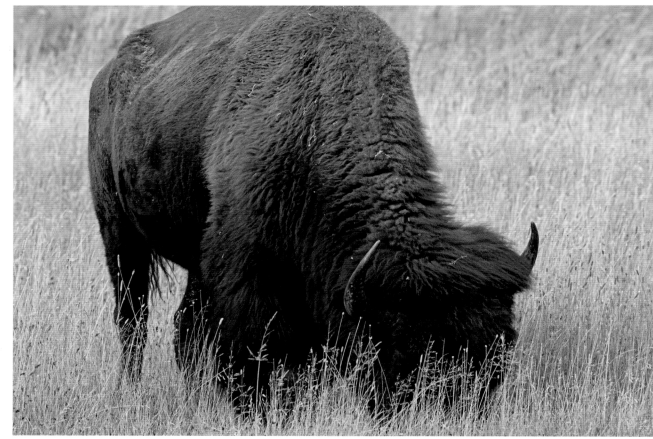

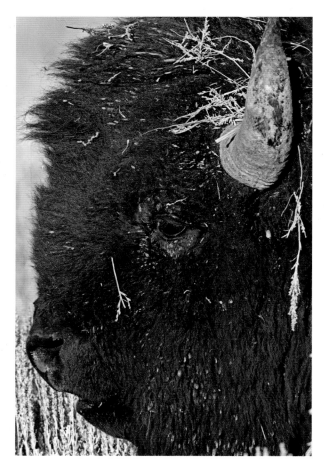

These two images of Bison in Yellowstone National Park show how a telephoto lens will isolate your subject. Both Bison were the same distance away from me but the close-up of the males face was made with my 500mm lens while the bison feeding was made with my 300mm lens.

You may not think of telephoto lenses as landscape lenses but as you can see by this image of the rainforest in Uganda the compression factor in telephoto lenses bring the background of the mountains in the mist up against the foreground of the single tree.

Another quality of telephoto lenses is they compress the field of vision. Objects that look far apart with your normal eye become compressed when you look through a telephoto lens. This makes the telephoto lens ideal for photographing some landscapes. If you want to make the peaks of mountains seem like they are right next to each other, use a telephoto lens. If you want to silhouette the elephant against the setting sun, use a telephoto. Knowing the nuances of your equipment will open you to new results.

As magnification increases, depth of field decreases. This means that because telephoto lenses magnify, they have a shorter depth of field, especially at larger apertures. This can be a benefit if you are trying to blur uninteresting backgrounds that detract from the picture, but it also can be a detriment if you are photographing a bear up close and want the area from the tip of his nose to the back of the head to be in focus. This is fixed by understanding the different values of your aperture at specific magnifications. How do you learn what the different values are? Practice with your lens and do testing before you go on a trip.

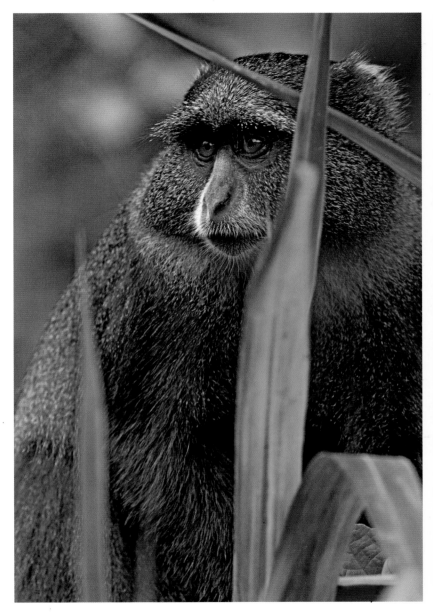

This blue monkey was sitting in the grass in front of tangles of bushes at the base of a tree. Because my 500mm F4 lens gives me minimal depth of field used wide open only the monkeys face is in focus. The grass in front and the leaves behind him are blurred.

How big is enough? For wildlife photography, a minimum of 300mm is required. There are destinations where the wildlife is used to people and you can get extremely close. In these cases, a 300mm lens is sufficient, especially if you are using a digital camera that increases the focal length of your lens by as much as 1-1/2 times. Adding a tele-converter will also increase your focal length. A 1.4 tele-converter (find more about tele-converters at the end of this chapter) will bring the focal length of the 300mm lens to 420mm. This will fill the needs of many who travel to photograph wildlife. A 300mm is ideal for zoos, sports, and places such as the Galapagos Islands. So if you are a person who only photographs wildlife on an occasional basis, it might be hard for you to justify the expense of a longer lens. If you plan to photograph wildlife on a regular basis, consider a lens in the 400mm to 600mm range.

If ever there was a place that you could get close to wildlife, the Galapagos is it. Keep in mind that just because this red-footed booby is tolerant of the person in the image it does not mean that they are tame.

Many wildlife destinations are places where wildlife are habituated to tourists, and travelers can get quite close to animals such as this polar bear in Churchill Manitoba.

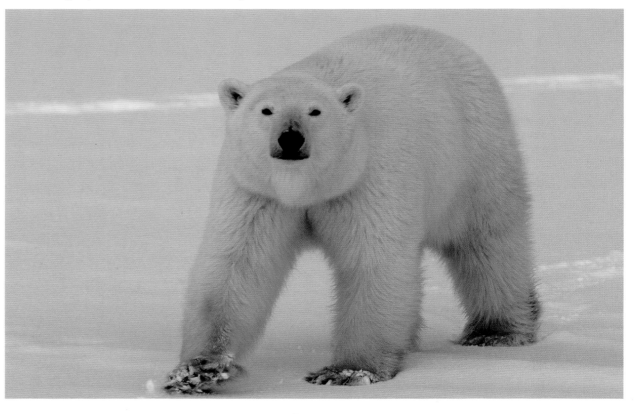

My lens of choice is a Nikon 500mm f/4 lens that gives me the magnification needed for most mammals. If I add a 1.4 tele-converter to it, I get the equivalent of a 700mm lens on my film cameras and 1005mm on my digital cameras. If my primary interest were bird photography, I would consider a 600mm lens, but I shoot a variety of subjects and the 600mm is more weight than 500mm. I prefer the shorter lens. If you are considering buying a lens in the 400 to 600mm range, remember that the speed of the lens is very important (see the section on buying lenses at the beginning of this chapter) and the faster the lens the more money it will cost. Lens quality is what is important, so if you need to save dollars to buy the better lens, it is probably worth the wait.

Which ones do I have? I have telephoto lenses starting with 70 to 200mm and going up to 500mm. These include both fixed and zoom lenses. Not all my lenses come with me on any one trip; I consider the variables and choose the best lenses for any particular destination.

With my 500mm F4 lens, the 1.5 digital factor in my camera, and a 1.4 tele-converter I have the equivalent of a 1005mm lens. This is more than enough for even small subjects like this Blue-headed Agama lizard high in a tree.

Zoom Lenses

When zoom lenses first came out, the quality of the lens was never as good as the quality of a fixed focal length lens. As technology improved, so did the quality of zoom lenses. Today, zoom lenses are sharp and are used by professionals without hesitation. As in every other choice in photography, there are advantages and disadvantages to consider.

Zoom lenses have become very popular for one important reason, they are convenient. They allow you to have more creativity in composition without the hassle of changing lenses. When you are traveling, the weight and amount of equipment you can carry with you is a major concern, and zoom lenses provide a very easy way of dealing with this problem. Many zoom lenses are compact, lightweight, and fit into a camera bag small enough for you to keep them with you on the smallest airplanes.

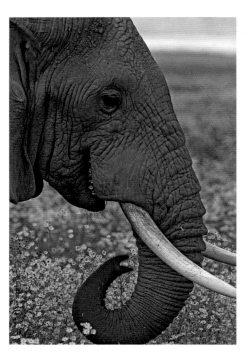

Zooms allow you the benefit of being able to change composition and focal length without having to switch lenses. Both of these images were made moments apart with my 80 to 400 zoom lens. The elephants were on the move and so having the ability to change focal lengths while shooting was a big advantage.

Zoom lens have come a long way since they were first developed. Today, good quality zoom lenses are just as sharp as fix focal length.

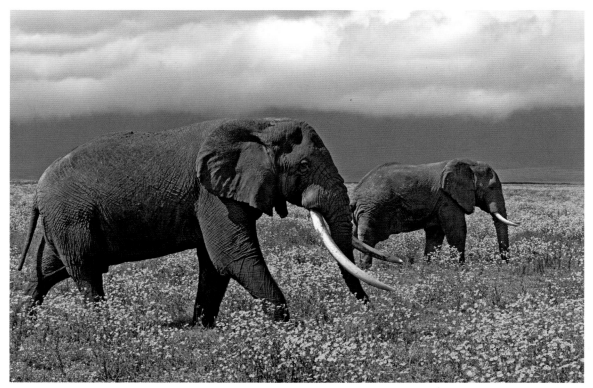

Another advantage of zoom lenses over fixed focal length lenses is the ability to change the focal length while you are looking through your camera. This will help you decide upon your composition. If you are not sure if you want to fill the frame or add some background, you can do both with a mere turning of the lens. Zoom lenses have a big advantage when photographing people in market- places or at events. They allow me to zoom in on the person when having to move in closer might disturb the mood.

There are two disadvantages of zoom lenses: durability and (to a lesser extent) speed. Since there are more moving parts in a zoom lens, they are inherently more fragile than a fixed lens. This does not mean that they are so delicate you should be worried about them breaking at the least little tap, but it does mean that over time the chances of a malfunction in a good quality zoom is greater than that of a fixed focal length lens. Manufactures may disagree, but from personal experience my zoom lenses have needed more repairs than the other lenses in my gear.

Many zooms are much slower than the same range in a fixed lens. There are exceptions, but they are very expensive lenses. With new technologies in lens manufacturing, speed is becoming less of an issue. Many new zooms are very fast lenses, but this is not always the rule. Even though it is becoming less of an issue today, speed is still a major consideration, especially in longer focal lengths and action photography where speed is essential.

Another disadvantage of the zoom lens to me is an advantage to others: you have choices in the composition of the exposure that can make too many things to think about. I know what an image through a 300mm lens will look like. Which do I use? I have both types and decide which to use based on the limits of the destination and the subjects I will encounter. Even with a fixed lens bias, I realize that having one lens that takes the place of two or three is a big convenience and a relief to my back.

When I saw this young girl walking in the market place at Otavalo Ecuador, I was struck by the fact that this girl was surrounded by people making deals and selling things, but still this was just her place to play and sing as she wandered the market. My 28 to 70 zoom allowed me to get rid of the mayhem around her.

Stabilizing Lenses

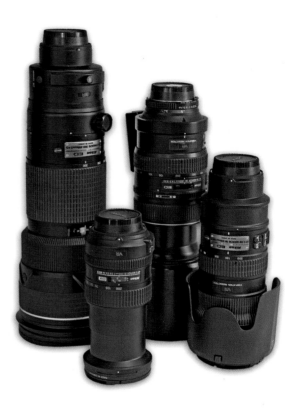

Vibration reduction or lens stabilization is a perfect example of where technology has freed photographers to concentrate on making the image and not having to be as concerned about the environments we need to work in.

The feature of lens stabilization is called Vibration Reduction by Nikon, while Canon calls it Lens Stabilization. It is a built-in gyro that reduces the amount of movement detectable by the camera. This is extremely handy when you need to handhold your camera, such as when you are photographing from a rocking boat or in windy conditions. These lenses are often slower than conventional lenses, however the ability to stabilize makes up for the loss of speed in the lens. Some stabilized lenses, such as the Nikon 200-400 mm f/4 VR, are very fast, but with that speed comes weight and size and it would be very difficult to handhold such a large and heavy lens. This feature on such a big lens helps tremendously when you are panning on a tripod or using a less-stable platform to photograph from, such as a mono-pod. Still, nothing beats a tripod, so don't think stabilization is a replacement for using one. This is a perfect example of technology freeing photographers to concentrate on making the image and not having to be as concerned about the environment.

Macro Lenses

Whole books have been written about close-up photography and it is a wonderful and exciting way to record the smaller things around us. There are lenses that have close focus ability, but for truly macro photography close focus does not give you the same results as a true macro lens. Macro lenses give true 1:1 ratio so images will be life-size reproductions of small subjects. Whereas in most photographic applications photographers are typically looking for the fastest apertures in lenses, macro photographers go the opposite way and look for the greatest depth of field.

My favorite macro lens, the 105mm micro from Nikon.

Galapagos Penguins are fast and fleeting, having Vibration reduction allowed me to be able to quickly get this image as it was snorkeling next to our boat.

In this image of a Green Jeans Poison Arrow frog in Costa Rica you can see how depth of field is greatly reduced during magnification. The frog is only about the size of half my thumb yet the area of focus does not even cover from the frogs face to the rest of the body.

An exception to this rule occurs when you use a flash to give you enough light to work with higher shutter speeds. Since you probably will be photographing objects very close to the lens, you need to have your flash mounted on a bracket to ensure that your subject is properly lit during the exposure. In many cases, two flashes are required to prevent unwanted shadows or to illuminate the background as well as the subject. There are many brackets available. If you are thinking of using one, shop around to find one you are comfortable working with. An alternative to mounting flash on a bracket is to use a specially designed ring flash or close-up flash. These flashes attach to the front of your lens and allow you to get into tight spaces where a flash on a bracket would be obstructed.

Various manufactures make different size macro lenses. 60mm, 105mm, and 200mm are the most common sizes of macro lenses.

Like all specialty lenses, macro lenses can be more expensive than non-macro lenses. If you enjoy making the occasional close-up image but are not serious enough about macro photography to buy a macro lens, there are less expensive alternatives that even the serious macro photographer might consider when traveling. Extension tubes or close-up filters are a good way to take macro photography. (I use the word filter here for the sake of clarity, they look like a filter that you put on the end of the lens. In fact, they are called close-up lenses.) I explain them in detail in the next section of this chapter.

As magnification increases, depth of field decreases. Macro lenses let you get in close (magnifying your subject) and have the smallest apertures allowing for greater depth of field. Since the smaller apertures will also increase your exposure time, stability is very important here. The use of a tripod, beanbag, or some other steadying device is a requisite for macro photography.

Using a tripod can be impractical when you are dealing with moving subjects like this Cat-eyed Snake in the jungles of Peru. The use of a ring flash enabled me to work close and fast.

Macro lenses can open up new alternatives for your work. Bring one into a field of wildflowers or garden and you will be surprised at how much wildlife you can discover. Whoever said they would photograph more often if only there were something around their home worth photographing never went looking with a macro lens. Plants, insects, and spiders all are subjects o explore with your macro equipment. You probably can find them all without leaving your own yard.

Like this bee on a coreopsis flower, you can discover a whole new world in your garden. Macro photography is a look into a miniature universe.

For traveling purposes, macro lenses are less appropriate for some destinations,while others seem to have been created for macro photography. On an African safari, macro work can be done at your lodge site, but on game drives it will be rare for you to leave your vehicle and use macro lenses. The tropical rain forest, on the other hand, is a macro photographer's dream come true.

Do I own them? I have a 105mm micro lens (Nikon call their macro lenses *micro*). I love this lens and although I do not bring it with me everywhere, I tend to go through separation anxiety whenever I do not add it to my bag.

The tropical rainforests are the ideal place for macro photography. This is a tree climbing crab in the Peruvian rainforest.

Extension Tubes and Close-up Lenses

Extension tubes go between your lens and camera body, adding space between the plane of film and the end of the lens. This changes the focusing capability of your lens, allowing you to get physically closer to your subject. By moving close to your subject, you increase the size of the subject in relation to how much of your frame is filled. This is an ideal way of getting close-up photography. There is no glass for the light to travel through so there is no distortion in the final result. You still need more exposure time, because the added distance between the lens and film causes a loss of light. Extension tubes are less costly than a true macro lens, and I recommend original manufacturer extension tubes to keep the metering system as true as possible.

Extension tubes are useful for more than just macro work. They enable you to focus closer than your lens will normally allow. This means it will focus on subjects closer to you. If your subject moves too close for you to focus, add the extension tube and presto, you can focus correctly.

Extension tubes cut down on the amount of light passing through the lens and you should expect to lose about a stop of light when using them.

Supplementary close-up lenses look like filters that simply screw onto the end of your lens and magnify the image. Photo courtesy of Hoya Filters.

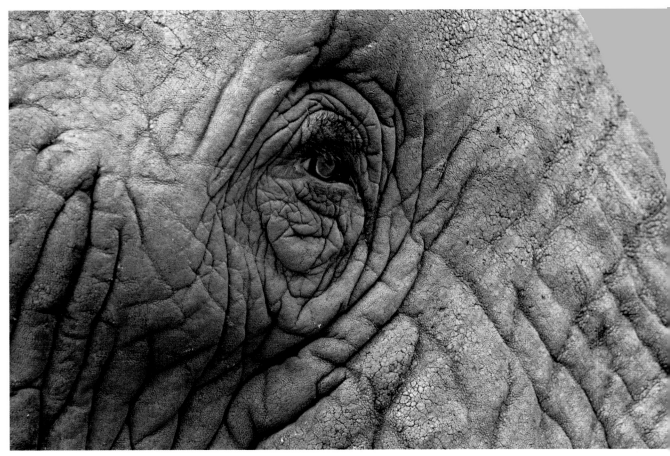

Even with long lenses like a 500mm, an extension tube will allow you to focus closer than your normal focus ring will allow. So if an elephant decides to walk too close for you to normally focus, an extension tube will let you get details like the eye of the elephant.

Supplementary close-up lenses look like filters that screw onto the end of your lens and magnify the image. The lenses themselves come in different magnification, so by stacking them you can achieve stronger degrees of magnification. If you use close-up lenses, be aware that stacking may make the frame of the lens visible in your viewfinder and cause vignetting. Close-up lenses range in price from inexpensive too extremely expensive because the better the glass in the lens, the higher the cost. As with any lens, the better the glass the better the resulting image.

Whether you use an extension tube or a close-up lense, you will be able to use these as macro lenses without adding too much weight, bulk, or expense to your equipment.

What do I have in my camera bag? I always have an extension tube that I use as much for the close focusing ability it gives me on longer lenses as I do for macro work.

Close-up lenses are an excellent way to be able to make beautiful images like this agama lizard in Borneo without having the expense and weight of a true macro lens.

Close-up lenses allow you to get in close to smaller subjects like this Pink-toed Tarantula in the Amazon.

Tele-converters

Tele-converters, also called extenders or multipliers, are an inexpensive and convenient way of increasing the focal length of your lens. Tele-converters are placed between the lens and camera body, and they typically come in tree magnifications: 1.4X, 1.7X, and 2X. The 1.4X tele-converter effectively multiplies the length of your lens 1.4 times. The 1.7X multiplies it 1.7 times. The 2X doubles the length of the lens. 1.4X and 1.7X may seem like odd multiples, but they give you outstanding resolution while increasing the length of the lens. The 2X is stronger, but the resolution is not quite as good as the 1.4X. Although the 2X and 1.7X are very popular in the amateur audience, the 1.4X is more popular among professionals.

Here are two examples of Tele-converters, the 1.4 and the 1.7

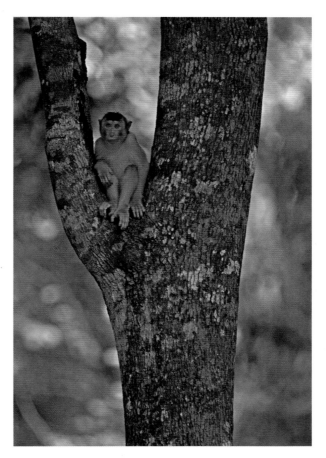

Wildlife can be elusive and often difficult to approach. Adding a tele-converter to your telephoto lens can really save the image. Long-tailed Macaque, Borneo.

Tele-converters are less expensive than buying a new lens and they are a convenient way of adding length without having to carry another lens. A 1.4X tele-converter added to a 300mm lens gives you the equivalent of a 420mm lens, while adding a 2X tele-converter will effectively give you a 600mm lens.

If tele-converters are so handy and less expensive, why would you want to buy long lenses in the first place? The answer is light. When you add a tele-converter to the lens, you decrease the amount of light able to pass through the lens. With a 1.4X tele-converter, you lose about one stop and with a 2X tele-converter, you lose about two stops.

You can buy an inexpensive tele-converter, however I recommend the original equipment manufacturer's brand when buying a tele-converter that are made for your lenses. Adding one to the lens for which it was made will make it more like another lens and less like a lens accessory.

A high quality tele-converter will make it more like another lens and less like an accessory. Zebra, Tanzania.

Chapter 8
Film Camera Bodies

Large Format Cameras

When it comes to camera bodies, you have choices, not just in brand names but also in format. By far the most common camera format is the 35mm SLR, however larger formats, such as the 6 X 7 or (the largest of formats) the 8 X 10, are noteworthy.

The larger format cameras give you unsurpassed image quality and are the standard for many landscape photographers. They are also by far the simplest in design and features. Some of these cameras do not even have a built-in light meter.

The basic film camera body is nothing more than a box that holds the film. It allows a predetermined amount of light to enter and expose the film. If you are considering buying a new camera system and need to economize, the camera body is where you can save a few dollars. This does not mean you should buy the cheapest camera available, it means you should think about what you want to do with your photography. Make your decision based on need, not whatever marketing people are trying to sell you.

When it comes to camera bodies choose the one that is right for you and your needs. Look for the features that will help your photography and not your bragging rights.

Landscape photographers often prefer large format camera for the exceptional image quality they provide. I made this image of the Grand Canyon with a Pentax 6x7 camera.

My aunt Beth, who's name I will change to Mary to protect her privacy, is very interested in photography. When she first became interested, she called to ask my advice on which camera to buy. We discussed what she might be photographing and what she hoped to accomplish with her camera. After hours (and I mean hurs) of discussion, I had suggestions, but just as important I told her what not to buy. My aunt happily went off to the camera store. After discussing all the options and telling the salesman what her nephew, the professional photographer, has recommended, she proceeded to buy exactly the equipment I had advised against. I guess the salesman, who probably got a higher commission on the system he sold her, knew more than I did when it came to wildlife photography. Did I mention, by the way, how much I love my aunt? I just wanted to make that clear; it has nothing to do with her will or anything, I just love my aunt! Anyway, after a few years of frustration, she decided to upgrade her equipment to pretty much what I had recommended in the first place.

When buying a camera body you more-or-less decide on the *system* you will use. If you are not interested in being able to determine your own exposure or choosing which type of metering system you use, you do not need to buy a camera with options. If, however, you plan on having control over your photography you want a camera that meets and keeps up with your expectations.

My Aunt Mary on tour with me in the Galapagos.

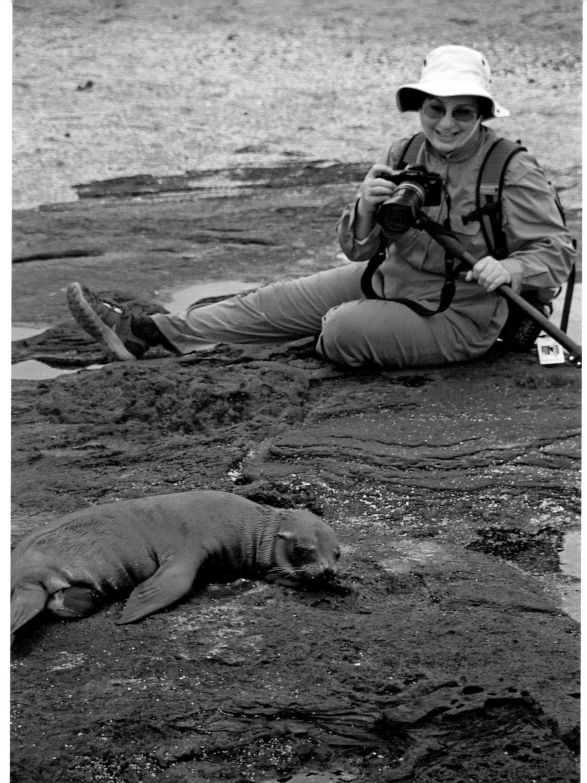

There are many good brands of camera on the market. I want to cover more about features and less about brands. Today, camera bodies have so many extra features that they can overwhelm you. Many features are redundant and can add to confusion. If you want to buy a new camera body, consider what you want to photograph and the features that make the most sense for your needs. Most brand-name cameras have a host of interchangeable lenses, but do they have the lenses and accessories for the photography style you are interested in? Will you be able to grow with the camera or need to upgrade when you want to be more creative?

When purchasing a new camera consider what you want to photograph and think about the features that make the most sense to your particular needs. Photographer in Bryce Canyon National Park.

As I mentioned before, I do not believe in a starter camera. Each time you buy a new camera you need to learn the intricacies of that particular model. Why not buy the camera you can use for many years, feel comfortable with, and that will give you the results you are hoping for? Look for the features to use on a regular basis. Some options I consider include: a depth of field preview button, the ability to choose different types of metering, how many frames can I take per second, and how rugged the equipment is. For digital cameras, I also consider the speed at which the camera will copy information to the digital film (so I can be ready for the next burst of images). I chose Nikon cameras when I started and still use the Nikon system today, because it had then and continues to have the features I feel are important. I know that my system allows me to grow as a photographer without having to buy new equipment every couple of years. There is always some new lens or accessory I am interested in purchasing, and it seems that the life of any digital camera body is about two years before advancing technology dates older models. However, it is not because the gear I already have does not allow me to create the images I want.

A depth of field preview button helps me understand how much of image will be in focus. This is really helpful when doing macro work like this rose hip with snow.

Chapter 9
Digital Cameras

The digital age of photography has come upon us so fast that it is hard to write about specifics because digital photography is continuing to change at an incredible rate. There is one feature that one cannot overlook. Digital cameras give you instant results, not just instant gratification. Instant results allow the photographer to correct exposure, focus, or depth of field. This is especially important if you have spent thousands of dollars on a once-in-a-lifetime journey.

Digital is a whole new realm of photography. There are many choices in digital cameras, from point and shoot versions that are simple to more sophisticated SLR versions. They all offer the user many options for being creative. Being able to do post-production adjustments to the photos is one of the benefits of digital photography.

Digital photography not only gives you instant gratification, but more importantly instant results. This lets you know if adjustments need to be made for highlights and shadows. Black-winged Stilt, Tanzania.

Post-production manipulation is an area of debate among photographers. Purists believe that manipulation of the image after the photo is made no longer allows you to call it a photograph. Those who like manipulating the image on a computer believe it is a new way of creating the final image. In digital, some manipulation often is necessary, such as adjusting the levels of shadows and highlights, especially if you are shooting in raw format. To me this is like making adjustments in the darkroom; I don't think of it as manipulation but as simply making sure your final product is what you saw through the viewfinder. With film, photographers can do this same manipulation in the dark room.

The kind of manipulation that has everyone in an uproar is when you add extra images to make the photo more exciting; for example, adding the gorilla you photographed at the zoo to a different natural habitat. I believe you create a photograph with a camera, either film or digital style. But adding extra zebras that were not there originally to an image does change things. I no longer consider that a photograph that was created with a camera. It is rather an art piece that was created by using many photos and technology. I think of it as a new art form like an artist using two different mediums to create art. It does not lessen the final piece of art, but a painting is not a sculpture and a photo is not a computer-generated image. If a photograph is manipulated to be the image you had in mind, and not the image you had in camera, I think the method should be stated as such. People can decide how much or how little they want to manipulate their images, but either way the original process of creating the original image uses the same techniques as film photography.

These two images are an example of making simple post production adjustments to your image. The photo of the Capuchin Monkey in Brazil on the left is the raw image while the photo on the right is the image after I adjusted the levels and sharpness.

The Digital Camera Body

Recalling that the camera body can be the place to save a few dollars (see Chapter 8), we must consider the digital SLR camera as more than just a box; it is a computer. As with any computer, the more sophisticated the machine, the more money you can expect to spend. Some people believe the cost and quality depend on the number of mega pixels the camera can provide. The more you have, the better quality the photo will be, particularly when making enlargements. This is something to consider, but new technology in producing cameras has made even small point-and-shoot cameras able to produce high-count mega pixels (ie: 6 mega pixels and higher) and they can give incredible results. There are, however, other things to consider in digital camera bodies of the SLR market.

Digital cameras are more than just a box that holds your film, they are sophisticated computers that offer you many possibilities.

Digital Speed

Speed is something we normally talk about when we are discussing lenses, however in digital format there is a different kind of speed to consider. Speed in lenses normally referrs to the amount of light a lens will allow into the camera in a specific amount of time. In the digital camera body, speed referrs to how much time goes by from the moment you press the shutter release until the photo is actually taken. There can be a delay in some camera bodies and this is something to consider when buying a new digital camera. It can be frustrating to have the subject ready at a precise moment, only to have a delay when you press the shutter release. This is not a problem if you are photographing geological formations, but to capture anything moving, such as a charging elephant or your daughter's first steps, the moment may be gone before the camera captures the image.

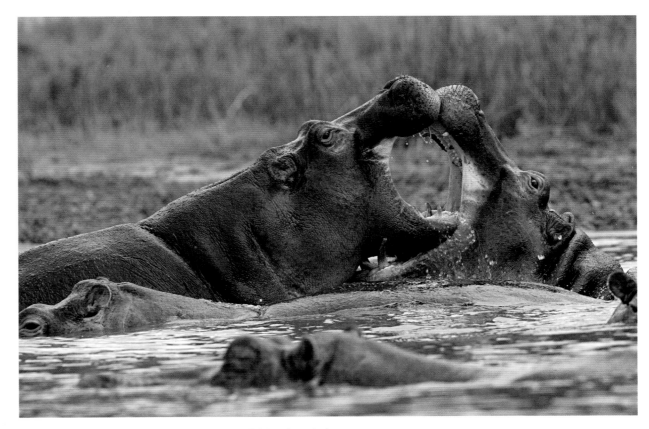

While in Uganda I photograph these two Hippos fighting. I needed a camera that responded immediately without any delay.

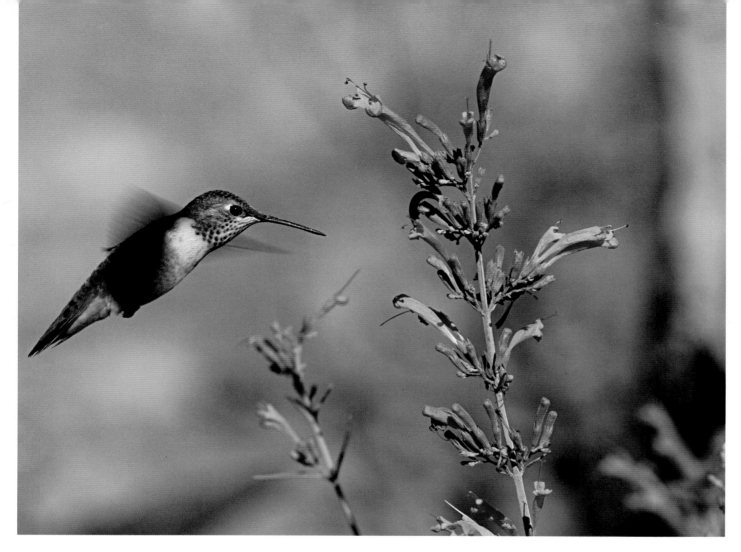

When photographing subjects like this humming bird it is necessary to make many exposures one right after the other. The bird moves so fast you never know if you are going to have a wing covering the face or catch light in the eye. I need to know I can snap at will without worrying if my camera will keep up with me.

Another speed-related factor to consider when you buy a new digital camera is how many images can be made before you wait while your camera processes the information it has gathered. When a digital camera creates an image, it first writes the image to a buffer, then downloads the image onto a memory card. This takes time and some cameras pause briefly between each exposure before you can create another image. To some degree, this problem has been addressed in most SLR cameras, but it remains something to ask about when buying a new digital camera. If you are photographing action, you may need more than the three or four images you can make before the camera needs a time out. In most cases, this factor will not cause a train wreck, but it can result in frustration when you miss an image because your camera body was just not ready.

Camera Controls and Shooting Menu

Another feature to be aware of when purchasing digital SLR cameras is the ease in which you can access and use the camera's controls and shooting menu. Is the camera's menu easy to read or is the monitor so small you need to put on reading glasses to see it? I tend to try to keep my settings as simple as possible, but many photographers like making custom settings that are stored in the camera and used by the photographer when the need arises. If this interests you, make sure the camera has the ability to store custom settings. If the camera feels good in your hands and you feel good about using the controls, you will make better images.

When I was photographing this beaver crossing a frozen pond I kept playing with my exposure because the beaver was so dark and the ice was so white. Being able to do that without having to fumble with camera controls made all the difference.

Memory Cards

One convenience of digital photography is that you no longer need to carry rolls of film, eliminating the worry about x-rays, film speeds, and maybe most important, film cost. But you still need to store your images somewhere, and the memory cards do fill up. Memory cards are the computer chips that store images when you take the picture; it is what is used instead of film, and they hardly weigh a thing. Carrying lots of memory cards is one method of being assured that you save all the images you tajke, and the latest cards have incredible amounts of memory. But if you are serious about photography, you will want some type of reliable storage device to download your images onto once your memory card is filled. Actually, you will want to carry both extra cards for use in the field and a portable storage device to download into at the end of the day. These are portable hard drives that let you temporarily store images until you have the chance to download them into your computer. They are powerful tools and some can hold week's worth of photo images, even if you are shooting in raw mode. Some, like the Epson models, let you view your images by way of a small screen built into the device. This is a big plus because the alternative is to carry a laptop computer with you. Laptops are great to have since you can work on your images as you are making them. But I worry about damaging the computer in the field, so I prefer to use portable storage devices. All you need to worry about now is whether your laptop or storage device, and all the cords and battery chargers, are going to survive the orangutans loading your "way too much carry on so it had to be gate checked" equipment into the belly of the plane. In my opinion, it is always going to be a hassle transporting equipment from one place to another. Whether it is rolls of film or expensive, heavy, and fragile computer equipment, it is all a wash in the end.

Memory cards are both lightweight and reusable.

This is one example of a portable storage device, the Epson P-3000. Photo courtesy of Epson.

This image of a brown bear in the bubbling white water can be an exposure nightmare.
Being able to see if my exposure was correct is a big stress reliever.

The biggest advantage of digital cameras is the ability to view your images right away. Seeing mistakes and recognizing that you need to compensate exposure is invaluable. If there is a problem, digital photography allows you to correct the problem in the field. Since images can be fixed in the computer after the image has been made, you can bring home images that would have been lost because of incorrect exposure. This can make the difference between a moment captured and a moment lost.

There are drawbacks to digital photography, including programs that take time to master. It was a daunting task for me, and I still am learning how to use the photo management programs. The basic principles of photography are the same, so if you understand them, the rest will come with only a minimal amount of work.

For me, there is one aspect of the digital world I have been sorry to see. It used to be that one of the greatest joys of being a wildlife photographer was meeting around the fire at the lodge after a full day of making images. The comradery of like-minded people telling stories of the day's adventures was a highlight of the experience. As more photographers switch to digital, the gatherings at the end of the day have changed from a time of sharing and togetherness to one of quietness and solitude. It seems more like a library with everyone sitting by himself or herself working on their laptops, tweaking their images. Sometimes the pleasure of the wine is in the time spent sipping.

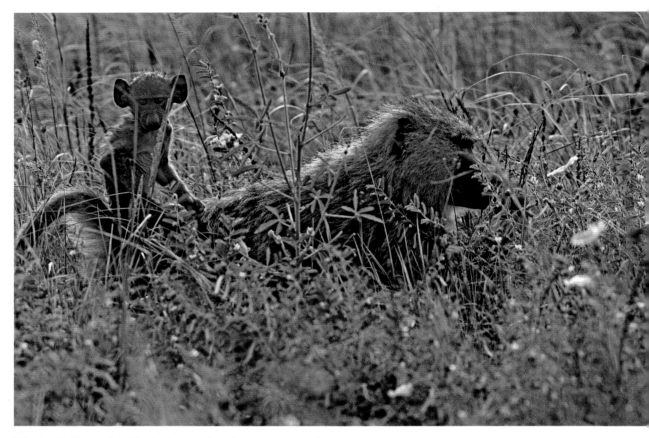

Whether its film or digital the basic principles of photography are the same. An Olive Baboon with baby on her back, Tanzania.

Chapter 10
Histograms

When I used slide film I was always worried about correct exposure, and often would bracket my shots to make sure I got the exposure I was hoping for. Bracketing is when you make the same image two or tree times at different exposures to insure that at least one will be correct. With digital photography, this has changed dramatically because of the use of the histogram. It is not always sufficient to simply look at your camera's monitor to see if you have correct exposure, looking at the monitor can give you a false sense of what you captured. The monitors on even high-end cameras are small, hard to see in direct sunlight, and not a good way to judge the quality of your image. Small nuances of exposure are lost on small screens.

The tool that digital cameras provide you with is the histogram. This is the graph that resembles an outline of mountains that shows up on your monitor. It is made up of peaks and valleys that tell you if your exposure is correct. It looks highly technical, but is an easy way to judge your exposure and is not difficult to read; it's all about the ends of the scale. The peaks and valleys in the middle are not important; what matters is that you don't cut off the end of the scale on the left or the right of the graph. If you cut off the left side of the scale, you have an under-exposed image; if you cut off the right, your image will be washed out, or over exposed. If you have cut off the left then increase your exposure until the scale is more centered. If you have cut off the right, then decrease your exposure until you have achieved the same result. This is a very simple technique to give you the proper exposure.

Subjects like this white polar bear on white ice and snow can really throw off your exposure. By using your histogram you can forget about bracketing to get the proper exposure. Once you adjust your exposure to get the right histogram, every image will be right on the money after that.

Under exposed

Over exposed

Three examples of histograms are provided to help you understand the graph you are looking for. Now you know why I am a photographer and not an artist.

Just right

You will need to learn how to adjust the exposure settings, so become familiar with the exposure compensation feature on your camera. Even when the exposure is correct, you may want to tweak your image once you have downloaded it into your computer, but this method will give you the correct exposure to begin with. Every camera is different and you may find that images look better to you if you favor a little more or a little less exposure. Understanding your histogram will give you this creative choice. Once you process the images with a photo program on your computer, you can adjust the levels of contrast. Photography is a creative process, so don't be afraid to put your own preferences in your work.

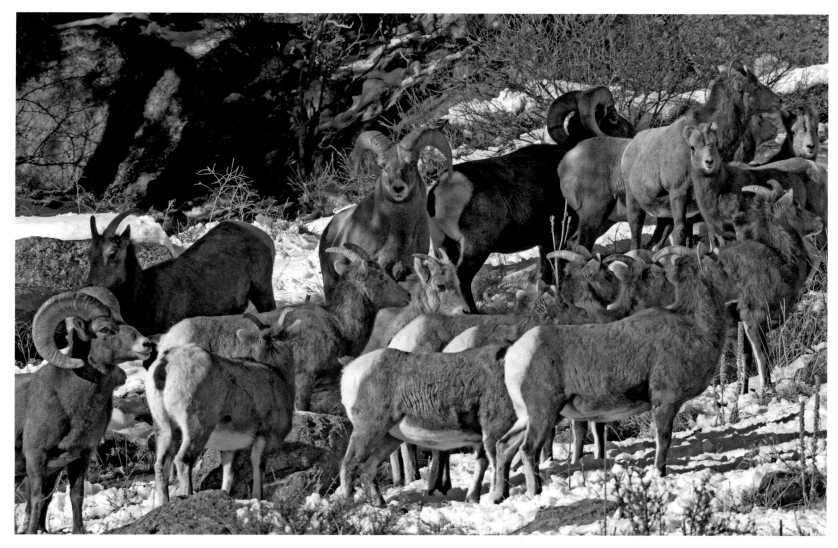

White snow around the Big Horn Sheep as in this image can easily throw off your exposure. Looking at your histogram allows you to make small adjustments to the exposure in the field.

Chapter 11
Point and Shoot Cameras

For some, a point and shoot camera is all you will ever need. They are simple, easy to use, and some come with very advanced features. They allow you to enjoy photography without the hassles of needing lots of gear.

There are two types of point and shoot cameras. One is rectangular in shape, has a built in moderate-length zoom lens, and will fit into your pocket. These are the point and shoot cameras that are normally thought of, and although simple in design they are very good cameras, handy, and easy to use. Enjoy their simplicity and have a good time making photos. Many pros find them very handy for documenting less serious aspects of their assignments, such as photographing people along on the trip or making a self-portrait. These small cameras are not intimidating and can be used when a larger camera/lens/flash combination gets in the way.

Many point and shoot cameras are weather resistant and can handle a certain amount of sand or water, allowing you to forget about keeping the camera over-safe and concentrate on making photographs. They will not accept larger lenses or allow you to use external flashes or filters, but as a camera that you grab when you want hassle-free photos, there is nothing wrong with them. If this is the only camera you own or will ever own, this book will help your picture making with good techniques. There is no reason to put less effort into your photography. Your photographic opportunities will be governed by the lens size and potential of your particular camera.

In some circumstances, wildlife are habituated to people and a point and shoot camera will do the job you might expect only from long lenses and sophisticated cameras. My friend Wayne Johnston took this image of a Long-tailed Macaque in Borneo using his point and shoot camera.

The second type of point and shoot camera is a 35mm SLR camera that accepts interchangeable lenses and accommodates various accessories. The important difference between the two styles is that the owner of the latter type does not care to take the camera off the program mode and will never do anything with the camera except point it and press the shutter release. If the reason for never changing the camera settings is because you are sometimes overwhelmed by using the camera, I hope this book will tame the intimidation of photography and show you the joys that using your camera can give you. If you know enough about the potential of the equipment, you have the means for hours of exciting opportunities making photos.

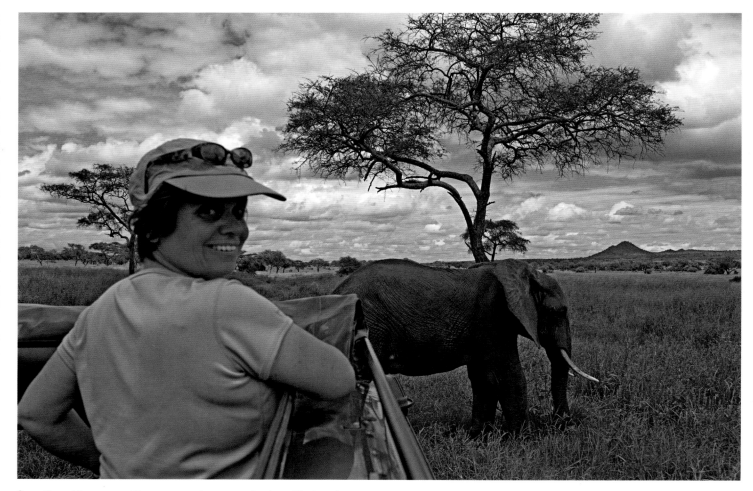

Sometimes I keep a small lens on an extra camera body and just use it as my point and shoot camera. It allows me to capture fun moments like this image of a guest on safari with me in Tanzania.

Chapter 12
Filters

Specialized filters are on the market for many different effects, but I tend to keep them as simple as possible and use only two or three types of filters. Because it goes onto the camera's lens, the quality of the filter will affect the quality of the lens. Stay away from brands you don't recognize and those you think you are getting for a bargain when you find a filter for half the price of the one everyone else buys. Some photographers do not put a filter on their lens because they feel it will adversely affect their image quality. Others always have a filter on the end of their lens to protect the lens from scratches and hits.

Purists say that if you put a $20 filter on the end of an expensive lens, the quality of your lens is lessened. I feel that as long as you buy quality filters you won't lose quality. I have seen plenty of lenses that have been bumped or dropped and were saved by a protective filter. You can make your own choice.

Warming filters bring out detail in feathers and fur. The image of bee on a cone flower on the left was made without a warming filter, while the image on the right is with a warming filter added in Photoshop.

The addition of a high quality filter like this Hoya skylight filter will save the life of your very expensive lenses. I am all for it. A high-end filter will not make a noticeable difference in the quality of your images. Photo courtesy of Hoya Filters.

The question then becomes, what filter do you use? Most people think of a UV or Skylight filter, but lenses are already coated for UV protection, so why be redundant? If you add a filter to the end of your lens, why not use one that adds something to your photography.

When using film, I use a warming filter, either an 81 A or B. It is slightly amber and it brings out details, such as in fur and feathers, and cuts through haze you find notmally in the atmosphere. An 81 B is slightly stronger than an 81 A.

When shooting digital, the white balance on your camera will compensate for the filter and the filter will no longer give you the warming effect you are looking for. So for digital cameras a less expensive skylight or UV filter is all you need. You can get a warming effect when you process the image on your computer, since photo management programs allow you to create warming effects.

Polarizer's are basically sunglasses for your camera lens, they darken and intensify the blue of the sky as well as remove glare from reflective objects such as water and wet foliage. Photo courtesy of Hoya Filters.

Polarizer Filters

The one filter you definitely want to have with you, whether you use film or digital, is a polarizer filter. These act as sunglasses for your camera lens, as they darken and intensify the blue of the sky and remove glare from reflective objects ,such as water and wet foliage. Even though it is better to create images when the light is at its best, Polarizer filters allow you to shoot in harsh conditions that would normally be unacceptable.

Unlike other filters, you take an active role in the amount of polarization you use by rotating the filter collar on the edge of the lens. There are two mistakes that I often see people make: turning the collar until the darkest image appears in the viewfinder and leaving the polarizer filter on the lens all the time. The reason you can turn the filter and determine the degree of polarization is to give you flexibility. Chose the amount of polarization you want, and if you think that less is better, then go with it, you are the photographer. Polarizer filters are at their best when the sun is at about a 90-degree angle to the lens. If the sun is not causing glare or if you don't need to make the blue sky more blue, you don't need a polarizer filter on your lens. At that point all it does is take away light and make you have to increase your exposure or open your aperture. Polarizer filters do not work on cloudy days.

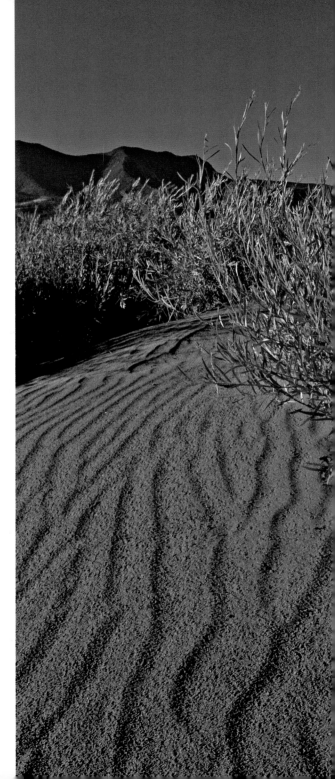

Polarizing filters are essential for cutting glare on reflective objects like the sand at Great Sand Dunes National Park in Colorado.

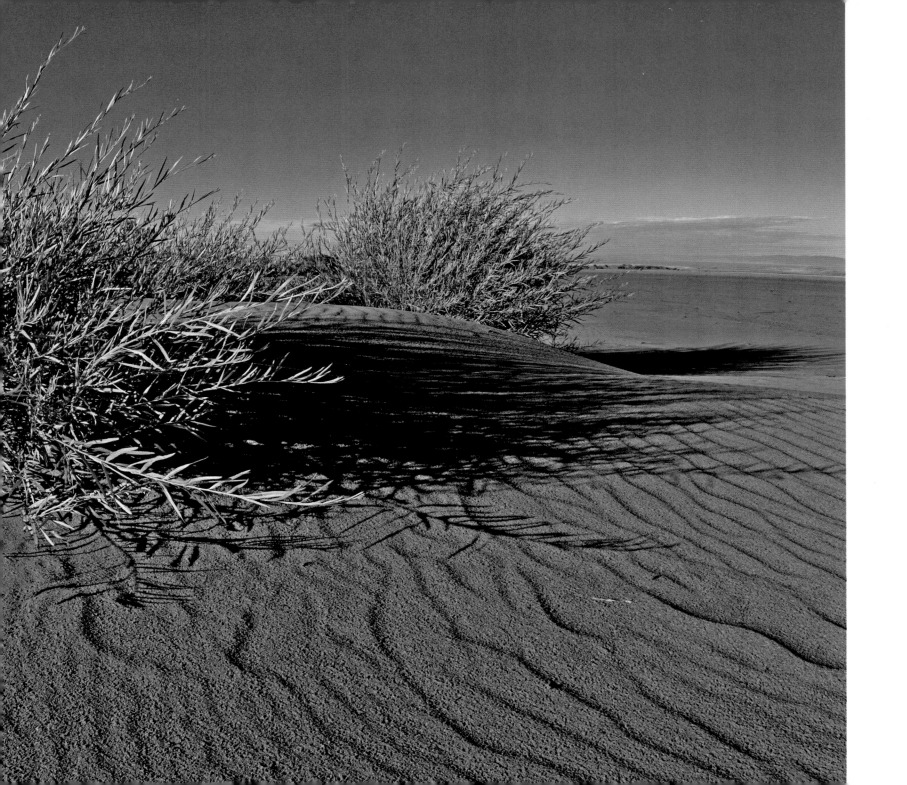

Chapter 13
Flashes

Flash photography is not just for indoors or nighttime, and it can be very useful in wildlife and nature photography. One of the great inventions of modern photography is the ability to use your flash set at TTL, meaning your camera's meter will get the exposure reading through the lens and will adjust the flashes output on its own. Knowing how to use your equipment will enable you to have more flexibility and control over the end results. Having another tool to help control the light is a wonderful option.

Flash units are another tool for you to use, but learn how to use it properly by reading the owner's manual and becoming comfortable with the controls on your flash. Modern cameras and flashes are incredible at determining correct exposures and seem to know when to add fill flash and when to give a full burst of light, but I still recommend learning how to override your camera's or flash unit's programmed settings. You need to be able to control your flash just like any other part of your equipment. Many people turn on their flash and hope for the best. You can do better than that.

Flash photography is not just for indoors or nighttime, and it can be very useful in wildlife and nature photography.

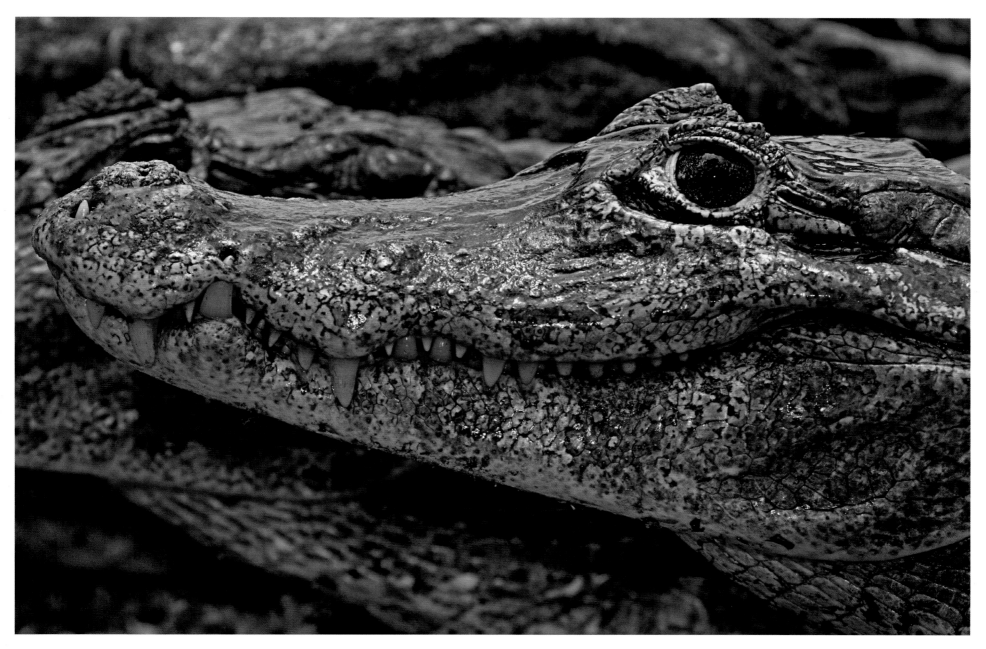

I used my flash to add detail to this caiman in Brazils Pantanal. Even in daylight, the caiman were dark and lacking detail on the overcast day.

Like your camera, a good flash unit allows you to fine-tune the flash output and under- or over-expose the flash for a desired effect. This is especially handy when using flash in daytime uses as a fill flash to bring out details. By adding just a little light you will be able to illuminate the foreground and put detail in backlit subjects. Fill flash lets you bring out details in the shadows. Even with your subject in good light, you can use flash to put a catch light in the eye of your subject and give your photos more life. The trick is knowing how much flash is enough or too much, and this becomes personal taste. Practicing with your flash is a good way to discover what is enough for you. By under exposing the image you can add just a hint of light when a shadow covers part of the subject, while not having it appear as an artificial light source.

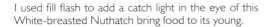
I used fill flash to add a catch light in the eye of this White-breasted Nuthatch bring food to its young.

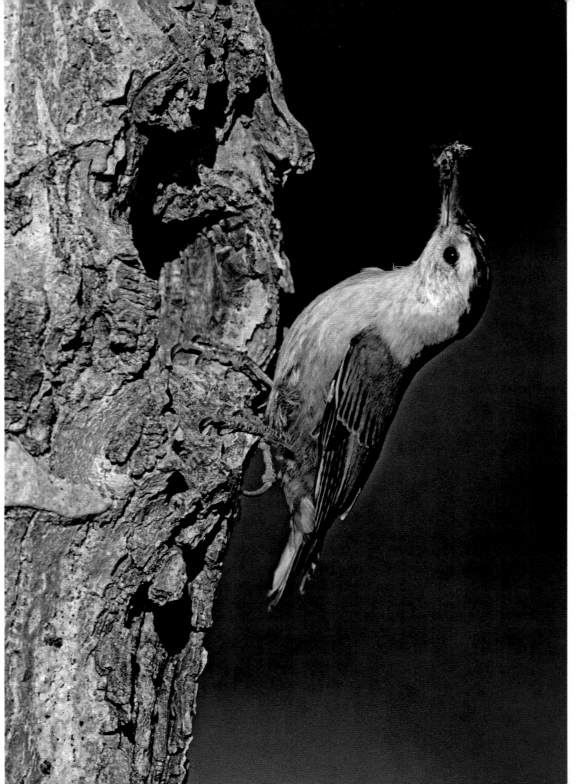

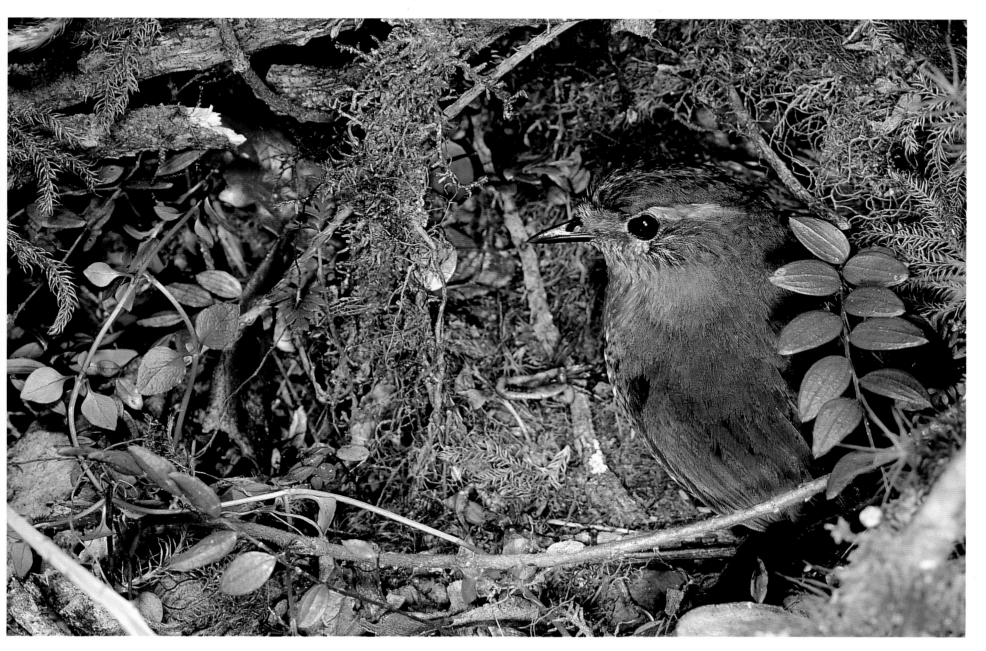

I often use two flashes when photographing birds at the nest. This way I can illuminate both the bird and the area behind the bird where shadows might occur. This is a Chucao in the southern forest of Chile.

For some applications you need not only your flash at full strength but also a second flash to provide required light and to cover unnatural shadows. I use this technique when photographing bird's nests, where one flash illuminates the nest and one flash illuminates the area behind the nest. When doing close-up or macro-photography of small objects, you may need extra light to attain the required depth of field. As magnification increases, depth of field decreases. This means that if you are doing extreme close-up photography, you may need extra light to work at smaller apertures with a shutter speed fast enough to stop the action.

If the flash unit is mounted on top of the camera and the lens is only inches away from the subject, the flash will *not* illuminate what your camera is pointed at. In this case, remove the flash (or flashes) from the camera in order to put the light where it needs to be. Even in non-close-up photography, having the flash off the center of the camera will eliminate red-eye. In a pinch, you can handhold or enlist the help of someone else to hold the flash unit, and there are many flash brackets available that allow you to work unimpeded.

If macro-photography is what you really like, a ring flash or specialized macro flash may be an accessory worth using. These are flashes that fit around the end of your lens. They are much smaller than a regular flash and allow you to change the focusing distance without having to make adjustments to all the brackets. Since they are mounted on the end of the lens, they will illuminate whatever the lens is pointed at. This is especially convenient when you are working in close quarters and do not have room for a flash mounted on a bracket. It is also more compact and lighter in weight than a conventional flash mounted on a bracket. Some camera bodies come with built-in flashes that are fine in some circumstances, but they are not as powerful as a separate flash unit. There are many flash units to choose from for any camera, but in general I recommend the most powerful flash you can acquire. You may not always need the full power, but it is nice to have when the need arises. The more powerful flashes also tend to recycle faster, meaning you won't have to wait too long for the flash to recharge and be ready to use again.

I used my macro flash setup to photograph this image of a Cicada in Brazil.

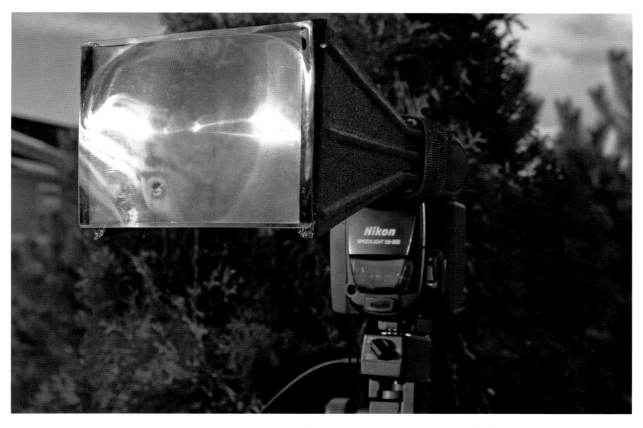

Sometimes you may find yourself far enough away from the subject that your flash will not have any effect. This is a common problem when working for example in forests where the subject is living in the tops of trees. If you increase the focal length of the lens, add a tele-converter to your lens, and increase the strength of your flash, you also can add a tele-extender to your flash. Just as in lighthouses where the light needs to be directed long distances to be seen, a tele-extender for the flash will direct and increase the light from the flash. They are inexpensive and can be purchased from some of the dealers mentioned in the Resources section at the end of this book.

If you want to increase the focal length of your lens you can add a tele-converter to your lens. If you want to increase the strength of your flash you can also add a tele-extender to your flash.

This Rehabbed Barn Owl about to be released is another example of my macro flash used on the end of my lens.

Chapter 14
Film and Memory Cards

Film or digital memory cards is something else you need to consider when planning your trip. I do not mean the kind of film or cards, but having enough of it with you. Film is the cheapest part of your trip, and for many photography is the reason to make the journey in the first place. It is downright nuts not to bring enough film to photograph everything that comes along.

It doesn't make sense to economize on making photos because you don't want to use up all your film. Bring enough to photograph freely. Lilac-breasted Roller in Tanzania.

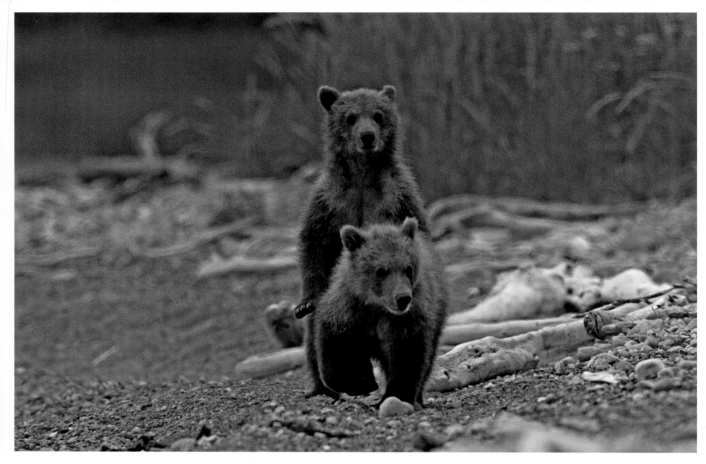

When action happens, like these two Brown Bear cubs running towards me, I like to have plenty of memory or film left in my camera so I can photograph without needing to worry about running out of frames.

Having only a few frames left when you are making a group image like this one is fine, but normally I like to have plenty of frames left for me to fill when the action starts happening.

Do you really think you are being prudent by waiting until the last exposure has been taken before you change film? If you anticipate something wonderful and you only have four exposures left on your film or memory card, rewind it or change cards and start fresh. If the action starts happening, do you think four exposures will be enough? I am always amazed when I hear people say, "Wouldn't you know it, just when I am taking pictures I run out of film." Well, excuse me, but "What Were You Thinking?" Have you ever known anyone to run out of film when they were not taking pictures? I have never looked at my camera in the morning only to find that while I was asleep my camera used up all my film, and this is true of extra batteries as well. If you are down to your last few exposures, you don't need to expose every last frame before you start fresh with a new roll or memory card. I always know when someone is down to their last few exposures. They start asking everyone to pose and say, "I need to take your photo to use up my last few shots." When you think about it, it is really impolite to announce to someone that you want to take his or her picture because you are trying to waste the film at the end of the roll. Just rewind it and don't worry about whether you actually did not finish the last few frames. Chances are, if you are just wasting film you probably end up throwing those frames away anyway.

One more thing about film and being prepared. Always have an extra roll or memory card at the ready in your pocket or at least within arm's reach. This way you will have the extra film when and where you need it. In seconds it will be in your camera ready to expose.

Now comes the big question. How much film or memory is enough? To make that decision, ask yourself some basic questions. What kind of photographer are you? Do you tend to photograph everything you see or are you more selective in what you want to photograph? What are the opportunities for photography? Will you have access to your subject for extended periods (such as is often the case on an African safari) or will you be spending the bulk of your time searching for the subject with only limited time for photography (as in trekking for Gorillas where time with the animals is limited to one hour by law)? Besides the main photographic opportunities, what are other possibilities for photography? Are there interesting historic sites or special events and will you be visiting native markets or villages? Do not rely on film or memory cards being available at local outlets, and if it is, don't rely on it being reasonably priced. How many times in your life will you be able to visit your destination? Is it a short road trip that you can make again or is this a once-in-a-lifetime experience? You can bring excess film home and use it another time; store it in the fridge and it will last for years.

Whenever possible I tend not to photograph everything I see, I prefer to wait until the right image appears for me to capture. I have lots of images of Galapagos Tortoises so I waited until someone came to photograph the same tortoise. Adding people in your images gives the viewer an idea of what the experience was like.

When I used only film, I would guess how many rolls I would need and triple the amount to take on a trip. Now that I use digital photography, I think in terms of how much storage I have for backing up images, but I still use the amount of images I might make as my guide. On a two-week safari in Africa I might create three thousand images, so, I need to have storage for at least that number.

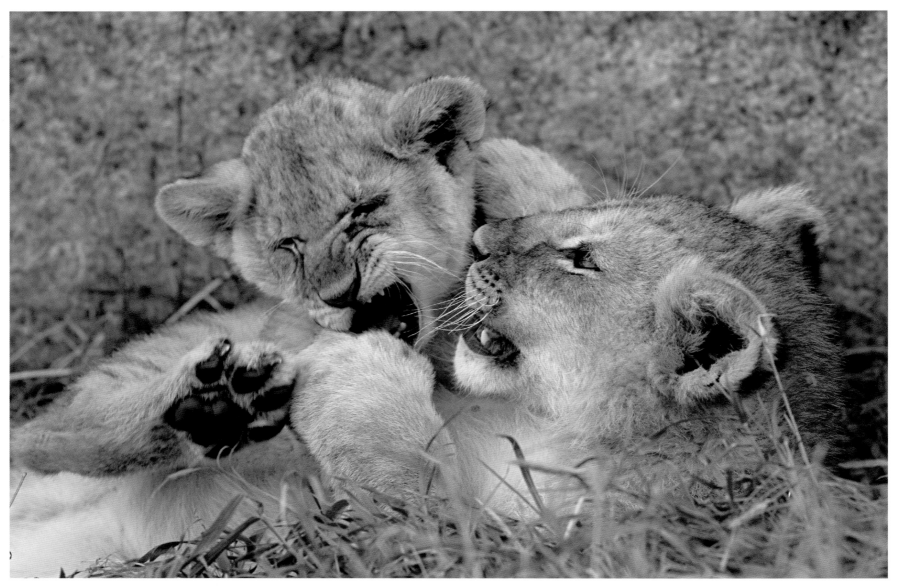

35-millimeter Film

You do have to decide what kind of film you are going to use, and this brings up new questions to consider. I believe in the KIS (keep it simple) principle. Use the kind of film you know how to work with. Of course there are considerations, but I am not one to try every new film on the market when I am happy with the film I am accustom to. Whether you use print or slide film depends on what you want your final photographs to be. If you like prints to keep in an album, use print film. If you like to show slides or make prints of the special photos you might hang on the wall, then use slide film. Print film is more forgiving; if your exposure is off it can be corrected (up to a point) in the lab. Slide film is unforgiving; you need to be right on with exposure when you create the photograph. Slide film is less expensive to buy and develop, but making a good print from a slide is more costly than making a print from a negative.

When using slide film exposure needs to be right on the money. Subjects like this Gentoo Penguin feeding its chick can be tricky.

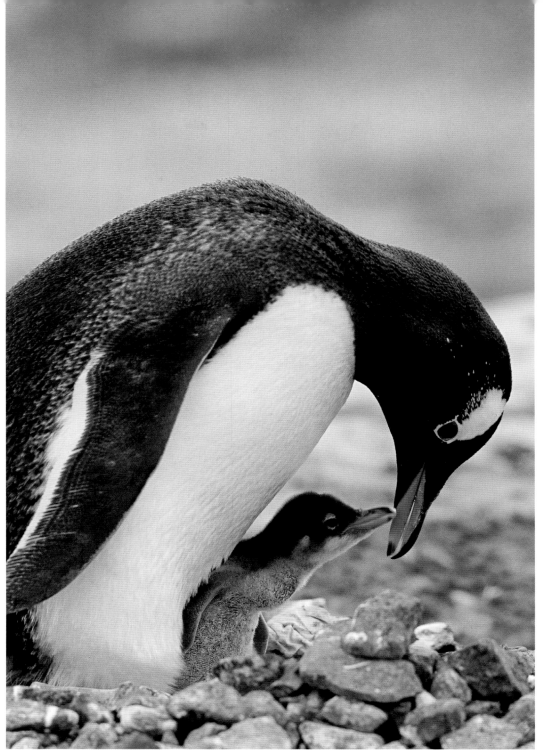

I normally use two speeds of film. My fast film is 100asa for wildlife and some scenics and my slower film is 50asa for scenics and wildlife where I have enough light. The faster the film the more grainy the image, so I like the slowest film I can get away with. With that said, today's technology is making leaps and bounds in the quality of film, and faster film is getting better all the time, so its speed is becoming less of an issue. There are circumstances that require faster film than I normally use, such as trekking chimpanzees in Uganda where the amount of light in the forest is very low and the use of a tripod for stability is almost impossible. In that case I used 400asa film. This is a matter of knowing what you are getting into, so learn in advance what the photo conditions will be. Besides asking your tour operator what to expec,t look at the work of other photographers who have photographed the area and subjects you will be photographing; their photos will give you lots of information.

Sometimes you have no other choice but to use faster film speeds like 400asa or higher. There was very little light when I was photographing this chimpanzee in Uganda.

Digital Film

With digital film you deal with the same issues you have with 35 mm film. You still need enough memory to capture the images you want. Many people rely only on memory cards to store their images, so they should be sure to bring enough memory cards to cover their needs.

You may be thinking that with digital you can look at the images already taken and delete any you do not want to save, but you will run out of memory when you are right in the middle of photographing. You won't have the time or the presence of mind to go through the photos taken, delete the ones you may not want, and still be able to make more images.

Make sure to bring enough memory cards to cover your needs.

It is so important to be able to just keep shooting and not have to worry about whether you will have enough memory to capture the images you want to get. Capybara, Pantanal, Brazil.

A good way to prevent running short on memory cards is to carry a storage device for the images already made. This can be a laptop computer or a portable storage device, as discussed in Chapter 9. I carry four extra memory cards besides the ones in my camera bodies and download the images I have made into a portable storage device as soon as I have the chance. This can be while I am having lunch in the field or in the vehicle driving to the next destination. Then I download the images from my portable storage device into my laptop computer when I have the time, back at the lodge or when I return home.

Just as a footnote, I do not like using high capacity memory cards. If a memory card malfunctions, I only loose the images that are in that card. Many photographers not only download their images into a computer, but also create a CD or DVD of their images right away. This insures that they won't lose the images in the event of a computer malfunction. Also, as with 35-millimeter film, make sure to have extra memory cards where you can get them right away. There are little carrying cases made that are dust and water proof, which enables you to have all the memory you need right in your pocket.

One last thought on digital film is that some brands of flash cards work better and faster with certain brands of cameras. Do some research on the Internet to see what other photographers say works best with your brand of camera.

Special Note

After you have downloaded images into a storage device, format the memory card so it is empty and ready to fill when you need it next. It can be very frustrating to put a fresh flash card into your camera and not be able to photograph because the card is full of the images from your last photo session. Then, while the action is happening, you are agonizing as you wait for the camera to delete the previous images.

The bottom line is whether it is film or digital film, don't let your capacity of your film dictate how many images you can make. Jackal, Tanzania.

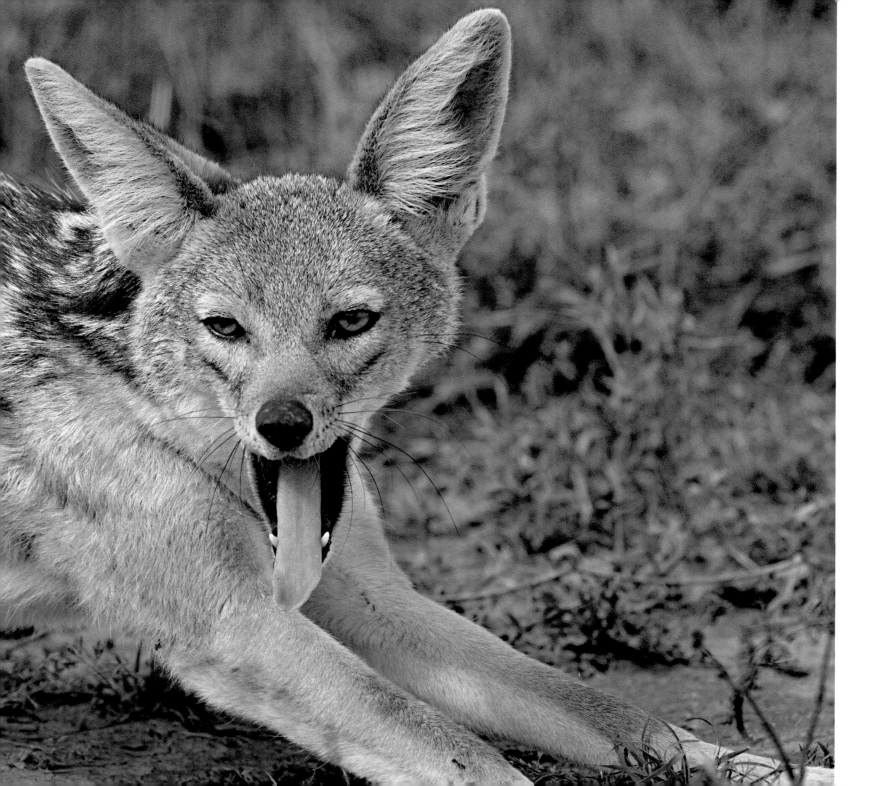

Chapter 15
Accessories

One of the occupational hazards of becoming a photographer is the enormous amount of photographic gadgets you acquire over the years. You find you can never have enough different camera bags or tripods (to build a life-size model of the Eiffel Tower). There are many types of accessories to feed your need to accessorize. Some I consider downright necessities while others are merely gimmicks.

Camera Supports

Camera supports covers a range of different products. There are beanbags, monopods, window mounts, and the support no one should ever be without, tripods.

No matter what lens you use or how fast your film, or which camera you are using, your photos will always be sharper with the use of a tripod.

Tripods

If you are not used to using a tripod, the first thing you will notice is what a pain in the neck they are to lug around and set up. They take precious time to place and always need to be adjusted. The second thing you will notice is that your photos look so much better. No matter what lens you use, how fast your film is, or which camera you are using, your photos will be sharper when you use a tripod. You simply cannot handhold a lens as steady as when you are using a tripod; it is the first accessory you should buy for your camera. Tripods are not always practical, especially on a boat or in a vehicle, but if you can, use one; your photos will show the difference and you will be pleased with the results. Most photographers have them; good photographers use them. Like many aspects of photography, the easiest way to get used to using them is to use them often. Soon, you will use tripods without a second thought. The trick is to find one that works well for you.

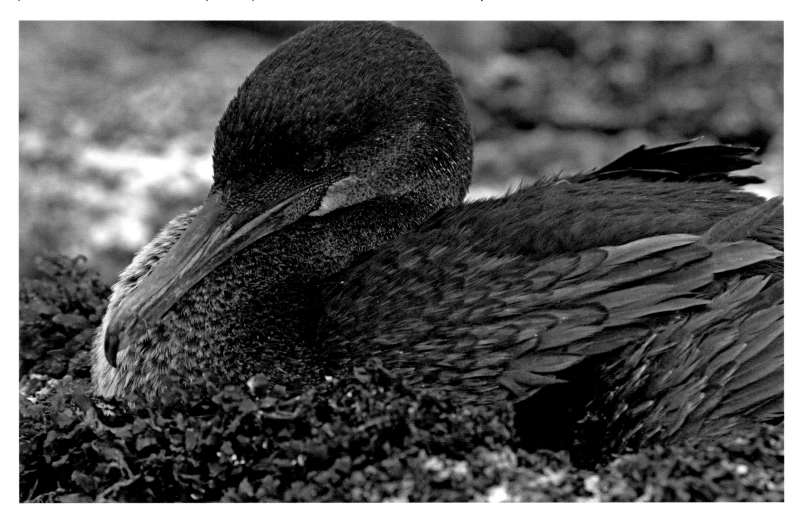

Even in the very best conditions, a tripod will always give you better results then hand holding your camera. Flightless Cormorant on the Galapagos Islands.

You want a tripod that is sturdy enough to hold the equipment you will use on it, not one that will bend under the weight of your camera lens. In the past this has always meant that tripods were heavy, but now carbon fiber legs make tripods lightweight while retaining their strength. If you can afford the carbon fiber it is well worth the investment, if not, the benefits outweigh the down side of carrying heavier models.

There are many models to choose from and you need to think about your specific needs to make the right decision. A feature to look for is the ability to have the legs open completely; that allows you to work at about ground level. Center columns are good for precision adjustments, but unless they are removable they prevent you from working close to the ground. Also, it is better to extend the legs on a tripod than to raise the center column. A camera sitting on top of a center column raised above the rest of the tripod is really sitting on a monopod, which is not as sturdy as a tripod.

Monopods

Monopods alone are a good way to steady your camera when a tripod is not an option. Our own body movement influences how steady monopods will be, and you probably tend to sway from side to side. Whenever I use a monopod, I also try to lean against something sturdy, like a tree or a vehicle. Tripods are the best, monopods are good if I can't use a tripod, and leaning on something steady is for when I can't use either one.

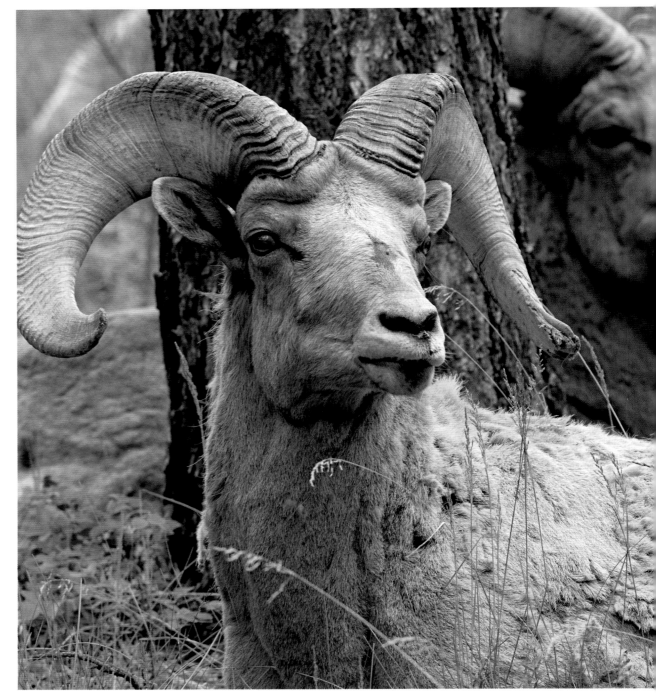

Light weight carbon fiber tripods are really worth the cost when you have you're carrying your equipment any distance in order to reach subjects like these big horn sheep in South Dakota.

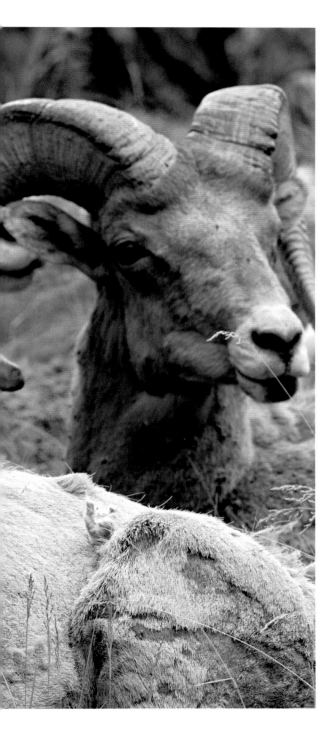

Other specialized supports are made for use in vehicles. Window mounts are very useful indeed. They allow you to attach your tripod head to the top of the window mount, making your vehicle the support. Many national parks and wildlife refuges have wildlife loop trails where you are obligated to stay in your car as you look for animals. Even when you are bound by park rules, wildlife will often allow you to approach much closer, if you stay in your car. Window mounts are perfect for this application. There are several brands on the market and I list some places to buy them in the Resources section at the back of this book.

Kirk Window Mount used when photographing from your vehicle. Photo courtesy of Kirk Enterprises, ©Jeff Bell Photography.

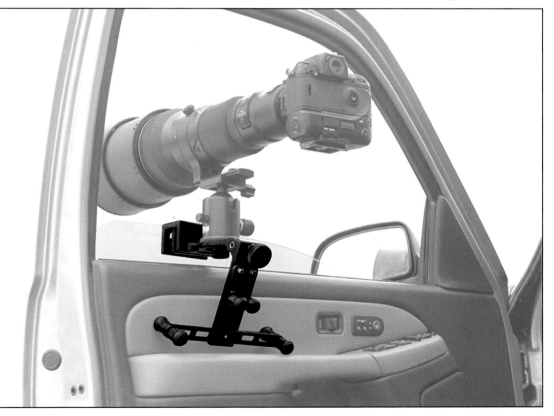

Beanbags

If you can't justify the expense of a window mount, another solution is a beanbag. Beanbags are cheap, easy to pack when empty, and work on any kind of vehicle. You can buy one or make one yourself. It is simply a small bag that you fill with beans or seeds. You rest your camera or lens on it to be steady. I use one all the time. If you make your own, include a zipper that will enable you to fill and empty it at will. When you travel, pack it empty and fill it when you get to your destination. This cuts down on the weight of your luggage. My beanbag has two bags that Velcro together so that it cradles the window of the vehicle and my camera lens. Make sure it is big enough to handle your equipment and don't be afraid to fill it about 8/10ths of the way. When I travel I fill it with dry beans. At the end of the trip I give the beans to a local who can cook with them, so they do not go to waste.

Tripod Heads

An excuse people give for not using a tripod is that they are awkward to use. One of the reasons for this might be that they don't have a suitable tripod head. Pan and tilt heads are wonderful if you have the time for precise adjustments, but they have at least two handles to adjust so are not always practicle for applications where time counts.

For wildlife photography, a ball head is better suited for the job. Ball heads have just one knob to adjust, giving you speed and flexibility in movement. They are compact and easy to pack.

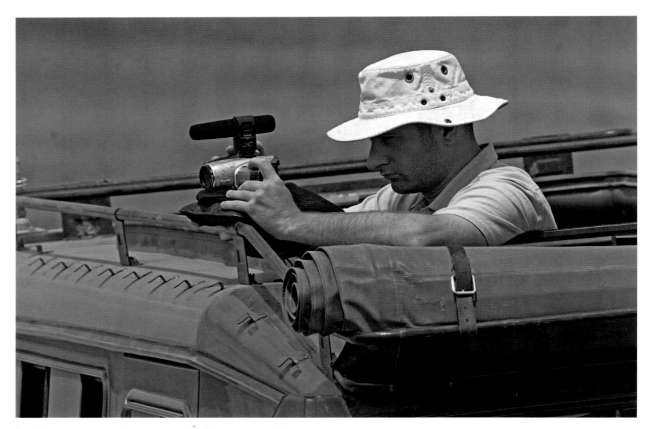

Ian Keller using a bean bag to steady his video camera while on safari. It is a simple inexpensive way to steady your camera when a tripod is not practical.

If you use large lenses, make sure your tripod head is rated for the weight you are putting on it. The Wimberley head is the best on the market for large telephoto lenses. It has a gimbal design that allows you to move it around its center of gravity with ease and very little effort. It can be bulky for travel but is worth the effort. It is not the best choice for short lenses, but it can be adapted in a pinch. I tend to bring a very small ball head for use only with small lenses, like a wide angle for landscapes, and a Wimberley for large lenses. I wish there were one tripod head that fit all my needs, but I continue to use both for my photography.

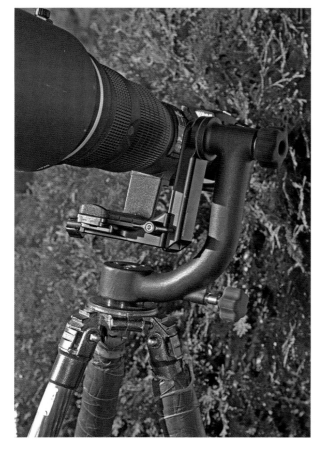

Without exception the best tri-pod head on the market for use on a large lens is the Wimberley Head. It has a gimbal design that allows you to move it around its center of gravity with ease and very little effort.

Camera Bags and Vests

Backpacks, shoulder bags, hip packs, and photo vests are but a few camera-carrying devices there are to choose from. Which one is best, you ask? All of them! There does not seem to be one camera bag that is good for all cameras in all cases.

Camera backpacks are great for getting your gear from point A to point B, but may pose problems if you need to access your gear in a hurry. Shoulder bags give you better access but may not be big enough for all your gear, and Chiropractic visits to fix your shoulder could mean a second mortgage. Your choice depends on your needs.

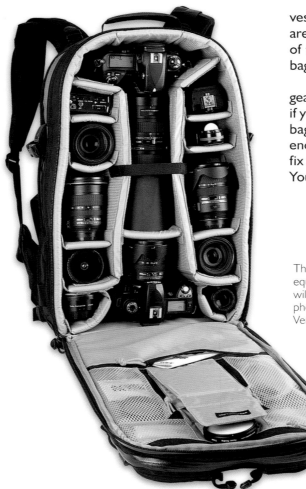

There are many choices when it comes to carrying your equipment, top loading, belt packs and back packs. You will probably end up with more than one type as your photography develops. The pack pictured is a Lowepro Vertex 300. Photo courtesy of Lowepro.

Backpacks

Photo backpacks are by far the easiest way to carry your gear from point A to point B. They offer space to carry large lenses and lots of accessories in a fairly comfortable manner, but can be cumbersome when you have little space to work from. If you share a seat in a safari vehicle, space will be at a premium when you need to lay your bag flat in order to access your gear in a hurry. If you are hiking, there is no better way to carry heavy equipment for long distances than on your back; the problem is accessibility. Some backpacks give you a small access on one side of the pack. Photographers deal with this problem by carrying one camera and lens in your hands while carrying the rest of the gear in the pack. This way, if a photo does present itself, you have a chance to capture it before it is gone. The biggest problem with backpacks is that they give you room for lots of gear and we tend to want to fill it. Think about how much you will carry in the pack throughout the day and how you will feel when the day is done. If you have only one bag for traveling, the backpack is probably the most convenient bag there is.

Hip Packs

Hip packs are ideal for both comfort and access, but the amount of gear they carry is limited. Their carrying capacity can be increased with extra pouches attached to your belt, but there is only so much you can carry in this manner. Some photographers use hip packs in combination with a backpack for better access and to distribute the weight more evenly.

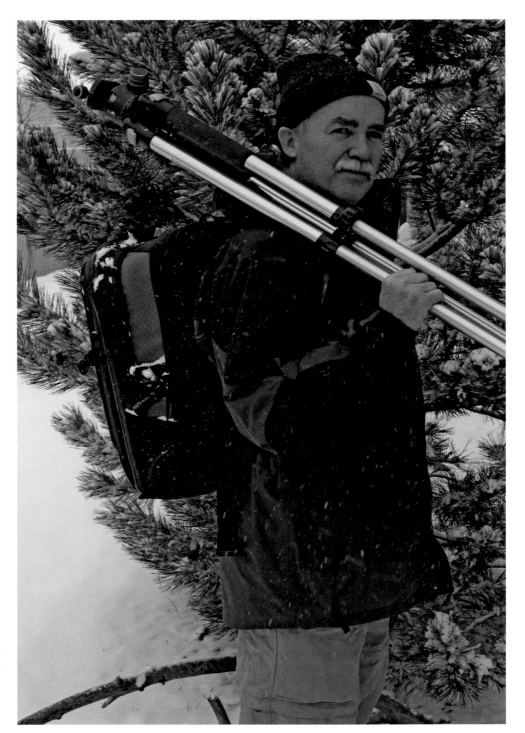

Backpacks are by far the easiest way to get your gear from point A to point B. My buddy Mark carrying his load.

Shoulder Packs

In terms of easy access, the most convenient is the shoulder bag that opens from the top and gives you complete access to all your gear. They come in different sizes, but there is a limit to the amount you will be able to carry on one shoulder. They are terrific for working from a vehicle, but cannot handle larger lenses like a backpack can. Shoulder packs are the most uncomfortable to carry for long distances.

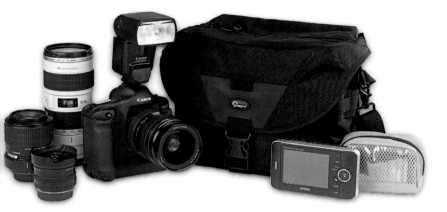

In terms of easy access probably the best bag that you can get is a top loading bag like this Reporter D300 from Lowepro. Photo courtesy Lowepro.

Photo Vests

Photo vests are another way to carry gear, but I prefer to use them for only one or two items that I am using at the time. They offer the least amount of protection from being banged around or from rain or snow. There are padded vests that offer more protection, but these can be hot when working in warm climates. I also don't want to worry about what I am carrying in my vest or what will fall out of my pockets when I quickly lie down on wet ground to photograph a frog or other critters. Wildlife looks best when photographed at eye level, so if you end up on the ground to get the shot of the tortoise passing by, you'll be lying on top of your expensive gear. This can be crushing to your equipment and uncomfortable for you. Vests are handy and they can hold lens tissue, extra film, and even the occasional extra lens. The pockets are easy to get into and can keep you organized, but just because the vest has 23 pockets you do not have to use them all.

In order to get this image of a Land Iguana in the Galapagos I had to lay down on my stomach. If I were wearing a photo vest filled with lenses I would have had to empty my pockets or risk damaging my gear.

Extras

Other items you may want to consider when traveling include a cable release, tool kit, cleaning kit, and extra batteries.

Cable Releases

A cable release or other way to trigger your camera without having to press the shutter release is very important, especially when making longer exposures. When you press the shutter release you put pressure on the camera body that can cause the camera to move. Often this movement will have no disastrous effects, but it may mean the difference between a sharp or a soft photo, especially during macro work. In lieu of a cable release, you can use the camera's self-timer to trip the shutter without touching the camera. A cable release also can be used when you are pre-focused and waiting for the subject to enter the frame. A cable release will enable you to watch without looking through the viewfinder. You will see when your subject comes into the pre-focused area. If you are looking through the viewfinder, the time between seeing the subject and pressing the shutter may give the subject time to move out of the focus area.

Photographing this lightning over the Colorado plains required holding the shutter open for many seconds. A cable release allowed me to accomplish this without shaking the camera with my hand.

Flash Cables

A flash cable allows you to remove your flash from the camera body. It is important if you do close-up work and take your flash off your camera body, or if you use a tele-flash on a flash bracket. It ensures that light from the flash is directed at your subject. By controling the light, you have more options and increase your chances of getting the photo.

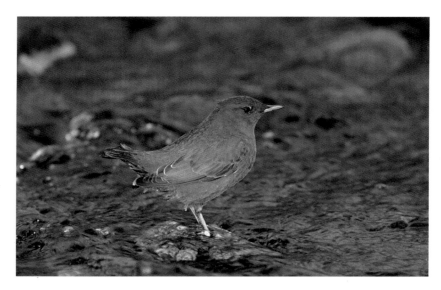

When using my tele-flash my flash unit is on a bracket away from the camera. This helps me direct the light where I want it, like on this Dipper in Colorado.

Tool Kit

I always pack a tool kit and it has saved my photographic life in the field where no other repair shop was close by. It is not a good idea to dismantle your equipment in the field, and to do so would probably void any warranty, but I have taken my chances when no other choice was available. Sometimes the results were better than others. My tool kit is home made and it includes various things I have found useful over the years. Below is a list of the contents and some of their uses.

1. a set of jewelers' screwdrivers for tightening loose screws
2. small needle-nose pliers for getting into hard to reach places.
3. gaffers' tape to seal light leaks and other uses. The tape is wrapped around a film canister so I don't have to bring the whole roll. In the canister I carry a paper clip (you always need a thin pointy thing), extra screws that are left over from past repair jobs, and some rubber bands
4. rubber jar opener to remove filters stuck on the ends of lenses
5. children's ear syringe to blow dust out from nooks and crannies
6. lens tissue and cotton swabs

Extras for Digital Photography

7. adapter(s) and transformer for electrical currents for the country you are going to
8. adapter to change one outlet into two or three. This will allow you to use the outlet to charge batteries without hogging the only one at a remote lodge.
9. battery charger(s) for all your electronics

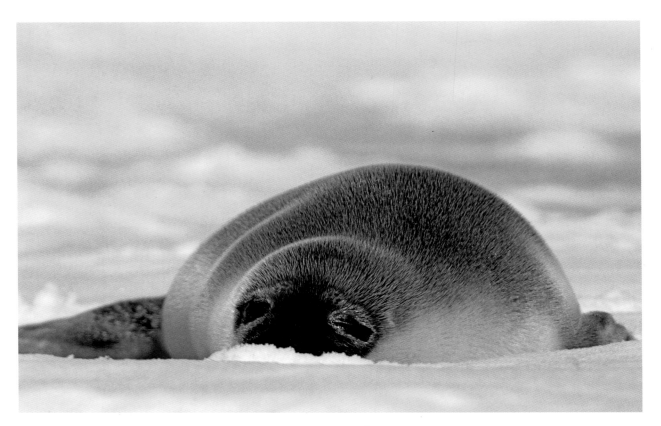

I would never attempt any major repair on my own, but a minor problem fixed by a strip of black tape or tightening of a lose screw has saved my photography when I have been days away from any repairman. Hooded seal pup, Gulf of Saint Lawrence, Canada.

Airports and Packing

It is becoming more difficult to travel securely with camera equipment. This presents problems for photographers as airlines are not responsible for lost or damaged electronic or camera equipment. It will do no good to yell and argue with airline employees, so do what you can to protect your equipment before you arrive at the airport.

Checked Luggage

Sometimes the amount of gear required for an assignment is more than is allowed as carry-on baggage. This has not been a problem since there are companies that make cases to safely ship photo gear. Pelican and Light Box are two of them that I recommend. The cases are well padded and with the proper lock are virtually safe from anything except actual theft. The problem now, at the time of writing this book, is that the only way to lock your suitcase when checking it at airports is to use a new generation of travel locks that airport security people have keys to. The locks are getting better but the manufacturers are only now making them substantial enough to offer any real deterrent to break-ins. These locks are only good if you have an external means of attaching the lock. Cases with only combination locks are not supposed to be locked when checking them in at an airport.

One solution is offered by the American Society of Magazine Photographers (ASMP). When using a combination lock on checked luggage, tape a note onto the case with instructions that you are reachable by cell phone up until the plane actually boards and that if security personnel need to open the case, they can call you for the combination to safely open the lock. You will need to carry a cell phone to receive the call and need to have phone reception in the event security does need to reach you. Whether or not this will work every time, I do not know. At least one other photographer who used this technique did not have any trouble. This plan will only work on U. S. domestic flights. If you are traveling outside the United States, your bags are at higher risk once you enter another country. If you do lock your bag with a heavy-duty lock within the United States, you take the risk of having security personnel force your case open, possibly rendering it useless as a carry case. If you do not lock your bag in a foreign country, you take the risk of having anyone with access to your luggage steal your bag. The only way to ensure that your camera gear arrives at the same destination as you do is to carry it with you, but that also poses some problems.

Carry-on Luggage

Carry-on luggage for domestic travel is now limited to one carry-on and one small personal item. However, the Transportation Security Administration (TSA) has an exemption for photographic equipment. If you go to their website (http://www.tsa.gov/travelers/airtravel/assistant/editorial_1248.shtm) and click on "transporting special items," then on "Photographic equipment," you learn that "You may carry one (1) bag of photographic equipment in addition to one (1) carry-on and one (1) personal item through the screening checkpoint. The additional bag must conform to your air carrier's carry-on restrictions for size and weight."

Traveling by plane has become a challenge to say the least, especially internationally. The best way to insure your gear arrives at the same destination as you is to carry it with you. Fur Seal colony, Skeleton Coast, Namibia.

TSA also informs you that your individual carrier may not allow the extra bag, so you should check with the carrier before departure. When I checked with a few of the major carriers, they told me that when transporting photographic equipment you would be allowed an additional camera bag, however I had to go through a couple of layers of customer service people to find that out. It was a surprise to them. If you plan on using the extra bag exemption, I would print out the page from the TSA website for reference and also see if I could get some verification in your file from your airline. If you are traveling international, the carrier may also allow the extra bag, however the country you are traveling to may not. At least domestic travel is getting somewhat easier.

This is the page from the TSA website. http://www.tsa.gov/travelers/airtravel/assistant/editorial_1248.shtm

Even with this exemption, I try to limit my carry-on. I suggest that if you are using film, it should go in the smaller carry-on (*never pack film in checked luggage*) with tickets and other personal items. Film should be removed from boxes and plastic containers. It is a good idea to wrap a small rubber band around the film and film lead to prevent the film lead from tearing. Pack the plastic containers in your checked bag so that you can put the film back in them when you reach your final destination. By placing the film in see-through, zip-lock, plastic bags, the security people can see it and are more likely to inspect it by hand for you. No matter what they say, not all security personal will hand-check your film. Most security agents are helpful, especially if you make it easy for them to see each roll, but some agents flatly refuse to hand-inspect film. It might be as easy as an agent passing those little cloths over the batch of film and putting them into the machine that tells them if your film is explosive. I have had an agent take out each and every roll and wipe it down individually. It might take you from five to thirty minutes to pass through security, so give yourself plenty of extra time to have your film checked. If this helps your piece of mind, I have had film go through X-ray as many as seven times on a single trip without any damage to the film.

For the cameras and lenses, you will need to use your carry-on bag allotment. I use the largest camera bag allowed by the airlines, a Lowe Pro Vertex 300, and a smaller top-loading bag for extra gear. Even though this bag is allowed on larger jets, smaller planes will require you to gate check even a bag of this size. If you have the room, pack some clothes around the loose gear in your bag for extra protection. The good news is that you can lock carry-on bags after they have been screened by security. If you are forced to gate-check your camera bag, lock it before it is taken from you. Remembering that you "get more bees with honey," be nice to flight attendants and explain your dilemma to them. Most flight attendants will try their best to help you as long as your bag is within the size limits and you have not over-packed it. In any event, you are at the mercy of the people you are dealing with, smile, be nice, and pack your bag as though it is going to be taken from you.

Another method of transporting extra gear is to carry it in the pockets of a camera vest. This too must be done within reason. I saw one photographer have to check excess gear he was carrying on him because it was spilling over into the adjoining seat. Still, photo vests have pockets big enough for many lenses and it can cover you if all of your gear does not fit into your camera bag. It weighs you down, but I do know more than one photographer who uses this technique.

All of these packing woes is yet another reason for choosing the right equipment to bring. If you think you may need it, you should bring it, but if you know you will not be using it, then leave it home.

Make sure you bring everything you intended to bring. It is so annoying to arrive at your destination and realize the battery charger (flash cards, extra batteries, cleaning material, and the list goes on) that you put on the dresser to pack is still on the dresser. Make a list and check it off as you pack. Be methodical and try to put items in the same place every time you pack them; this way you remember where you put it and don't need to spend time trying to figure out where it is. My wife always is amazed that when I pack for a two-week pleasure trip, it only takes me half an hour. This is because I am used to traveling and I know I can easily get by without an extra shirt or pants I may forget.

I am always slow and extremely careful, however, about packing my camera gear. I need to pack the particular piece of gear and all the accessories for that gear before going on to the next piece of equipment. Therefore, when I pack my camera I also pack the extra batteries and charger. Then I go on to the lenses. When I pack my macro lens, I also pack my ring flash, flash bracket, and sync cords. This goes on until I have packed and accounted for everything I need for the trip. Only once do you need to carry pounds of gear thousands of miles to arrive and find out it is unusable because you left a sync cord at home; then you will develop this system on your own.

Chapter 17
Weather

Some of the most beautiful photographs are made during bad weather. There is beauty in all weather, and raindrops, snowflakes, and fog can add to your photographic adventure. Think of the atmosphere in photos of a fishing village on the coast of Maine or snow-covered buffalo roaming the plains of Yellowstone National Park. Bad weather may be a challenge, but it does not mean you can't make good photos. No-matter how well prepared you are, the one thing you can never control is the weather.

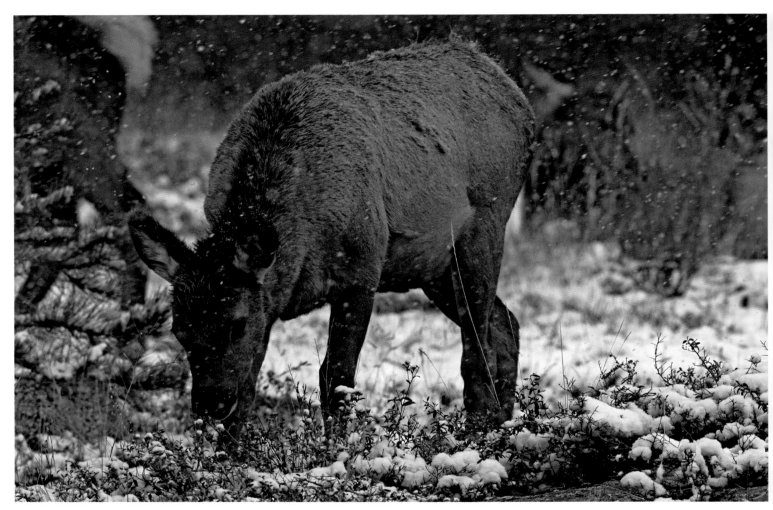

Weather should not be a deterrent to photography. Weather can add atmosphere to your photos like this young Elk during the first snow of the season in Rocky Mountain National Park.

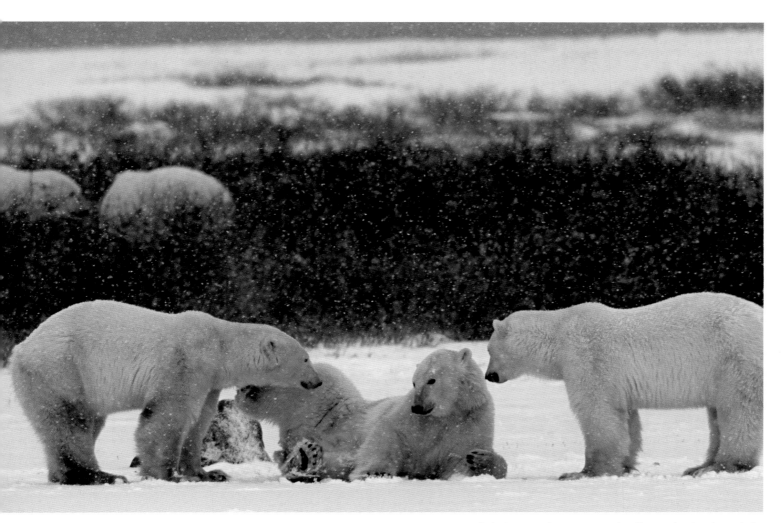

If you are going to a rainforest you can expect it to rain during some part of your trip. If you are hoping to photograph polar bears in the snow, you know what I mean. Planes may be delayed, cars may get stuck in mud, and wind may blow a gale. These can change your photo plans but they do not end them.

With the likely possibility of bad weather, you can arrive at a destination prepared for the elements. Make sure you have clothing to keep yourself comfortable. When you get cold, sunburn, or wet, your spirit and desire to take photographs will be dampened as well. Pay attention to pre-departure information a tour company sends you. Do your own research about what to expect.

Polar bears and snow go together like spaghetti and meatballs. The problem is that weather is simply unpredictable and there is never any way of planning for it.

Water

Water in the form of rain, snow, fog, or the iced tea your buddy just spilled on your camera bag can ruin your camera. Unfortunately, there is nothing I can say that will help you prevent your buddy from spilling his tea; he's your friend so deal with him. Rain, snow, and fog, on the other hand, are a little easier to prepare for.

In the case of an unexpected spray of water, the best you can do is have fast reflexes and quickly wipe off your gear before the water does any damage. I carry a small camp towel to deal with such an emergency. The kind sold in sporting goods stores for backpackers come in various sizes, but a small one is all you need. They absorb large amounts of water quickly and after ringing them out they dry fast as well. They suck in water that a regular towel would miss. Camp towels are great also in fog where a light mist can accumulate into a substantial amount of water coating your camera. Wipe the camera off every once in a while to prevent big drops from running into spaces in the camera. Extend the lens to remove any water that may have found its way onto unexposed parts and hold the camera in a way to allow the water to run off, not into your gear.

You can see the rain falling in this image of a Grants Gazelle one rainy morning in Ngorongoro Crater in Tanzania. Covering my camera and lens with a nylon cover allowed me to continue photographing even though the rain was really coming down.

Rain can actually be a blessing if you are photographing subjects that become more active right after a rain storm, like this golden frog in Borneo.

One of my favorite times to be out photographing is when the snow is falling. Snowflakes add a new dimension to your subjects, like this House Finch in Rocky Mountain National Park.

Humidity

Another way to deal with moisture is to cover your gear with a protective shell. There are commercially-made products, from a simple rain cover to a plastic housing with which you can submerge the camera underwater. Unless you are planning to photograph subjects underwater, the latter is a bit extreme. But a simple rain cover is an excellent way to protect gear in the field. Specially made covers for lenses are available, or you can make one yourself. Anything that repels the water will work. A plastic bag and some rubber bands will do in a pinch, but if you want something more durable and reusable, be creative with a pair of rain pants or a poncho; you can make a shell for your gear that will be the envy of all the photographers. I made one for my longest lens and camera combination by cutting off the leg of an old pair of rain pants, keeping the elastic at the bottom of the leg to chinch around the end of the lens. At the other end, I cut the seam to give me more room to drape it over the camera but still be able to look through the viewfinder. I glued Velcro tabs to seal it. With my gear protected from the elements, I can stay out in the rain or snow without fear of ruining the equipment.

Humidity is a tough problem. You can't always feel it or see it, but it seeps in like some villain in the night. If you are traveling to a tropical rain forest for a week or two, and are fairly careful, chances are the humidity will not have long enough time to damage your equipment. If, however, you are spending an extended time in the jungle or the wilds off the beaten path, like Florida, there are precautions you can take.

To prevent damage, simply wipe down your gear after each photo session. Store your equipment in a good camera bag that is dry (a wet bag is no protection against humidity). Silica gel packs or other types of desiccant work well as long as they are not saturated, but in the tropics they quickly absorb as much moisture as they can hold. Unless you are able to dry them out in an oven or other container, they no longer will do any good. If you live in Florida or are staying in well-equipped lodges, the air conditioning will keep the humidity from doing harm. Unfortunately, many jungle lodges do not have electricity, never mind air-conditioning.

I know a photographer who figured out that he could dry his camera out by placing it on the door of an open oven. He kept the oven at a low temperature and knew just how much heat his camera could handle before it began to melt. This was done without film in the camera and it took time and constant monitoring. Unless you have an extreme situation, this is not the most practical method, but it did work.

Working in humid areas like a rain forest or the Florida Everglades just requires a little more TLC for your cameras. Wipe them down and dry them out back at your home or lodge. Not only was it hot and humid when I photographed this Tricolored Heron chick, but I was working in waist-high water.

I believe dust is a photographer's worst nemesis, especially in places like Africa where the dry season is often the most popular time to be there. Zebra heard, Botswana.

Dust and Sand

Dust and sand are problems, too, especially in places like Africa where, during the dry season (often the most popular time to be there) there is dust everywhere. It is a double-edged sword; on one hand the dust creates magnificent sunsets because dust particles are suspended in the air, on the other hand it creeps into every small cranny it can find. All of a sudden you will hear a grinding noise when you are focusing or you will notice your aperture ring is hard to turn or sticks. These are signs of dust or sand in your camera and lens. It is especially important for digital photographers to avoid this because the sensor in the camera body is electrically charged and acts as a magnet for every dust particle out there. Be very mindful of this when changing lenses; keep your camera body protected. The best way to guard against dust is to keep your gear covered when you are not photographing. I know this goes against my suggestion to be prepared and ready, but covered is not hermetically sealed in a watertight box. It may be that all that is needed is to put a bandana over the camera as you drive along looking for animals, or you may need to place it in your camera bag or pack to keep it from the dust. If you do put it in your camera bag, make sure the bag is accessible and your camera is ready to use when you can grab it.

This is easy with smaller lenses attached to the camera, but what about long lenses that won't fit into camera bags without being dismantled? On safari I use the Lowepro Lens Trekker that is made for carrying long lenses. It will fit up to a 600-millimeter lens with camera attached. I strap it to the seat in front of me so it is sitting ready for use when I need it. With my lens hood attached, the camera sticks out the top, but this is easily taken care of with a draped bandana or rain jacket. A daypack or other pack can work just as well if you use a little creativity. Cover your gear and wipe it off periodically; you should be OK. The biggest threat with sand is not blowing sand you are aware of, but sand clinging to your clothing or skin that you don't realize is falling onto your camera when you stand after sitting or lying on a beach. Be aware, get up carefully, and brush yourself off with your camera safely away somewhere, not close to you.

Sand is just another name for big dust and you need to be careful when photographing in this type of environment. While I was lying on my stomach to photograph this Pacific Green Turtle in the Galapagos, making sure the sand falling off me did not land on my camera was my biggest concern.

Cold

Photographing in the cold presents some problems, but nothing too difficult to overcome. The biggest problem is not with the camera, but with the battery inside the camera. Cold causes a battery to drain faster than normal, so bring extra batteries. Don't be fooled, when you get back to your room you might discover that your battery has new life and is working just fine, but change the battery anyway. As your battery warms it will have renewed life, but as soon as it gets cold again it will fail once more. Keep the extra batteries in your pocket to keep them warm until you need them. Since you may be traveling in remote areas where they do not recycle batteries, do the planet a favor and bring used batteries home with you and dispose of them in the proper place; better yet, used rechargeable batteries.

Moisture on the lens is another problem. If you are in below-freezing temperatures and get moisture on the lens, it will freeze on the glass. If you need to clean your lens in the cold, do not use a liquid or your breath; instead, clean it with a dry lens cloth or tissue.

The most valuable advice I can give you here is that once your camera becomes cold, let it stay cold. When you take a cold camera into a hot place, condensation will form both outside and inside the camera. The electronics in your camera could be ruined. To prevent this, put your cold camera in the camera bag or pack (or even a plastic bag) before bringing it into a heated room. It is fine to go from cold to cold, hot to hot, or hot to cold temperatures, but never cold to hot. Many people try to keep a camera warm by sticking it inside their coat between shots, but this is the worst thing you can do. Not only are they putting the cold camera into a warm place, they are also putting it in a place with lots of moisture. When you bring a nice warm, moist camera out into the cold again, it will freeze.

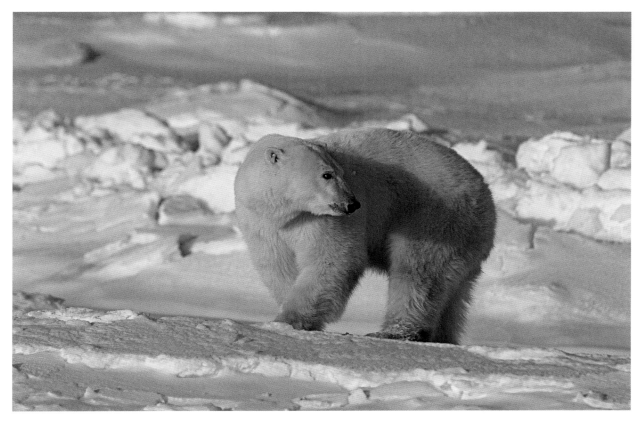

Whenever I have been leading a tour to photograph Polar Bears the biggest concern people have is using their camera in the cold. Make sure you have extra batteries since they are what are affected most by cold.

In the cold it is important to make sure you are dressed for freezing temperatures. While photographing this Artic Hare the temperature was -25°.

The last advice about photographing in the cold is to make sure you are dressed appropriately. If you are uncomfortable, you will not want to take photos. Being prepared for the elements makes the difference between an adventure and an ordeal.

Heat

The biggest issue with heat is having a camera and/or film in the sun for long periods, nowithstanding that a camera on a tripod for extended periods is necessary in many situations. The problem occurs when the camera becomes hotter than the temperature around it. Simple precautions can put your mind at ease. A bandana draped over the camera will shade it from the sun and keep it from overheating. Never leave a camera or film in an enclosed car, where the temperature can be compared to an oven. Normally when using film in the desert or other hot place, I keep my film sealed in a zip-lock bag and stored it in a cooler. Your camera bag is a good defense since the padding acts as an insulator. If you are staying in an air-conditioned hotel or lodge, you may find the cool camera lens fogging when you bring it into the heat of the day. It is hard to believe you need to worry about cold on a hot day in the middle of desert, but all the rules about cold to hot apply if you are staying in an air-conditioned room.

Traveling to hot areas will not present too many problems for your photography. Never leave your camera in an enclosed car where temperatures can truly be oven-like. Hiker exploring Bryce Canyon National Park.

Exposure Basics

Built-in camera meters are precise and typically give great results, however there are times when you will want to over- or under-expose your image. A good exposure accurately renders an image that represents what you saw through the viewfinder. When you have too much light, the image will be overexposed and with too little light, the image will be underexposed. Correct exposure is a combination of three elements: film speed, aperture, and shutter speed.

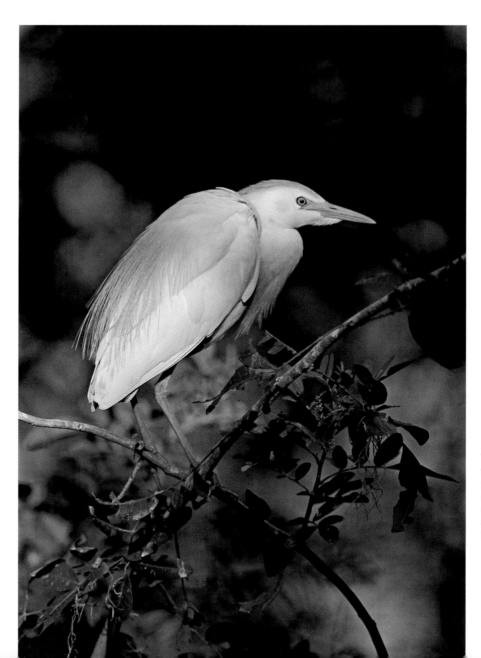

There are times when you might want to override your camera's meter and either under- or over-expose your image. This is especially true in cases with both white and dark areas in the same frame, like this Cattle Egret in Florida.

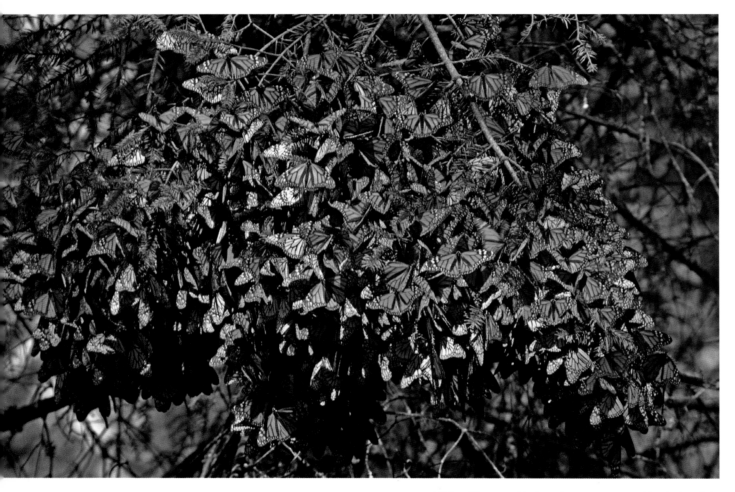

Film speed

Film speed is set and stays constant. Since light is always changing, there is no single correct exposure for the film you choose to use. The speed of your film, both regular and digital, is represented by the asa/iso number; the higher the number, the faster the film. In low light situations or when you need to freeze the action of moving subjects, you want higher film speeds; in brightly lit conditions, you want lower asa/iso. You don't want to use a high asa/iso all the time, because the higher the film speed the more grain (noise if it is digital) you will see on your final image.

The shutter speed and aperture are not constant. You change them in different combinations to achieve the result you want. Proper exposure makes the photograph, and understanding how to manipulate the exposure enables you to make creative photographs. Even with digital film, proper exposure matters. You can bring out details in dark areas and soften highlights in light areas with Photoshop techniques, but you can't make a properly exposed image from one that was taken wrong to begin with.

Higher film speed helps when you are working in low light situations. Photographing these wintering Monarch Butterflies in the Mexican forests would have been much more difficult if I did not increase my film speed to asa 400.

Aperture

The opening of the diaphragm in your lens allows light to pass through the lens onto the film. The size of the opening is called the aperture, which is controlled by the aperture ring or dial. The smaller the aperture of the lens, the greater the depth of field will be. Depth of field is the area of the photograph that is perceived to be in focus. It changes depending on the size of the lens being used. The aperture is broken down into numbers called stops, or F-stops. These numbers are in one-stop increments, typically 2.8, 4, 5.6, 8, 11, 16, 22, and 32. Each one-stop increment lets in exactly twice as much light as the one before it. Thjerefore, F 8 lets in twice as much light as F 11 and half as much light as F 5.6.

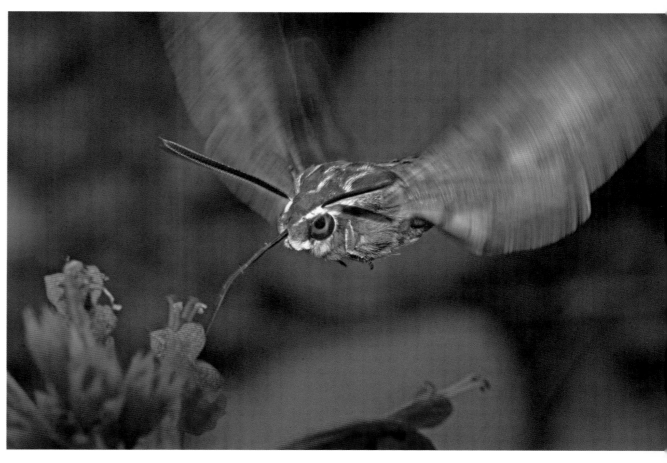

As I mentioned in the section on macro lenses as magnification increases, depth of field decreases. Even though I was using F 16 to photograph this sphinx moth in my garden only a very small section of the moth is in focus. This was due to me magnifying the moth with my micro lens.

A small opening is needed with a high F-stop to make the image. The bigger number refers to a smaller opening, and the smaller number refers to a bigger opening. The reason for using one aperture over another will be determined by the amount of depth of field you want or the desired shutter speed you want to use.

If you want greater depth of field, as in a scenic photograph where you need everything in focus, you need a small aperture such as F22. If you want to isolate the subject from the background, and only have the subject in focus, choose a large aperture such as F 5.6 or smaller.

To include the entire scene of this person watching the sunset in Namibia I used an aperture of F 22 and a shutter speed of 1/15 of a second.

This Brown Capuchin Monkey in Brazil was moving fast so I need as much shutter speed as I could get. That meant using the largest aperture on my lens, F 4.

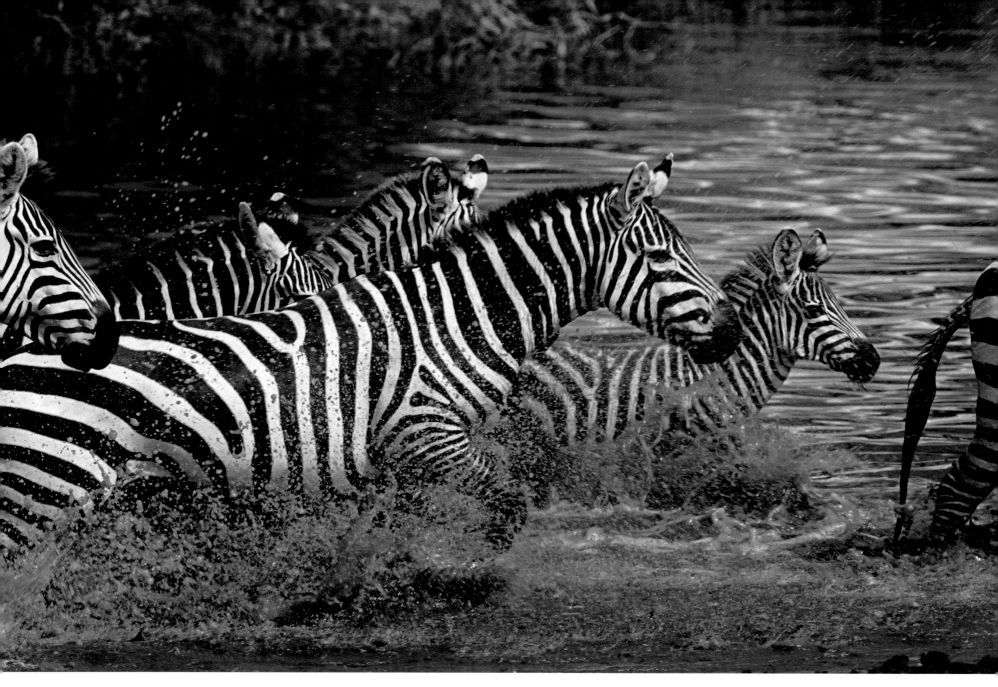

To freeze the action of these Zebras running across a river in Tanzania I used a faster shutter speed of 1/320 of a second.

Shutter Speed

The aperture determines how much light passes through the opening of the lens. Think of the shutter as the door and shutter speed as how long the door stays open. When you make a photograph, the shutter opens for the film to be exposed. The amount of time the shutter should be open is determined by the size of the aperture on the lens.

Differences in shutter speeds are measured in one-stop increments. Until you reach exposure times of one second or more, the numbers of your shutter speed refer to fractions of a second, such as 1/30, 1/60, 1/125, 1/250, 1/500, or 1/1000 of a sceond. You chose one shutter speed over another depending whether you want motion in the image frozen (stopped) or blurred (moving). When photographing a waterfall, you may want to freeze (stop) the scene to see every drop of water falling, even though it is in motion. Use a fast shutter speed, like 1/500. If you want to show the movement of the water and give it a more flowing (blurred) feeling to the image, use a slower shutter speed, like 1/30. You decide if you want more or less depth of field and frozen or flowing motion.

When the meter in your camera gives you an exposure for the photograph as (aperture) F 8 at (shutter speed) 1/250 of a second, you can change either the aperture or the shutter speed as long as you change the respective other to match your change. Although you can make less than full stop adjustments, for the sake of understanding the explanation is in terms of one-stop increments. If you increase the aperture one stop, you decrease the shutter speed one stop as well. For example, F 8 at 1/250 will give you the same exposure as F11 at 1/125, or F5.6 at 1/500. If you want more depth of field, you would favor a smaller F-stop, while if you wanted to freeze the motion, you would favor a faster shutter speed.

In order to give this water fall a more veil like effect I used a slow shutter speed of 1/15 of a second.

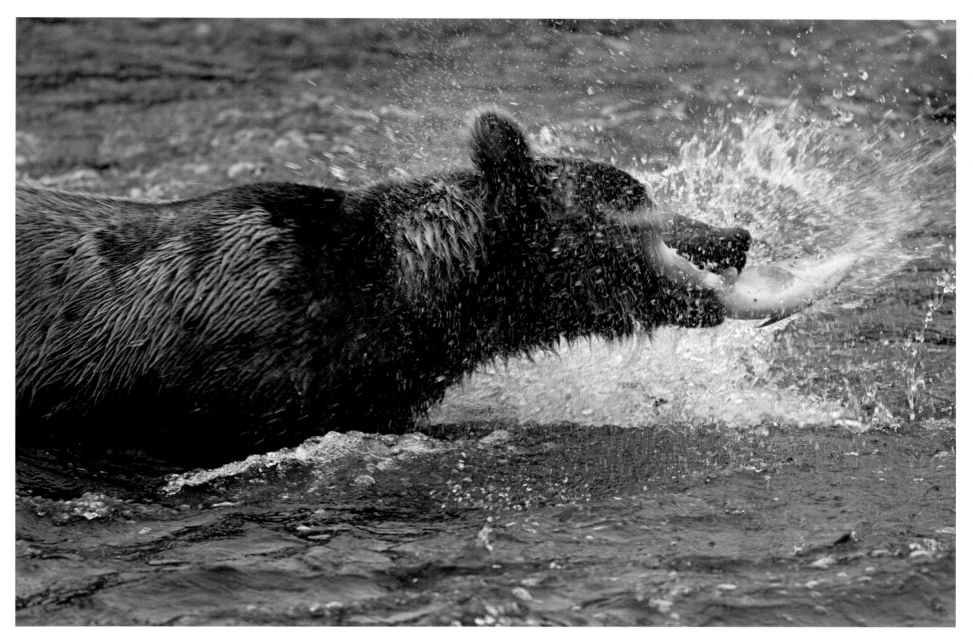

Sometimes using slower shutter speeds to show motion is favorable like this Brown Bear catching a salmon in the Brooks River Alaska.

If you are making a photograph that requires a large depth of field, you will use a slow shutter speed. Handholding your camera for longer exposures gives poor results, so use a tripod or other support to steady your camera. The general rule of thumb for handholding your camera is the reciprocal of the length of the lens. If you are using a 200mm lens, the slowest shutter speed you should handhold your lens is 1/250 of a second. (Use 1/250 because it is the closest shutter speed to 1/200.) This is the general rule, however you may be steadier than most or a little shakier than others. With lenses that reduce vibration and stabilize cameras, you can handhold at slower shutter speeds. The old rule is becoming older and maybe obsolete, but always use some type of steadying device if you can; handholding is the least favorable way to photograph.

This Pronghorn in Custer State Park, in South Dakota, was made at 1/80 of a second. Slower shutter speeds definitely require the use of a tripod for good results.

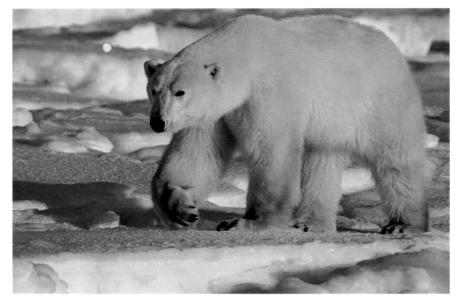

Your camera meter sees this Polar Bear on white ice as 18% gray. I needed to overexpose one stop to get the correct exposure. Many people think you would underexpose the frame but 18% gray is darker than white so you need to overexpose.

Don't be fooled

The meter in a camera is designed to average the exposure needed for a photograph. It does not see the world in color, but rather on a gray scale that assumes the entire world is about 18% gray. Most of the time this is fine, but on occasions there are enough very light or very dark areas in the photograph to throw your meter off and give you a poorly exposed photo. If you make a photograph with lots of white, for instance a white polar bear on white snow, your camera meter will see it as all gray and give you an underexposed photo, since gray is darker than white. In this case, you need to increase the exposure by one or more stops to properly expose the photo. If you make a close-up photo of a black cape buffalo on safari in Africa, you need to underexpose, because your camera meter sees it as lighter than it really is.

If you are unsure, *bracket* the exposures to ensure that some of the photos will be properly exposed. Bracketing is when you make one exposure at the setting your camera suggests and another one or more at exposures either over or under what your meter suggests. You might change your exposure by 1/3 to 1 stop depending on the situation. Bracketing is like an insurance policy; if you spend money and time to go somewhere and photograph, you might as well take a few extra frames to ensure good results. When you use digital images, you can check your monitor and histogram to make sure your exposure is on the mark.

18% gray is lighter than this dark Cape Buffalo in Uganda. I underexposed the image by 1/3 a stop to get the right exposure.

Chapter 19
Composition

One might think that when photographing nature, especially wildlife, you need to take what you get in terms of composition. But nature photography requires pleasing the eye of the beholder. You look for compositions that give your images balance, repetitive patterns, and details that bring the images to life.

Your images should have the same components that make all good art. This image of a Marine Iguana with a Lava Lizard on top of its head has balance, the second Iguana on the left, repetitive patterns, all of the lizards have the same profile, and the inter species connection adds life to the scene as well.

I once got some good advice from a friend who was an artist and saw me agonizing over a selection of images. I could not make up my mind which image I should choose to fulfill a request from an editor. The images were slides stored in a sheet that held twenty images. As I sat there wondering, he said, "turn the sheet upside down." He explained that good art is good art whether it is right side up or upside down. He told me to turn the slides upside down and choose the one that looked best in that position. I did what was suggested and it worked.

There are many rules of composition and you don't need to know them all, but following a few simple guidelines will improve your photography. Remembering that there are exceptions and that rules are meant to be broken, here are a few methods to help you create beautiful photographs rather than photographs of something beautiful.

Sometimes it is a good idea to step back from the subject and look at your image as art. Is it pleasing to the eye, does it have a mood? This image of a young Lion in Uganda is very peaceful to me.

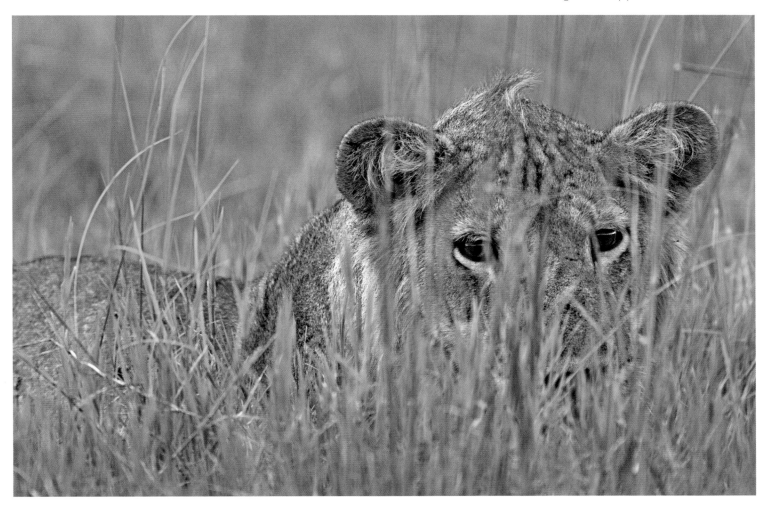

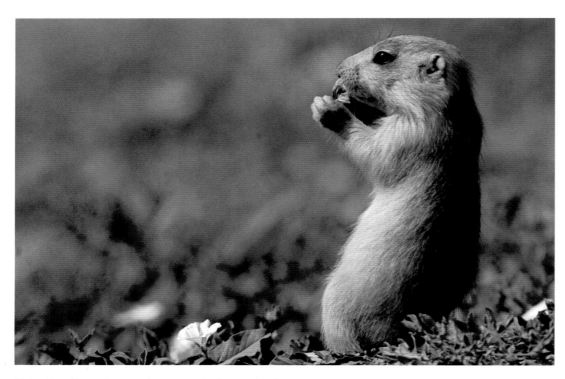

Little things like paying attention to your background and catching the highlight in the eye can make your image successful. Prairie Dog, Colorado.

Positioning

If at all possible, put yourself in a place that will give you the best chances for a nicely composed photo. Pay attention to the direction of the light, the time of day, and habits of the subject you want to photograph. Being in the right place at the right time is not normally a stroke of luck. Ask yourself if the place is somewhere photographed better with morning or afternoon light. Look around and make sure there are no power lines or other unsightly debris in the area. Look at your setting and decide where you want to stand.

Being in the right place at the right time of the day is not usually an accident. Photographing Chimpanzees at Nagamba Island in Uganda is better in the morning light when the sun is at your back and not behind the chimps.

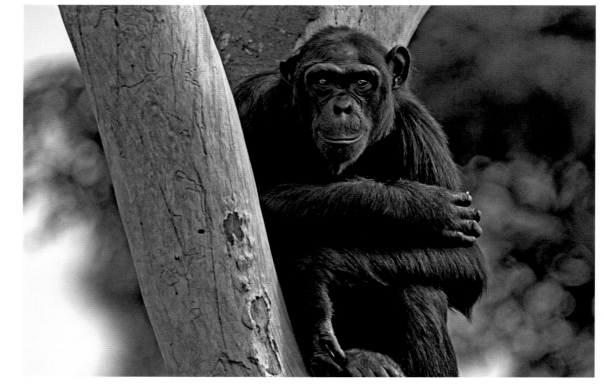

Wildlife always looks better if you photograph it at eye level, not *your* eye level, but the eye level of your *subject*. When you see documentaries of film-makers of wildlife, the cameraman often stands in ponds or hangs from a tree. The act of getting down on your belly may make the difference between a snapshot and a powerful photo. You balance the desire to make good photos with the issue of the safety of you and your camera. A camera does not make you invincible. When you can, lying on the ground or moving to higher ground can add power to your images. Don't be afraid to get a little dirty to get better results; however, don't be so involved in your photography that you put yourself in danger.

Look carefully at what you see in the viewfinder. When we get excited, we forget about everything except what excited us. Once, while I was working on whale-watching boats off Cape Cod, Massachu-setts, regular customers sometimes brought photos they had taken on previous trips and told me that even though they were pleased with their results, they had remembered the whale looking much closer than what the photos showed. They were right. That is what they remembered, but it is not what they saw. We have 35mm eyes and telephoto brains. When photographing the whales, the guests were excited and not paying attention to how much of the frame the whale filled. They were looking at the whale, not the photo. Their brains isolated the whale from the rest of the scene so their memory was of the whale, not the whale with water around it. If you take a moment to look at everything you can see in the viewfinder, you will see what the camera sees. It takes some effort at first, but if you practice this soon it will become second nature.

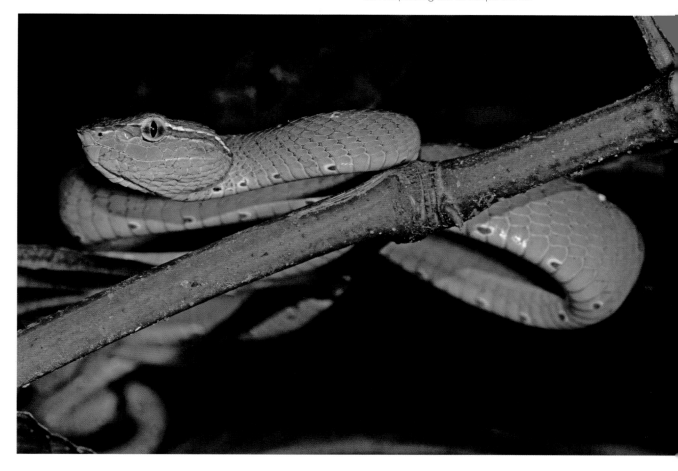

Wildlife by definition is wild. Whenever I am photographing venomous snakes like this Wagler's Viper in Borneo, I always have someone who knows about snakes with me to insure I am not pushing the envelope too far.

A common mistake people make is putting the subject directly in the center of the frame. It is human nature to do so and many cameras auto-focus at the dead center of the frame. Having a subject dead center lessens the impact and gives an insignificant feeling to the photo. Most SLRs allow you to choose were in the frame the camera will focus. If your camera only focuses in the center, all it takes to override this is slightly depressing your shutter release button when you are pointed at the area of the frame you want to focus on. Then, as you continue to depress the shutter, move the camera slightly to create a more pleasing composition.

To help you decide where in the frame to put your subject, there is a simple rule of composition called "The Rule of Thirds." It is easy to use. Look into your camera and think of an imaginary tick-tack-toe board on your viewfinder. This divides your frame into nine equally separated parts, three horizontally and vertically. The lines also intersect at four points in the frame. These points are called "power points" and are generally considered the place in the frame with the most impact, visually speaking. You should try to place your subject on one of the power points. If your subject is looking to the left, put it on one of the right power points; if it is looking to the right, put it on one of the left power points. This gives the viewer of the photo room for their eyes to roam and is more natural to the human eye.

Try not to put your subject right in the center of the photograph; it lessens the impact of the image. The face of this Galapagos Tortoise is purposely not in the center of the image.

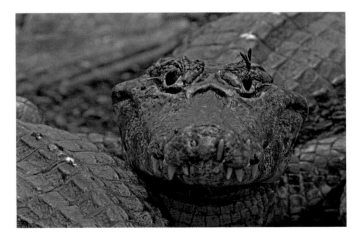

The main focus of this image is the wasp drinking from the eye of the Caiman in Brazil. I put it in the upper right power point of the frame.

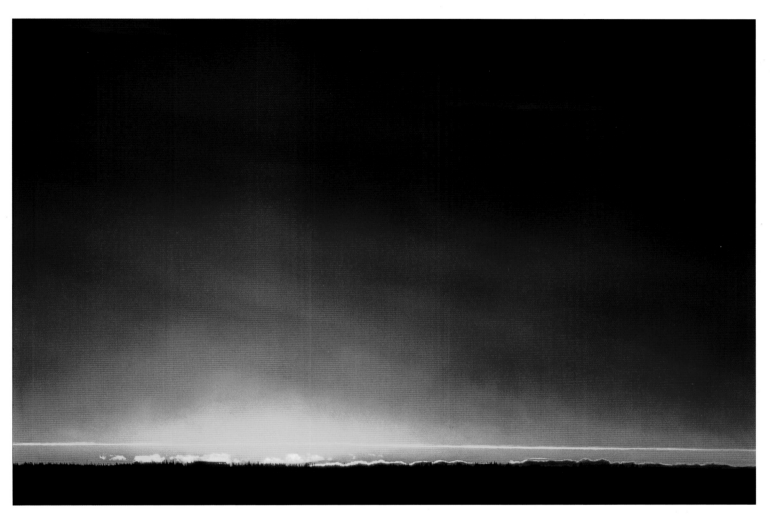

If I would have put the horizon in the center of the image I would have cut the picture in half. Getting rid of the boring and too dark foreground made this northern sunset more dramatic.

You notice that none of the lines dissect the frame directly in the center; this is important. A horizon is any separating line that dominates the photo. This could be where land is separated from the sky or a river runs through a landscape; it can be horizontal, vertical, or diagonal. You never want the line of a horizon to run directly in the center of the frame. Doing so cuts the image in half and gives the impression that two images were place together. By placing your horizon nearer one of the imaginary lines, either one-third from the bottom or one third from the top of the frame, your photo is more pleasing to the eye. It may take time, but at the expense of beating this to death a little practice will make it become second nature.

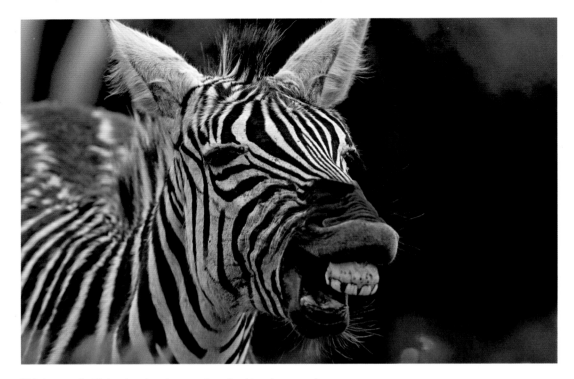

This image of a Zebra braying always gets a chuckle when people see it. Humor makes people feel comfortable with your photos.

You want to tell a story with your photos so know behavior is critical. This male lion at a kill in Botswana not growling, he is exhibiting a behavior known as "fle mening," to test the readiness of a nearby female.

Be aware of details that add interest to your images: behavior, interaction, animation, and humor. Human qualities enhance photography. The look of innocence in a young animal and the humor of cubs playing add to the wonder of photos. One of the reasons to know as much about your subject as possible is to be able to put their natural behavior into your images.

If you want to improve the look of your photos, you might consider taking an art class. Good art is good art anywhere, as a painting, sculpture, or photography. Knowing the principles of good composition will improve your photography and open your eyes to new ideas.

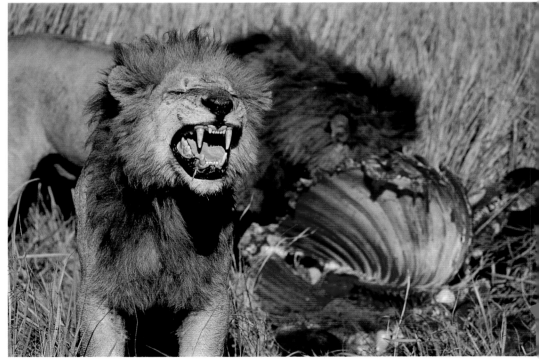

Chapter 20
Photographing People

Over the years travelers have become more wary of photographing people in foreign lands. I hear about native people not wanting their photo taken because they think it steals their soul. I see tourists invading a market or town trying to pose people into looking like the image the tourists have in their minds, not the image unfolding before them. They talk to the people as though they were talking to a cute little cat or dog and once they have their photo, they turn and go away primed for the next inopportune moment, complaining that the local tried to charge them a dollar for the photo. What do we expect? How would you feel if someone from a country that was totally strange to you shoved a camera in your face, took your photo, and left without having the decency to treat you as a real person? How can you ever expect to share cultures with others if your idea of sharing is taking pictures and giving nothing in return?

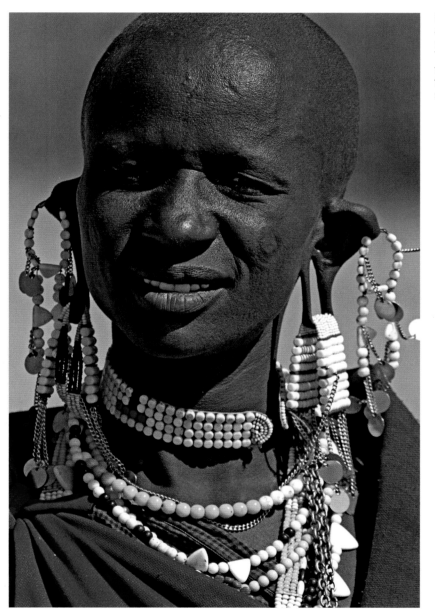

So many tourists visit Masai villages and get upset that the Masai ask for money to have their photo taken. This is a behavior that the western world has created because it is easier to give someone a dollar than to give someone respect.

This farmer in Southern Chile was glad to see that I was interested in how he grew crops. Not only was he happy to have me photograph him but also, I got a first class tour of his farm.

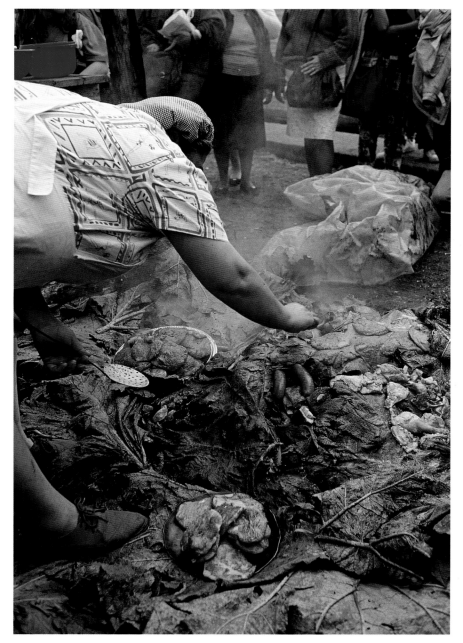

I am not talking about paying them money. Paying some-one for the chance to photograph them makes them models. Talking to someone with respect, not as a novelty, will get you more than good photos; it will earn you friends and respect in return. I do not pay for photos because I want images of people, not models. When I go to a market or village, I first go around and talk to people, whether I know their language or not. I make friends or let them know I am a person just like them, no better, and no worse. If you arrive at a market and want to photograph, take some time to interact with the people. You may want to buy some of their wares so they understand you are interested in what they do, not just for photos. Buy fruit or bread and give it away to others around you. You will be seen as a nice person and not another annoying tourist. Not only will you be able to photograph, you will probably have natural-looking photos. The taboos about photographing native people are something we created and continue to keep alive. I am not saying that everyone everywhere will be happy to have you photograph him or her, especially if they have expe-rienced other less considerate people than you. Don't think of your camera as a barrier but a bridge between people of different cultures.

When I go to a market or village I begin my photo session by first going around and talking to people, whether I know their language or not. This woman also in Chili is preparing a traditional barbecue called a Coronto.

Smiles open doors. You do not need to know the language to communicate. Communication without words gets you involved with your subject. Try to communicate with others for at least three minutes before taking their photo. Give the locals time to get comfortable with you. That will add stories to your images and make your trip more rewarding.

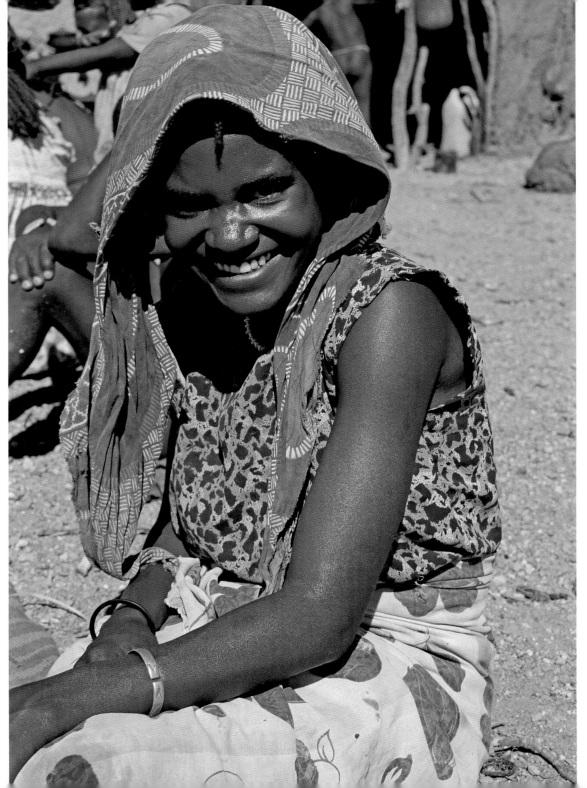

Your camera can be a bridge not a barrier, especially with digital cameras where you can show people their own image. Seeing their own image can cause lots of laughter, as is the case with this young Himba girl in Namibia.

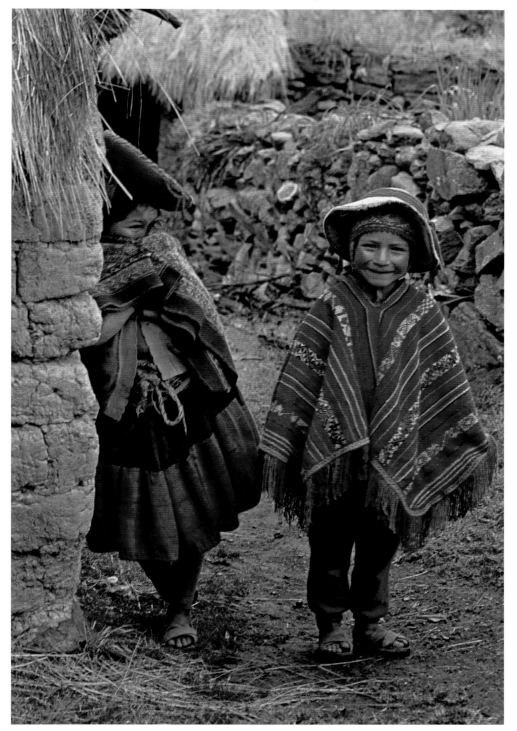

I once participated in a photo project that my friend and fellow photographer Mario Corvetto organized. Mario and I photographed families in a country where most people do not have access to cameras. We each returned a year later with prints of the photos we had made the year before. In both cases we had photographed someone who had past away during our absence. The photos we gave them were the only documentation they had of their lost love ones. Both of us were touched by the impact our photos made so we turned this experience into a project that was nothing less than incredible. Mario arranged with the Andean community of Patacancha in Peru for us and a group of photography enthusiasts from Washington and Lee University to document all of the people of the village. We did the shoot and then returned a few days later with the images to give to the people we photographed. The village was remote, with no electricity or other amenities, and the people there would never have had photos of themselves or their loved ones. The project started with ceremonies performed by the shaman and culminated two days later when the photos were delivered to the people. I have never witnessed a more powerful use of photos in my life, and now I truly understand what a photo can do. We made the images, but better still, we made contact with people and it changed us all forever.

These two children are from the village of Patacancha high in the Andes. After photographing everyone in the village, we gave each family a photo album with pictures of their family.

I know an old adage, "take only photos and leave only footprints," but I no longer abide by that code. I think it is time that travelers realize that we are the experience to the people we visit. We are not observers in a zoo; we are participants in the global community. Whether we want to or not, we leave an image of what we are to the people we visit. It can be an image of another human being from a different land, a new friend. The people I have met during my travels have touched my life in ways I am not literate enough to put into words. We are ambassadors of our culture; let the footprints you leave be in the hearts of the people you meet.

I have traveled all over the world to photograph wildlife, but it is the people I have met along the way that have touched me most. A guest, sharing her images with some school children in Tanzania.

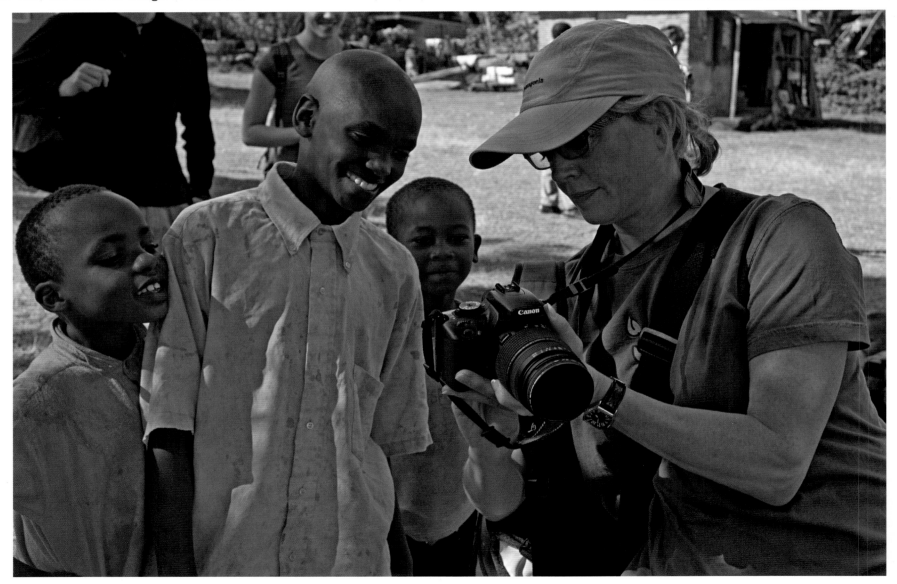

Chapter 21
Ethics

There is an ethical responsibility in being a nature photographer. Your camera is a tool, not a license. It gives you responsibility, not a right to interfere with others. Everyone has a right to enjoy the natural world as they wish to do so. Whether you use the camera to create and sell images or create memories, saying "please" and "thank you" will go a long way to helping you gain the photographic opportunity you are hoping for. Rude and bossy attitudes as you push through a crowd will guarantee to unite others in your group against you.

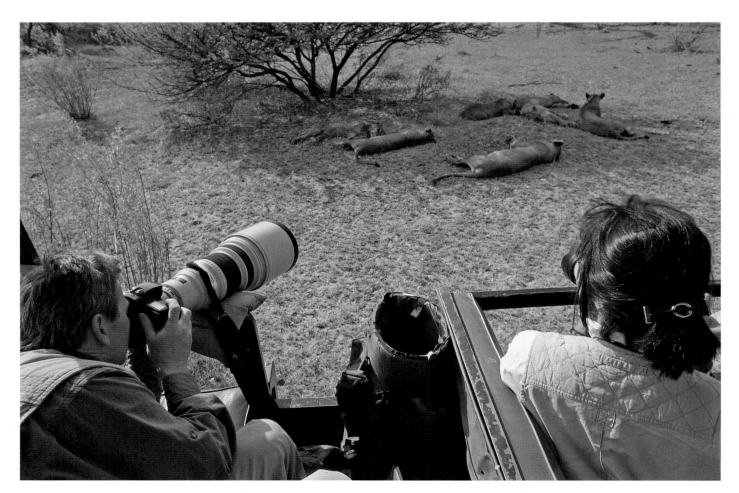

If you feel that carrying a camera gives you special rights, it is quite the opposite; it gives you more responsibility.

Sometimes areas are off limits to people to preserve and protect nesting sites or historical landmarks like these Masai rock paintings.

If you travel by yourself to national parks or other places where you are likely to encounter other travelers, plan your time so you can photograph when crowds are less likely to be around. Some locations are off limits to visitors to protect fragile habitats, nesting birds, or historical landmarks. Obey the rules. There may be a thousand people a day who would like to make the same image and in doing so destroy the habitat of a rare plant or disturb a nesting bird. (I have seen photographers kneel on top of a rare orchid in order to get a better shot of the orchid they were photographing.) Everyone has an excuse why they should be the exception to the rules.

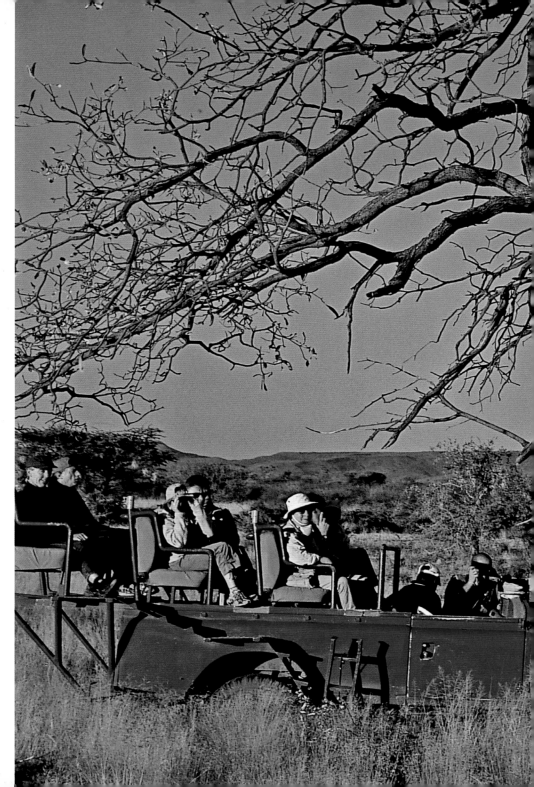

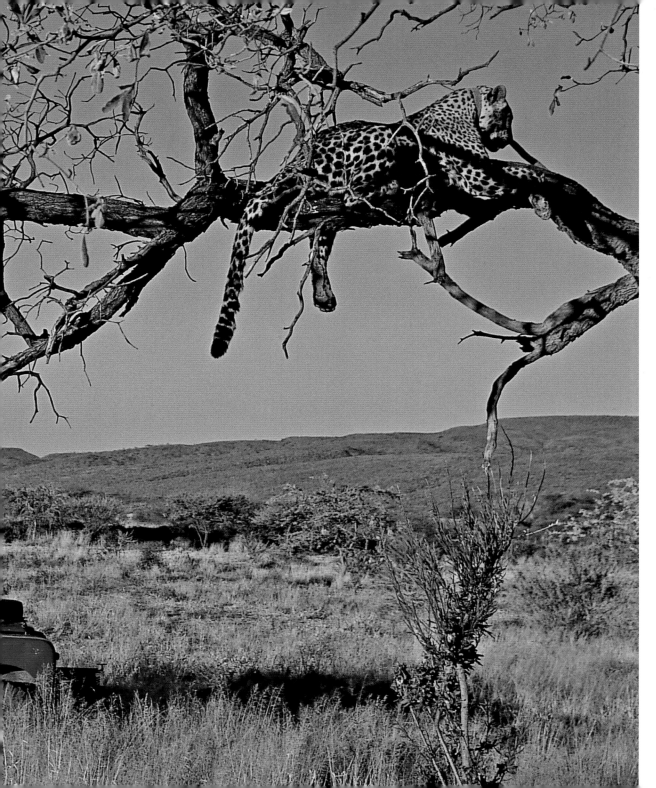

Because of careless photographers, all photographers have developed a reputation for doing whatever they need to do to get a photo, regardless of the problems they cause.

I was on a tour bus in Denali National Park in Alaska one summer and as we passed a photographer making some images the driver announced that we were passing the biggest threat to wildlife in the park, photographers. He gave his opinion of how photographers would do anything for their shot and should be banned from the park. The driver was wrong about photographers in general, but right about some photographers he had seen. Unfortunately, good photographers go unnoticed. Although I tried to correct the driver and explained that all photographers were not the same, there were about thirty people on that bus who left the park thinking that something should be done to curtail the behavior of photographers.

The most important reason for knowing your subject is to get images of wildlife being wild, not reacting to you. Ensure that your impact on the subject does not cause it harm now or in the future. No matter how much money you have spent and how many miles you have traveled to be at the location, no photo is worth risking the well being of the subject.

Most photographers are ethical and respect wildlife and other people like this group on safari in Namibia.

Some photographers will "garden" if the setting is not just right. This can have dire consequences for wildlife. "Gardening" is when you cut or remove vegetation in order to help the composition of the photo. This is especially disconcerting when photographers are working around nests and dens of wildlife. There is a reason the animal chose that particular site to build it's home, and often that reason is because of the protection branches or other vegetation around it offer. If you must remove a branch or other obstruction for the photo, tie it back. Do not cut it or pull it out by the roots. This way, after you are through, you can put everything back the way it was when you found it.

It is not true that if you put a chick that has fallen out of a nest back into the nest the parent bird will abandon the chick because of human smell. However, you should be aware that odors we introduce can open a nest to predation. If you leave any food at your photo site, predators (like a fox) might be attracted to the food and find a nice juicy group of chicks in the nest instead.

This female Cardinal is perched right above the nest. It is camouflaged to protect it from predators and is at risk if the moss around it is disturbed. Never cut twigs or leaves obscuring your view of the nest. If you must, tie back the branch so it can be replaced when your photo session is complete.

This Fox Sparrow was very weary of my camera near her nest. Instead of risking her abandoning the nest I choose to use my long lens from a distance and photograph the adults bringing food to the chicks.

Before you work at a den or nest, you must be aware of the tolerance level of the subject. Some birds and animals have high tolerance for you photographing them, others may not. If you cause the parent bird to be away from the nest too long, that may cause the chicks to become cold or over-heated. Young animals need to be fed on a regular basis. If you prevent the parent from feeding it's young, you may seriously threaten the young animal.

Photographing animals at their home is the exception to the rule that you should think of your equipment in terms of what it can do and not what its limitations are. Sometimes photographing at a nest or den requires specialized equipment, such as a remote-control cable release or multiple flash units. If you do not have the equipment required or you lack the knowledge needed to prevent too much stress to the subject, you should not attempt nest or den photography. There may be times when you discover an animal that is oblivious to you and gives you all the liberties you could hope for, but that is not the norm in nature. Most animals require some degree of getting used to you or need to be unaware of your presence before you can make images of them.

This House Wren was extremely tolerant and did not seem to mind that I was photographing her nest. This is not the norm in nature and extreme care needs to be taken around dens and nests.

Your responsibility to the animals does not end once you have taken the photo. Sometimes people are careful not to disturb an animal as they approach; they crouch, crawl, and never make a sound. Problems can arise after they got their shot. Then all hell breaks loose. They may stand up, laugh, or don't care about their impact after the photo was made. This not only scares the subject, it could also put the photographer in danger if the animal feels threatened. If it took you twenty minutes to approach an animal, it should take you twenty minutes to leave it as well. Treat all your photo subjects with respect. By not interfering with your subject, you will have a great "how the animal never knew I was there" story to tell around the campfire.

Sometimes being extra careful when photographing young animals is as much for your safety as it is for the safety of the animals. Brown Bears are very unforgiving when it comes to protecting their young.

Chapter 22
Remembering Why You Take Photos

There are bad photos, there are photos that are poorly exposed, badly composed, and just slightly out of focus. There can be a big difference. I always say that the second accessory you should get for your camera is a good sized garbage can, so you can get used to throwing away the reject photos. The difference between a bad photo and one that is not properly exposed or focused is significant. A good photo is one that evokes memories; it brings back a moment in your life that meant something special to you. So what if it is not the best exposure or it does not compare with the photos others have taken. If it makes you feel good, it is a good photo. If it is just a bad shot that does nothing for you, go ahead and throw it away. But if it makes you feel something, if it reminds you of a dream trip you always wanted to make, or it makes your heart smile, it has done its job and you should hold onto that photo forever.

Wandering Albatross on South Georgia Island. Not the best image of an albatross in my collection, but certainly one of the ones that means the most to me.

I was on a trip to Antarctica and the South Georgia Islands when a large colony of Wandering Albatross were found nesting on one of the islands. We all went to the shore to photograph the birds. The birds were quite tolerant, so I got on my belly and began to crawl towards one of the nests to get some close-up, wide-angle (20mm) photos of a bird when it got off of its nest. The bird started to waddle over to me so I lay still, to not cause the bird any further distress. Suddenly it began to grab at my hair with its beak. I was nervous, for the beak of this bird is almost a foot long and I wondered how much damage it could do to my head. My fears were unfounded, as the bird simply began to preen the hair on my head and an eyebrow. My camera was beneath my neck and I wanted to get some shots of the bird, but I was afraid if I brought the camera to my face the bird would move away. As the bird separated each hair of my eyebrow, I slowly turned the camera towards the bird, turned the aperture to close it down for the greatest depth of field, and hoped for the best as I began to photograph without looking through the lens. The results were awkward. The bird's features were out of proportion because of the wide-angle lens being too close to the bird's face, and the sky is filled with uninteresting clouds. I love this photo. It brings me back to an experience few people have ever had and one that I will probably never have the chance to repeat. Who cares if it is not the best quality, it makes me happy.

Young girl waving goodbye in Uganda.

There are many reasons I love to photograph. I love that I can earn a living through my passion. I love the many people I have met on travels and adventures. I love that I see so much of this incredible planet and I love that my work has been used for conservation. But for me, the most important reason I love photography is that it has enabled me to see the world in a very special way. It has taught me to look for the details and the small things that make the big picture so complete. It has given me a way to share what I love with people who mean the most to me.

Chapter 23
Helpful Tips for Photographing Nature

Know your subject. Know as much as you can about the wildlife you will be photographing.

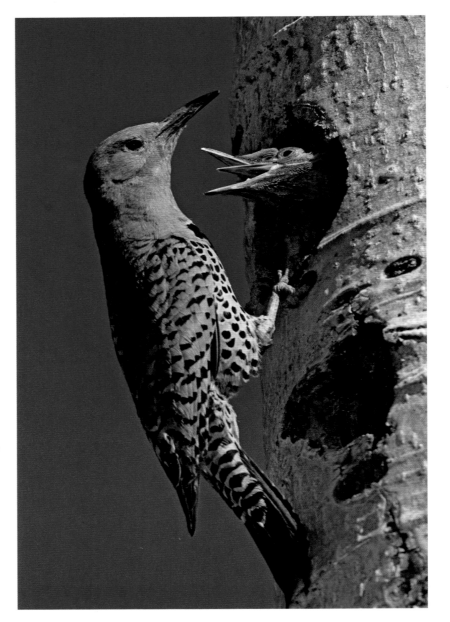

Know as much about your subject as possible. Northern Flicker at the nest with chicks.

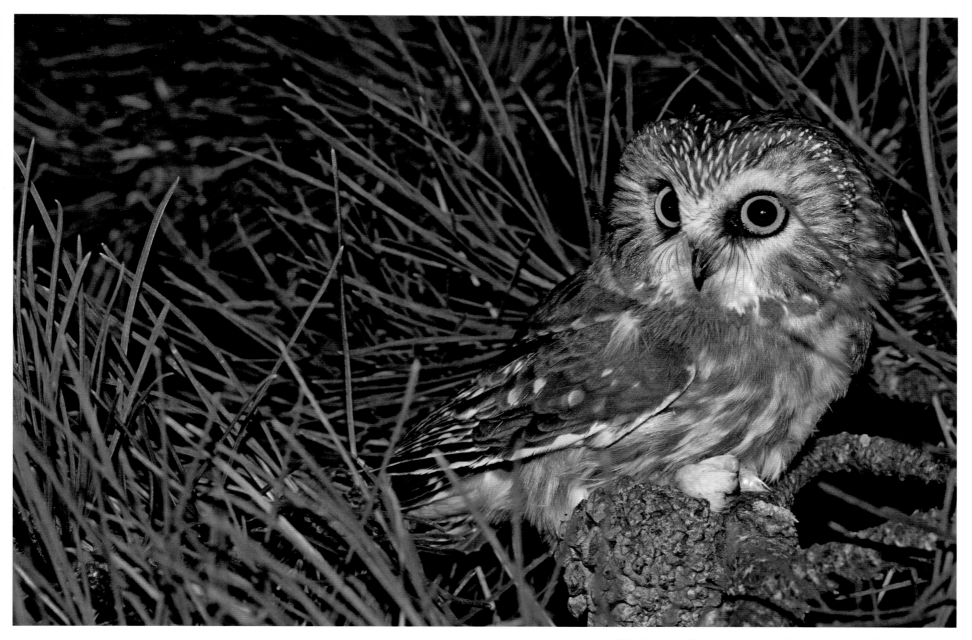

This Saw-whet Owl had just been released from a banding station. Being silent and moving slow prevents adding any more stress to the owl.

Be quiet. Even if your subject is very tolerant, this is a good habit to get into. You may even find that being quiet helps you to be focused on what you are doing. If you must talk, whisper.

Try not to move around. Once you are in place, try not to make extravagant hand or arm movements that may alarm your subject. If you are in a vehicle with others, don't move around causing the vehicle to move and others having to deal with the motion.

Photographing polar Bears in Churchill Manitoba is normally done from giant tundra vehicles that can be giant sails in the northern wind. Even one person walking down the aisle makes the vehicle rock back and forth.

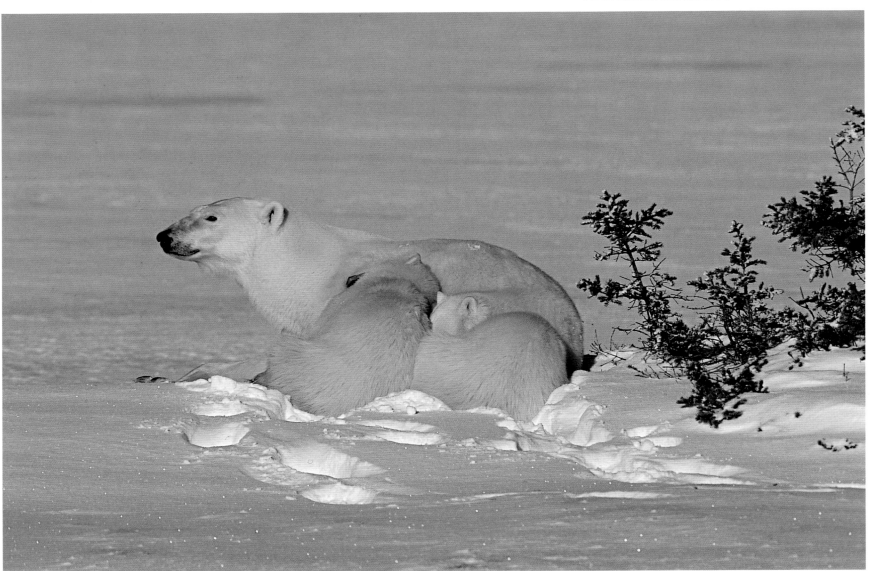

Think about the angles. Get down low, move to one side, and use the habitat to enhance your image.

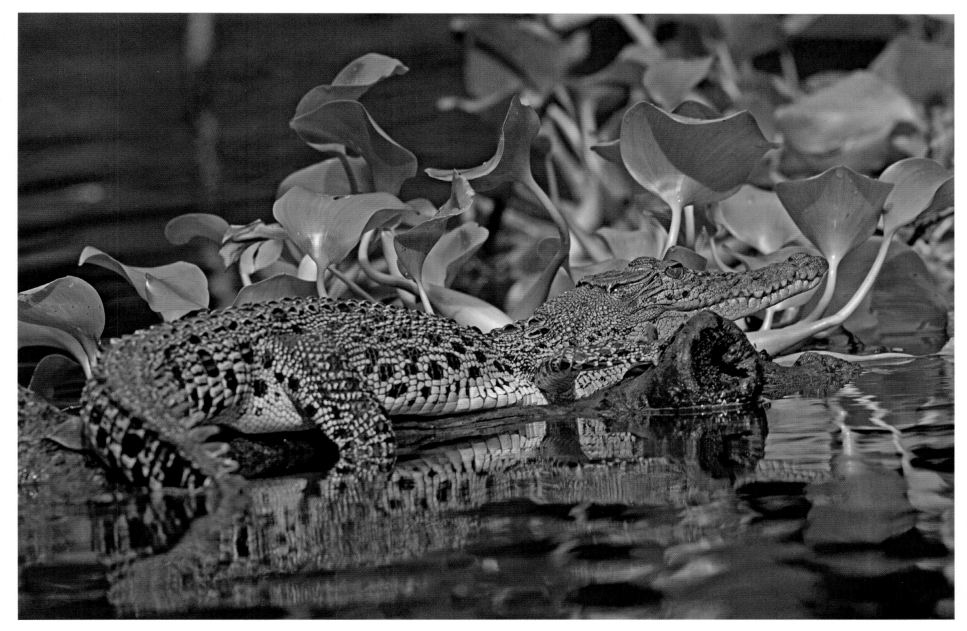

Being in a small boat while photographing this Crocodile in Borneo gave me the ability to be low in the water at the Crocodile's level. It is always better to be eye level to your subject.

Be ready. Have what you need with you and know what pocket you put it in.

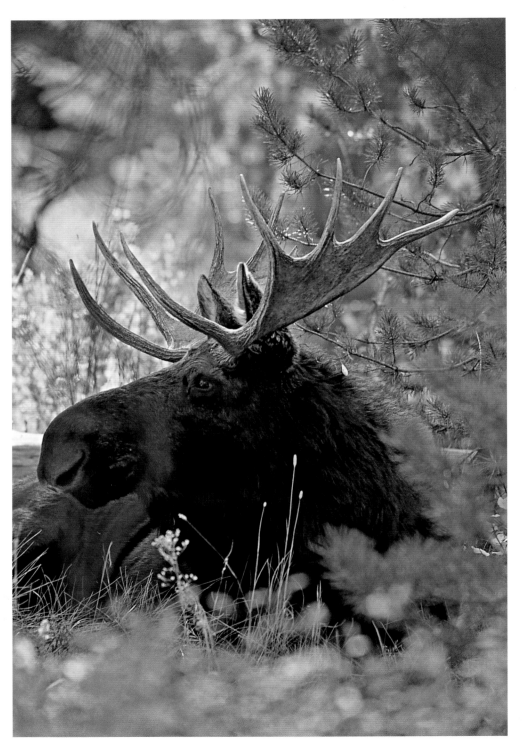

I hiked for twenty minutes to find this Moose in Wyoming and I would have been very frustrated if when I found it I had run out of film or needed new batteries.

Anticipate. If the animal is moving, try to anticipate where it will be instead of hasing it. Let the animal come to you.

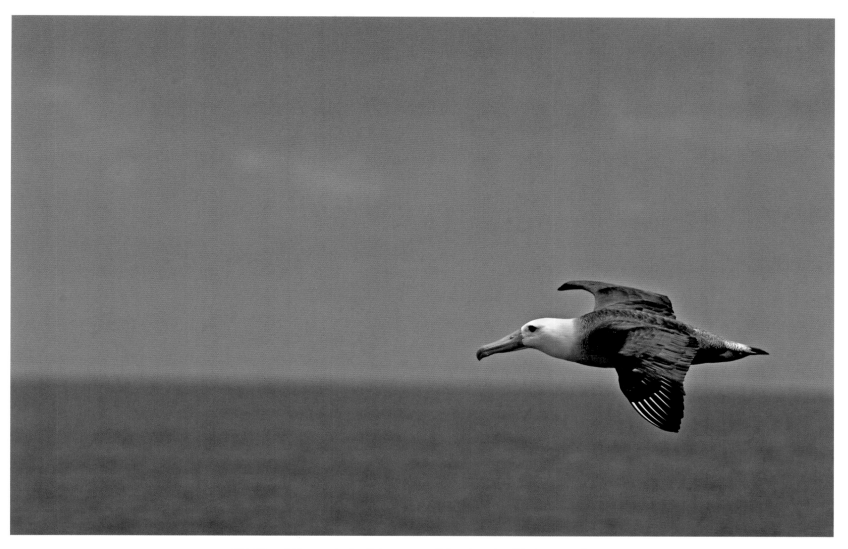

This Waved Albatross in the Galapagos was flying along the cliff edge towards my group. I waited until it came into view and followed it in my viewfinder until it was in the right place for the image.

Be aware of your surroundings. Pay attention to the direction of light and the backgrounds. Put yourself in the most favorable position for the best images.

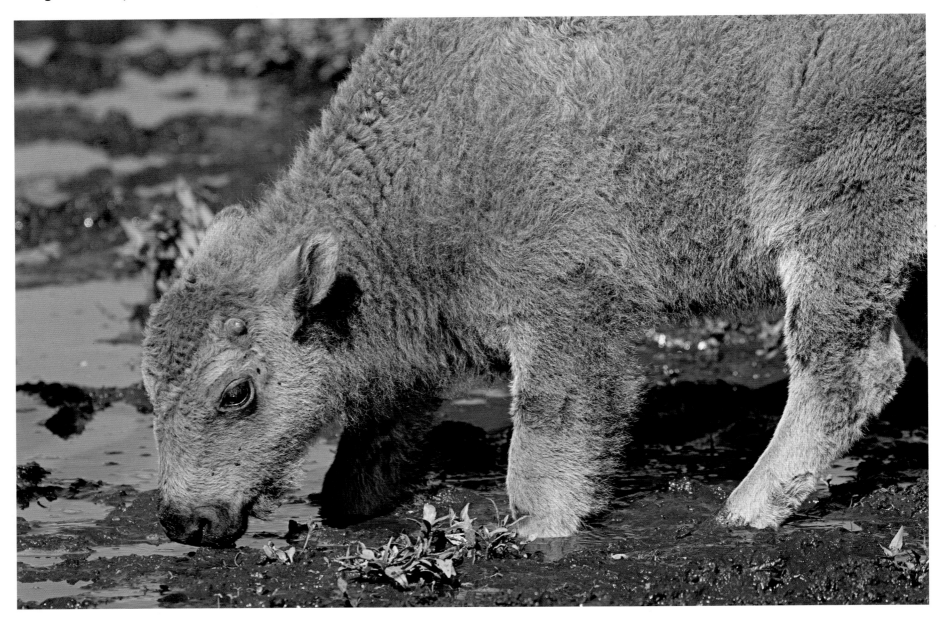

When I photographed this calf bison in Custer State park in South Dakota we were in a vehicle that allowed us to move around the young bison to have the light falling onto our subject.

Know your equipment. Memorize your owner's manual.

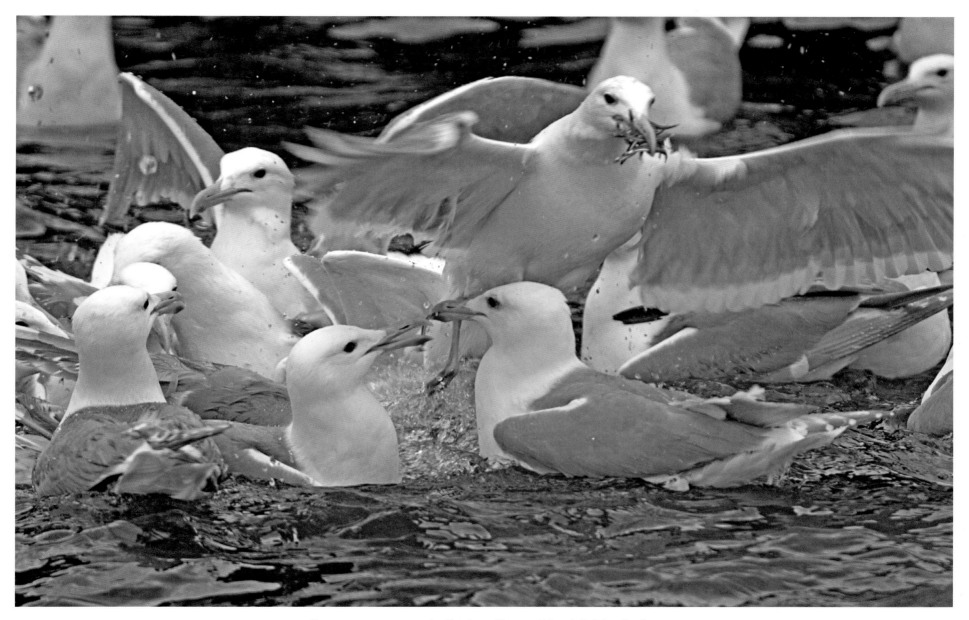

If you want to capture action like these Glaucaus Winged Gulls in a feeding
frenzy, you need to be able to just grab your camera and react.

In landscape photography, foreground is the key.

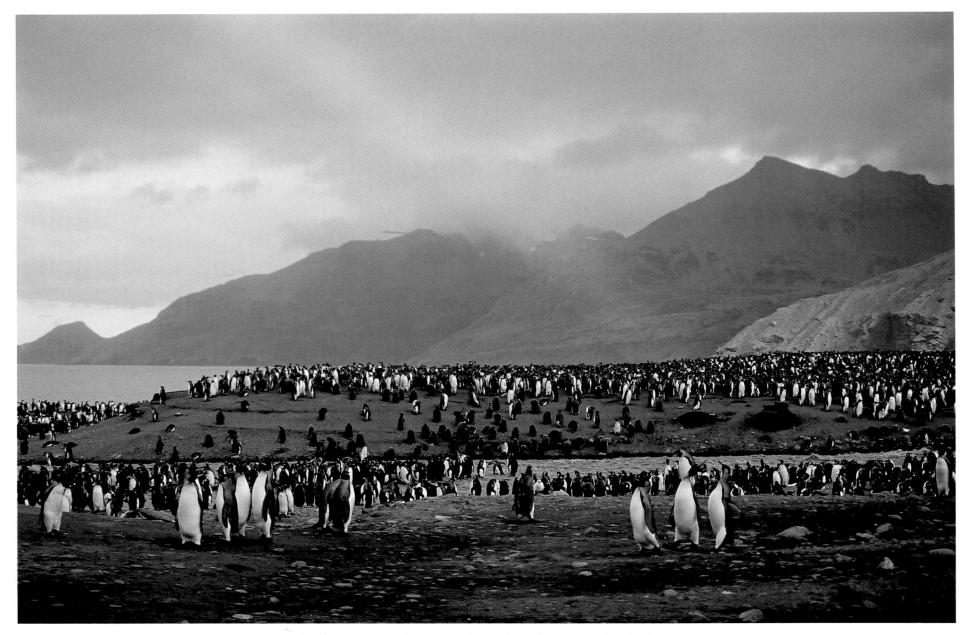

The King Penguins in the foreground of this image draw your eye into the photo,
allowing you to fully appreciate the rainbow in the background.

Use a Tripod. If you can't use a tripod, use a monopod, beanbag, or other means of steadying your camera.

For good sharp photos nothing, including stabilized lenses, beats a tripod. Use one. Young Bighorn Sheep, in Colorado.

Be Ethical. Respect the wildlife and habitat and photograph responsibly.

No photo is ever worth risking the wellbeing of your subject. No matter how much money you have spent or how far you have traveled, the subject always comes first. American Avocet on the nest, California.

Photographic Resources

B&H Photo
http://www.bhphotovideo.com/
420 Ninth Avenue, New York, NY 10001, U.S.A. (800) 606-6969
photo@bhphotovideo.com
Cameras, lenses, and pretty much all your camera needs. Most pros use them for purchasing equipment and film.

Green Planet Expeditions
http://www.greenplanetexpeditions.com/
19 Chieftain Court, Lyons, CO 80540, U.S.A. (866) 485-7996
info@greenplanetexpeditions.com
My travel company specializes in small groups. We have a selection of both photo and natural history tours and often create special one-of-a-kind tours for photographers.

Kirk Enterprises
http://www.kirkphoto.com/
333 Hoosier Dr, Angola, IN 46703-9336, U.S.A. (800) 626-5074
kirkphoto@aol.com
Kirk sells some manufactured equipment but they have a whole line of specialized gear they manufacture themselves. A great place to keep tabs on for the innovative gadgets Kirk comes up with.

L.L. Rue Enterprises
http://www.rue.com/
138 Millbrook Road, Blairstown, NJ 07825, U.S.A. (800) 734-2568, (908) 362-6616
Lots of photographic equipment but most noted for the ultimate blind. It sets up almost instantly, and is a well thought out blind made for photographers.

Lowepro U.S.A.
http://www.lowepro.com/
P.O. Box 6189, Santa Rosa, California 95406, U.S.A.
info@lowepro.com
Makers of camera bags of all kinds. If you need to put a piece of photographic gear in a bag, chances are they have a bag to fit it.

Mondo Verde Expeditions
http://www.mondove.com/
P.O.Box 2937, Frisco CO, 80443, U.S.A. 877-870-0578
If you ever want a cultural experience that will go way beyond any expectations, call Mario at Mondo Verde Expeditions. Mario and I work together on many projects and share a common ethics in running tours.

Natural Habitat Adventures
http://www.nathab.com/
2945 Center Green Court, Boulder, CO, 80301, U.S.A.
(800) 543-8917
Natural Habitat is a natural history tour company that I started with. They have more destinations than most other companies. Their guides are top shelf and who knows, you may get me for a guide.

Samy's Camera
http://www.samys.com/
431 S. Fairfax Ave, Los Angeles, CA 90036, U.S.A. (800) 321- 4726
Samy's is a chain of camera stores in California that has saved me more than once when I could not find things in any other stores. They have great staff and go the extra mile for you, with prices as good as New York stores.

Visual Echoes
(847) 438-3587
They make a very compact Tele-extender for your flash. It is inexpensive and fits into your pocket, a great tool to have.

Notes

Notes

Notes